BEAN
PLAYS ONE

Richard Bean was born in Hull, East Yorkshire, and on leaving school worked in a bread plant which later inspired his first professionally produced play *Toast*. He studied Social Psychology at Loughborough University and went on to work in the Personnel and Training departments of the telecoms company Standard Telephones and Cables. Other jobs after this included stand-up comedian, actor, inventor and occupational psychologist. He first turned to writing with the BBC radio sketch show *Control Group Six* with Clive Coleman and Andy Clifford. His first play, *Of Rats and Men*, was the winner of a Middlesex University playwriting prize possibly because it was the only entrant. It was performed at the Edinburgh festival fringe and later was adapted by radio for the BBC Monday night play and nominated for a Sony Award. His first experience of writing for the stage was with the Unicorn Arts Theatre writing and devising plays for children. His first professionally produced stage play was *Toast* (RNT/Royal Court, 1999). This was followed by *Mr England* (RNT/Sheffield Crucible, 2000). His relationship with the National Theatre continued with *The Mentalists* in the Loft Season in 2002. In 2003 he had three premieres: *Smack Family Robinson* at Newcastle Live! Theatre; *Under the Whaleback* at the Royal Court (co-winner of the George Devine Award); and *The God Botherers* at the Bush. In 2004 English Touring Theatre produced *Honeymoon Suite* at the Royal Court (co-winner of the 2003 Pearson New Play of the Year Award).

Richard Bean

PLAYS ONE

THE MENTALISTS
UNDER THE WHALEBACK
THE GOD BOTHERERS

Introduction by Paul Miller

OBERON BOOKS
LONDON

First published in this collection in 2005 by Oberon Books Ltd.
(incorporating Absolute Classics)
521 Caledonian Road, London N7 9RH
Tel: 020 7607 3637 / Fax: 020 7607 3629

e-mail: oberon.books@btinternet.com
www.oberonbooks.com

The Mentalists first published 2002, *Under the Whaleback* and *The God Botherers* first published 2003, by Oberon Books Ltd.

Cover design: Andrzej Klimowski

Cover typography: Jeff Willis

ISBN: 1 84002 569 7

Printed in Great Britain by Antony Rowe Ltd, Chippenham.

Contents

Introduction

THE NATIONAL THEATRE runs a very good scheme for helping writers. They're given a room and a typewriter and some money for a limited period. And perhaps advice, if they want it. Mostly they're left to get on with it. I worked there for a few years and watched them come and go.

When writers came to take up residence at the Studio, they followed trusted patterns of behaviour. On the whole, they smoked heavily in the tea and coffee area, joking nervously about how little work they were doing and I would kid them that there were CCTV cameras recording their every mistake or missed day. Occasionally they struck up conversation with no-one, disappeared for days, if not weeks at a time, eventually emer-ging with a few pages of a compelling but ultimately unproducable play. None knew how to take command of their room, though, like Richard Bean.

The 'Blue Room' (it has a shabby cobalt-blue carpet) was Richard's for a year under the Pearson scheme, and he arrived with computer equipment, books and other such exotica. We weren't used to such proficiency. He can't be any good, was the unspoken supposition. Industrial quantities of copier paper were fetched up the stairs every day. Dictionaries and reference works appeared. I think only what I came to understand as his natural sense of discretion prevented him from following what I'd now guess might have been his instinctive desire – to put up a shelf.

Richard had brought *The Mentalists* with him and we organised a reading of it, while he embarked on writing first *Mr England,* then *Honeymoon Suite* followed by *Distant Water* – this last one eventually became *Under the Whaleback.* Other plays were started then and remain work-in-progress – not since Olivier had costume fittings there in the '60s has that room at the top of the Old Vic Annexe been put to more sustained creative use than it was that year.

His previous play *Toast,* which was produced at the Royal Court in association with the Studio, had introduced us to his

David Storey-like ability to lovingly imagine and embody the world of men at work. The humour there was intrinsic to the situation (and very funny) but perhaps we thought it incidental to his talent. The reading of *The Mentalists* introduced us to the gale force laughter that Richard can unleash.

Rather than men at work, here it's men-who-should-be-at-work. Ted and Morrie understand everything and yet nothing about life. Morrie's myopia about reality is carefully cultivated. Dimly, he's aware of the tangent to facts at which he lives. But it suits him, rather like Joxer in *Juno and the Paycock*, to be a character. To be Morrie wouldn't necessarily be an unpleasant experience. And ultimately his self-preservation instincts are sounder than Ted's.

To be Ted, though, would be a tougher experience. Ted is vigorously trying to break through to some understanding – it's his inability (refusal?) to recognise the truth which is his tragic flaw. He has huge gifts – energy, stamina and a refusal to yield to apparent contingencies – that would otherwise mark him out as something of a genius. Nor is he blinkered enough to think that only he has the answer: his admiration for others' achievements is genuine.

> TED: Only Maurice Calvert would think of sticking his
> knob in a milk bottle.

In the smoke-and-mirrors world of Morrie and Ted, it's probably best not to go in for too much socio- or psychological examination – there is, after all, hardly any reliable evidence – but certainly there seem to be several missing fathers in the equation. The end result, as Morrie says, is that

> You're prone to obsessions aren't you. Obsessions
> that go bleeding wrong.

The question of politics arises. Ted is perhaps temperamentally an authoritarian socialist at heart, though he would recoil at the badge. Like Reggie Perrin he can come across as a bit of a fascist. He is perhaps what happens when the extremes of right and left meet round the back. I like to think his humanity

would always win out. This is possibly sentimental in view of what happens in the play, but the audience is left to judge.

Keith in *The God Botherers* also contains contradictions. On the face of it he has devoted his life to that most extremely liberal of occupations, foreign aid work. But his heart doesn't bleed liberalism.

> KEITH: I'm a pacifist, naturally, but you've got to admit, the British army is the best in the world... If it had been us at Srebrenica instead of a bunch of Dutch transvestites there would be six thousand Muslim men still alive today.

The play takes place in a small country 'somewhere in the developing world', where, in Keith's words:

> The borders don't make sense, the capital is on the coast, which is no fucking use to anyone, there's no rule of law, no running water, you never know when the electric's on, the last war's fucked everything, and the next war will fuck everything else.

Into this comes Laura, the quintessentially well-meaning but ordinary young Western woman. We follow her reactions to the new world she's in by means of her letters and e-mails home to pals. Initially disorientated by Keith's lack of soppy concern, she gradually adapts surprisingly well. By the end, she's absorbed something of his tough-minded pragmatism and is starting to make a real difference there. She's even come to an accommodation with Monday, the mimani assigned to look after her.

Like Morrie, Monday is one of Richard's gloriously loose-tongued magpies. He collects anything glittering from what is in front of him and assembles it all in his head in a mad collage. As with all the other magpies (*cf.* Irene in *Mr England*) there's a sense of a brilliant mind doomed to uselessness by faulty wiring.

> MONDAY: I was born a Muslim, but in the orphanage Jesus Christ came to me one night when I was playing Scrabble and made me his lifelong friend... I am also

technically Jewish, but that was a clerical error. I am circumcised, and a very poor job they did too. I could have done better myself.

A theme of the play: religion as a social construct. Blokes make up religions as a way of getting the world to run as they want. Religions are stories made up to support a way of life. And as such, it's fiercely implied, they need close scrutiny Linked to it, another theme: ignorance.

> KEITH: ...Actually that is the fucking problem, cos no-one is taught the bloody truth anymore are they, they're taught a concocted apology for the truth by some twenty-two year old Australian supply teacher who puts a question mark at the end of every fucking sentence and thinks the Spanish Armada is a tapas bar in Putney.

Ships again. In *Under the Whaleback,* Richard returns to the world of Hull trawler men that he'd previously studied obliquely in *Toast* and fully in the radio play *Unsinkable.* His imaginative identification with this group is powerful and on-going. (Later, it underpins *Honeymoon Suite.*) The play is rich with favourite themes: male myth-making, the world of work, emotional constipation in the face of life's crises and the unexpected ways behavioural tropes pass through generations.

A three-act structure, each act a play in itself. (The obvious formal allusion is to the great one-act sea plays of Eugene O'Neill.) We follow Darrel from his introduction as a snacker (deckie learner) on the Kingston Jet in 1965, through the calamitous 1972 voyage of the James Joyce and on to the museum ship Arctic Kestrel. One set – these floating factories are seen as ultimately indistinguishable. The detail of the life on board ship (especially in Act Two) is meticulously imagined without being suffocating. As in D H Lawrence's mining plays, realistic action becomes the metaphor, not just props and business.

Darrel survives the sinking of the James Joyce having been given a survival suit by the legendary Cassidy in Act One. He's had to watch Norman and Roc (from Act Two) perish in

front of him. By Act Three (we're in 2002 now) he's in charge
of the museum ship; the industry has calcified to this half-life.
Out of the modern world, Pat turns up. Another magpie:

> I've always been against the death penalty, unless it's
> for something really serious.

Fathers and sons are investigated; echoes reverberate up and
down three generations of men.

Looking back at these three ostensibly highly contrasted
plays it's hard not to feel that a tragic condition is being
described. Running under all of them is a sense that male ego
and pride is both a positive, generative thing – it yields imagina-
tive and material benefit to the world – and yet also a crushing
and stultifying burden to the men doomed to live it. Jokes,
stories, myths and religions are born which will help these
damaged men control their world.

By the end of all three plays someone has broken through,
usually by facing an unpleasant truth about reality. The arrival
of the police in *The Mentalists* could just be the making of Ted;
Laura in *The God Botherers* has faced out the realities of Tambian
life; even Pat (we hope) has learnt some-thing:

PAT: I'm me! I'm gonna be me from now on!

Morally questioning, sociologically fascinated, playfully inven-
tive and outstandingly funny, Richard Bean's plays have been
the most hopeful thing that's happened to the British theatre
in years. Enjoy.

Paul Miller, April 2005

THE MENTALISTS

Characters

MORRIE
fifty-five

TED
fifty-five

The Mentalists was first performed at the National Theatre (Loft) on 8 July 2002, with the following cast:

TED, Michael Feast

MORRIE, Duncan Preston

Director, Sean Holmes

Designer, Jonathan Fensom

Lighting Designer, Steve Barnett

Sound Designer, Rich Walsh

Company Voice Work, Patsy Rodenberg and Kate Godfrey

Scene 1

Summer, and a sunny day.

A bed and breakfast hotel room in Finsbury Park, London. The establishment is a poor quality, but not seedy, two or three star hotel. It has been created from two Edwardian town houses knocked together. Furniture consists of a trouser press, double bed, mini-bar, telephone etc. The door is up stage left, the double bed centre stage, and there is an en-suite bathroom just off stage right. There is a full length horizontal mirror on the wall stage right. There is a television and a telephone on a full-length-of-the-wall shelf stage right. The decor is death defyingly bland pastel. In the back wall there is a large double sash window, which opens onto the back of the hotel and the kitchen bins. A coffee table is centre stage on which is a half full bowl of fruit. There is a double bed in the centre of the room. A foil platter of fresh sandwiches in cling film suggests someone is expected. The general state of the decor is one of worn out bland conformity in need of a clean.

Enter TED. TED is a man of about fifty-five, with neat grey hair. He is gaunt to thin. He carries a briefcase with papers and books and a suit in a thin plastic dry cleaner's bag with wire hanger, and black business shoes. He deposits these on the stage left side of the double bed. He is wearing smart creased shorts and a white short-sleeved shirt with deck shoes and no socks. He stands in the middle of the room and looks around disapprovingly with hands on hips.

TED: Typical. Tut! Look at this, eh? Morrie?!
 (*TED sticks his head out into the corridor looking for MORRIE.*)
 Morrie! We're in here. (*To himself.*) Daft bastard.
 (*Enter MORRIE laden down with a video camera, box, tripod and a plastic carrier bag. He is also fifty-five and well kept in a mutton dressed as lamb sort of way. He is overweight to a cuddly degree. He wears smart, cream, chino style slacks, white shoes, and a dark, nightclub style silk shirt. His hair, which is grey, suffers from having had a far too trendy, spiky cut. MORRIE deposits the camera boxes on the stage right*

17

side of the bed and immediately inspects the sandwiches. TED
paces about the room, looking critically, and with some
disenchantment, at the space from different angles.)

TED: Bloody typical isn't it. Eh? I wanted a bigger room
with two singles. Hard work moving a double. It's small.
Huh, and when you want a double, you know, to sleep in
– can you get one? No, you bloody can't!

MORRIE: (*Inspecting the sandwiches.*) Meat. Ted! Every single
last one of them's bleeding meat.

TED: I like a bit of meat.

MORRIE: (*Lighting a cigarette.*) Bad for you matey. Kill you
in the end.

(*MORRIE puts the platter aside, sits on the stage right side*
of the bed and looks at the room.)

Class hotel this, once.

(*MORRIE stands looking for an ashtray. He finds one, puts*
it in the palm of his hand and sits again.)

TED: Should've gone to that Trust House Forte place near
Shepshed. It's shit at Shepshed, but at least it's purpose
built. This is a conversion.

MORRIE: It would've been easier if you'd come and picked
me up instead of me having to get a taxi.

TED: I've had a long drive as it is.

MORRIE: Did you get stuck in traffic?

TED: Me?! Na! A50, M1, A1, A10. Three hours. Huh!
Nobody gets in my way when I'm driving matey.

MORRIE: Is that your car then?

TED: Company car. Couldn't exactly be the fleet manager
without having a nice car myself, eh? Three litre, sixteen
valve, air conditioning, walnut trim, ABS as standard,
driver's air bag – the bloody lot. It's not a Cavalier.

MORRIE: What's ABS?

TED: ABS. It's a braking system. They test the car in
Iceland. Drive it about on glaciers, and bloody hell mate,
that, that is *the* place to test a motor. You see, if an elk
jumps out on you when you're cornering on ice at fifty
you've got to have ABS brakes or you'd total the elk,
total the car, and kill yourself into the bargain.

MORRIE: Why do the elks jump out at the cars?

TED: Instinct matey. Fucking instinct.

MORRIE: Do they hide in the bushes, waiting?

TED: I'm not an expert.

MORRIE: Why do they do it?

TED: It'll be a territorial thing.

(*TED sits on the bed, picks up the instructions on how to dial out, and dials.*)

Service. It's a dirty word in this country. You go to America, ha! – anything you want – and! – with a smile, and a 'have a nice day'. And you know what?

MORRIE: What's that china?

TED: They bloody well mean it!

(*On the phone.*) Denise, hello it's me, Ted, I thought you might be at lunch, well I'll just leave a message, I'm in Exeter. Er…that's about it, actually, nothing more to say. Exeter. Bye.

(*He puts the phone down.*)

MORRIE: You're in Finsbury Park Ted. London, N5.

TED: (*TED taps the side of his nose smugly.*) I know.

(*He manhandles MORRIE gently sideways, and walks to the window. He opens it and looks out as if checking his car. Satisfied, he closes the window and then runs his wet finger along the sill.*)

(*Showing his finger.*) Look at that. Filth. Switzerland, that's another one. Tut! You can eat your breakfast off the streets. You know what? You're not allowed to have a shit after twelve o'clock at night in Switzerland. Not if you live in a block of flats. You'd get arrested. Too much noise you see. Ha! They don't bloody mess about like we do. You don't see anyone begging, nobody starving. There was a beggar outside here, sitting there with his mutt, he said, 'Have you got any spare change?' – I said 'Of course I bloody have,' and walked on. Huh, you'd have given him money I suppose?

MORRIE: If I'd have had any I would. There but for the grace of God go I.

TED: Still a bloody commie eh? Ha!

MORRIE: International socialist. Though it's a private thing nowadays. Family tradition.

TED: (*Laughing.*) Family?!

MORRIE: My old dad was an anti-fascist.

TED: Yeah, yeah. Look at the state of this place!

MORRIE: My friend Andreas, his brother's got a hotel in Cyprus, Larnaca, very reasonable prices. I stayed there three weeks. I was a virtual prisoner I was. Took all my money off me, three hundred quid, missed my flight three times. Mind you, I could have a woman any time I wanted.

TED: Vagrants? They're laughing at us matey.

(*MORRIE follows TED about the room all the time smoking and holding his ashtray in his hand.*)

MORRIE: My old dad designed the perfect murder, which involved the use of a wino.

TED: You told me Morrie, you told me a thousand times.

MORRIE: It's only any good if you want to kill those you live with.

(*TED turns and faces MORRIE.*)

TED: I know your dad's plan like the back of my hand, now can we stop pratting about and make this film.

(*MORRIE gets on with setting up the camera, TED with emptying his case of papers which he lays out in order on the bed. Pause.*)

MORRIE: You need a wino what no-one's gonna miss. 'Bout your own age, and much the same size.

TED: Morrie!

MORRIE: You bang 'em on the head and take 'em back to your place, dress 'em in your gear, 'ang him up like he's hung himself. Kill the wife and kids then torch the house, petrol – whatever, but do a good job, especially on the wino, and then fuck off. The Old Bill will think you've topped the family and then, full of whatsaname…

TED: Remorse.

MORRIE: – remorse, you've been and gone and topped yourself, so they stop looking for you. The perfect crime.

TED: (*Without interest.*) Did he ever do it?

MORRIE: We'll never know. (*Beat.*) You have to have false teeth or it's no good. You take your false teeth out and stuff them…

TED: Morrie will you shutup! I'm sick of hearing about it! (*Beat.*) It's a bloody pipe dream.

MORRIE: I never said it was easy.

(*TED sits on the bed deep in thought.*)

Can we sort the money out first china?

TED: Sure. I'm sorry. Long drive. It's good to see you again matey. Brings it all back, eh. Good times, bloody good times.

MORRIE: Ted?

TED: What do you think is fair compensation?

MORRIE: Fifty quid?

TED: Fifty. It's a deal.

(*TED walks past MORRIE to end up down stage right looking towards the door up stage left.*)

MORRIE: Any chance of…

TED: Set up here I think.

(*MORRIE has moved to down stage right.*)

MORRIE: Here?

TED: (*Indicating a chair near the door.*) Yeah, I'll sit over there.

MORRIE: You're going to sit over there are you?

TED: Yeah.

MORRIE: That means, you're going to see the door as background, cinematically.

(*TED moves to stand in front of the door.*)

TED: It's not a bad door.

MORRIE: It's alright.

TED: Couldn't be bloody wood though, could it. Tut! Do you know what that is Morrie?

MORRIE: 'Course it's wood.

TED: Veneer. Tut! What's happened here is – they've gone and got a photographer to take a picture of a nice looking bit of maple wood and then with some glue they've stuck the ensuing photograph on some piece of old shite chipboard, and they've got the nerve to call it a

hotel door. Whereas Morrie, the door I want, the door I deserve, is the door they subsequently make out of the nice looking bit of maple wood after they've got tired of taking photographs of it. That door! The maple wood door, that is MY fucking door!

MORRIE: You never change do you. Look at you. You've gone and got yourself emotionally involved with a bleeding door.

TED: I've accepted the door! It's shit, the room's shit, everything's shit, but I'm not gonna bring unnecessary tension to an already tense situation.

MORRIE: I'm not tense. Nothing wrong with the door...unless someone opens it.

TED: I told reception that we're not to be disturbed. The three Ps. Planning, Preparation, and...fuck.

MORRIE: Does she know what we're doing?

TED: She knows we're filming, yeah.

MORRIE: Does she know what?

TED: No. Nobody knows.

(*MORRIE goes into the en-suite bathroom. TED sits on the stage left side of the bed and takes his shorts and deck shoes off. He is now only wearing underpants.*)

MORRIE: (*Off.*) You couldn't pay me now could you china? I'm out of pocket.

TED: Look! I'll sort you out at the end of the day. You're not going anywhere are you. I've got sandwiches in.

MORRIE: (*Off.*) They're all meat.

(*We hear a tap turned on and then off. A second tap is then turned on and then off.*)

(*Off.*) Both taps work. I like this. An en-suite bathroom. (*He sticks his head out as if he has something important to say.*)

Tiles are good for bathrooms aren't they?

(*Off.*) I was going to have an en-suite put into my place, but the bedroom didn't have any plumbing.

(*MORRIE stands in the doorway of the en-suite and addresses TED.*)

Patrick said – do you know Patrick?

TED: Patrick? No.

MORRIE: Ex-copper. Very wiry hair.

(*TED manhandles MORRIE aside from the bathroom door.*)

TED: Come on matey I need a piss.

MORRIE: He said I could fit me one of those whoosh toilet whatsanames. You know, it chews it up like a food mixer and whooshes it down the pipe so you only need really thin pipes. But he said he'd have to mount the pipes on top of the architrave and I didn't like the idea of that. All that mashed up crap charging round the room. It'd be like living in the middle of Ben Hur. (*Beat.*) Am I putting you off? Put a tap on. I find that helps.

TED: What?

MORRIE: I don't have that problem much myself, but I could never piss next to my old dad.

TED: Ha! You're a card!

MORRIE: He took us all to Whipsnade Zoo once and I had to stand next to him and it was just a big trough, you know, no dividers, and he had a big one. Biggest one I've ever seen, like a baby's arm holding an apple, and I was only six, and I couldn't go.

TED: You and your bloody dad!

MORRIE: Later on I wet myself in the reptile house. Nobody noticed. It's usually alright, isn't it, you know if you're dying to go, but it's when you just want to do a clever one, and someone's there watching, though they're never really watching, it's just that they can tell. That's the sort of vision what made Bobby Charlton so exceptional. Whatsaname vision they call it.

TED: Peripheral vision.

MORRIE: That's it.

TED: What a player eh! These kids today they couldn't hold a candle!

MORRIE: Jackie Charlton was handy in a different sort of way, but he never had the same p'ripheral vision.

(*Pissing is heard.*)

That's it. Go on my son. Yes, if you were standing next to Bobby Charlton trying to have a piss you'd have a bit of a problem. But next to Jackie, it'd be alright, although

he's a big chap Jackie so there's always the chance you might feel er…whatsaname –

(*Pause.*)

TED: (*From the bathroom.*) Intimidated.

MORRIE: (*Standing, excited by the revelation.*) Hey, Ted! If Jackie had had Bobby's pripheral vision, you wouldn't have stood a chance, not in a urinal without dividers. (*Beat.*) Me? I always go before I leave home.

(*The toilet flushes. TED re-appears and heads straight for the bed, sitting with his back to MORRIE on the stage left side. He now begins to dress, putting on a clean white, business style shirt and tie.*)

TED: No socks! Bloody hell! Brain dead!

MORRIE: You can borrow mine. They're not mine as a matter of fact. They belong to Andreas. Did I tell you about Andreas? He killed six Turks one night. What he does is, he talks to them, plays cards, then when they're not looking he slits their throats.

(*TED checks himself out in the mirror. Then, happy with the look of the shirt and tie, goes back to sitting on the stage left side of the bed. MORRIE follows him continuing his story. TED puts his suit jacket on.*)

TED: How are you getting on with that camera?

MORRIE: He was the first minder you know. People used to say to him, 'What do you do Andreas?' and he used to say, 'I'm a minder,' and of course no-one knew what the fuck he was talking about. Not until *Minder* came out on the telly that is, and then, of course everyone knew what he did, though it's not at all like it is on the telly. He minds for this crippled bloke in a wheel chair. Gets money from the government for it…can you believe it?

TED: I have no bloody difficulty believing that. We give it away mate.

MORRIE: I didn't believe it either, but he doesn't like being questioned. He nearly went into one, he did, and then the next day, what does he do? Wheels the bloody cripple into the shop, and says, 'There you are Morrie, now do you believe me?' He wheels the cripple round all

of his Cypriot coffee houses, and the cripple's not even a member, he's not even bleeding Cypriot. He's got it all wrong, that Andreas. He thinks he's walking a bleeding dog. Andreas has got a Cavalier.

(*TED goes over to the mirror to put his tie on. MORRIE breaks off from setting up the camera and stands behind TED talking to his reflection in the mirror.*)

I don't have a car. What do I need a car for? My daughter lives in Australia.

TED: (*Becoming impatient.*) Look…!

MORRIE: – if I'd known that that woman I married, was the sort of woman who'd secretly do the lottery, win the jackpot, and then fuck off to Australia with my only daughter I would never have walked down that aisle.

TED: Morrie!

MORRIE: If I had a son, I'd teach him to be selfish. Look at me. Give, give, give fucking give. Father Christmas I am. Yeah, and nobody gives a fuck about him. Not until December. You can wear my socks.

TED: My feet will be out of shot, won't they?

MORRIE: Depends on what you're planning to do with them.

TED: What?

MORRIE: If they're going to feature, then you'll need socks.

TED: Why would I want my feet to feature?

MORRIE: I don't know. I don't know what you want me to do.

TED: (*Assertively.*) Look, I don't want you to do anything clever, nothing bloody artistic alright? Just set the thing going and leave it, yeah?

MORRIE: Alright, alright.

(*Pause.*)

I could pan in and out every now and then to make it a bit more interesting.

TED: Just get the sound right and leave it matey. OK!

MORRIE: (*Petulant.*) I don't know why you need me here.

TED: Oh I'm sorry. Good of you to help out. I knew you would. You're reliable. A real pal. It's good to see you.
(*There is a polite knock at the door. TED freezes. MORRIE starts heading towards the door but TED grabs him by the shoulder.*)

MORRIE: What's up?

TED: Don't fucking move!

MORRIE: Why not? It might be some different sandwiches.

TED: (*Whispered.*) Be quiet!

MORRIE: Have you invited anyone to watch?

TED: Watch what?

MORRIE: I don't know. I don't know what you're gonna do. It might be worth watching.
(*There is a second knock. They don't move.*)
Why don't you let them in?

TED: (*A fierce whisper.*) Shutup!
(*TED covers MORRIE's mouth with his hand. A note is pushed under the door. TED stops and stares and then picks up the note. Inside the note is a credit card. He then opens the door, steps into the corridor and steps back into the room.*)
No-one there.
(*TED reads the note, throws the credit card onto the bed.*)

MORRIE: Not good eh?

TED: Bloody card's bounced.
(*TED goes into his wallet and finds another credit card. He picks up the phone, and dials reception.*)

MORRIE: What was all that about? You'll have cash for me? Today?

TED: Shhhhh! (*On the phone.*) Hello, Edward Oswald room 314... Yeah...well I'm totally amazed. I bought petrol with it this morning... Yeah...have you godda pen?... 5434 267 zero zero zero zero zero 3483 expiry date, four, two thousand and one... What do you need that for?... This is incredible, I mean it's a forty quid room, I'm not buying a bloody yacht... Edward Oswald...Oswald, like Oswald Mosley... It's a company credit card. Sumners Industrial, Loughborough.

MORRIE: Easy!

(*He puts the phone down.*)

TED: Never heard of Oswald Mosley. Kaw! What do they teach them in school eh? How to inject heroin, that's what.

MORRIE: I don't want a cheque. I'm in the middle of a correspondence with the bank.

TED: Cash. At the end of the day. Trust me.

(*MORRIE goes back to setting the video up. TED takes his shoes off, troubled by the sock problem. Then he puts his trousers on, and after that, the shoes, again with no socks. He then goes to the chair and sits on it with his briefcase on his lap. He takes papers from the briefcase and puts them on the edge of the bed. Amongst these papers is an old, tatty, hardback novel.*)

MORRIE: Do you know what you're going to say?

TED: I've got it written down.

MORRIE: You're not going to read it though are you?

TED: No, I don't think so.

MORRIE: Good. Nothing worse, and you're not a natural communicator. My old dad was a good speaker. Used to have 'em there, in the palm of his hand. Jokes – he was a professional comedian at one time, but he didn't like smoking. He could sing too. He played professional cricket as well. He hit six sixes in one over, that was before that Gary Sobers did it. But no-one took any notice. Oh yes he could sing. That's how he met my mother.

TED: (*Without interest.*) How is she?

(*MORRIE stops working and comes to the middle of the room.*)

MORRIE: She's dead.

TED: Is she? Bloody hell. Did I know that?

MORRIE: Yes, you did.

TED: Did you kill her? (*Beat.*) You always said you'd kill her – if you had to.

MORRIE: She was my own mother.

TED: Yes, I know, but you told me that if it had to be done…

MORRIE: She died in a car crash. She died a natural death.

TED: I'm sorry
 (*Silence.*)
 Were you driving?

MORRIE: I don't have a bleeding car! Haven't you been listening?

TED: Who was driving then?

MORRIE: Bloke from the council. He was bringing her to see me. Hit by a sodding fire engine they were.

TED: Did you get to meet her then?

MORRIE: Na. They wanted me to go and identify the body being the next of kin, but I said I'd never met her – which of course is true, sort of.

TED: Bloody hell, you didn't tell me – I'd have remembered that.

MORRIE: I told you. You forgot 'cos you don't give a fuck and you eat too much meat.

TED: I liked the old gal.

MORRIE: You never met her.

TED: What I mean is – I liked the sound of her, what you'd told me about her.

MORRIE: I made that up, didn't I.
 (*MORRIE goes back to setting the camera. He puts a tape in it. TED starts writing notes.*)

TED: (*Head down.*) Your dad's dead isn't he? I'm clear on that. Kaw! Only he could go out like that. Mind you, a fire engine comes close.

MORRIE: I think he planned it like that. He was a hard man.

TED: Ugh! I don't like to think about it Morrie. It gives me the willies. Ugh!

MORRIE: Like a god he was. He had a chest like a spare bed.

TED: You were a bit of a disappointment for him weren't you matey.
 (*MORRIE leaves the camera and approaches TED.*)

MORRIE: He told me straight. He said to me when I left school he said, 'Morrie, hairdressing's a puff's game.'

TED: You told me.

MORRIE: Even when I was in the world championships in Soho that time, he could've come and watched but he went and played snooker instead.

TED: Let it go matey! It'll eat away at you. Have you got that thing tested yet?

MORRIE: Getting there.

(*MORRIE moves back to the camera.*)

I've made a lot of the films with this one. Not bad quality is it?

TED: Did you do the balloon one with that camera?

MORRIE: What was her name? There's balloons in a few of them.

TED: I can't remember her name.

MORRIE: They always say their names at the beginning. Though it's never their real names of course. Got to protect their whatsaname.

TED: Anonymity. I never have the sound on.

MORRIE: You what?

TED: I never have the bloody sound on!

(*TED puts his case on the bed and stands, yawns with nerves, and rubs his face.*)

MORRIE: Well if you knew how much work I put into getting the sound right you'd listen out of respect for me – if nothing else.

TED: I'm not sure about this no socks business.

MORRIE: Do the shoes pinch?

TED: They do a bit.

MORRIE: Don't wear them then.

(*TED sits and takes his shoes off.*)

TED: It's what it's gonna look like, though. Some top people are gonna be ringing up for this one. I'm not trying to attract your usual half educated orang-utan.

(*TED stands and goes over to the camera, and moves MORRIE to one side so that he could look through the lens.*)

Ha! You've come a long way with your photography haven't you Morrie. Do you remember that first picture you sent into that porni mag? Ha! I still laugh at that. A bloody milk bottle!

(*MORRIE goes to sit on the chair.*)

MORRIE: Ten quid I got for that wasn't it?

TED: Sit over there will you Morrie. I couldn't believe they printed it. Only Maurice Calvert would think of sticking his knob in a milk bottle.

MORRIE: I get a lot of good ideas.

(*MORRIE goes to sit on the chair.*)

TED: Looks OK. this. To me.

MORRIE: (*Indicating the pine door behind him.*) That wood looks alright doesn't it? I like pine.

TED: Bloody hell! How many times do I have to tell you? It's veneer.

MORRIE: Mahogany's too dark. If you get a young girl, and take her back, it puts them off if you've got a dirty great mahogany wardrobe looming over the business. Depresses them. Reminds them of their parents' bedrooms. Yeah, I like a light pine. I bet you've got pine haven't you? You and Kathy up there in Ashby de la Zouche. I don't honestly think I could get it up in a room where there was a lot of mahogany.

TED: Is the sound alright on that thing?

(*MORRIE goes back to the camera. TED sits in the chair.*)

MORRIE: I usually put the sound on later. But this is different. Say something.

TED: (*After coughing.*) Good afternoon.

(*Pause.*)

MORRIE: Keep going.

TED: What do you want me to talk about?

MORRIE: What did you have for breakfast?

TED: I didn't have any breakfast.

MORRIE: Well count then.

TED: Right! (*Beat.*) One, two, three, four, five, six, seven...

MORRIE: Bit louder.

TED: (*Louder.*) One, two, three, four, five, six, seven...

MORRIE: That's too loud.

TED: (*Somewhere in between.*) One, two, three, four, five, six...

(*MORRIE presses record on the camera.*)

MORRIE: I've started it.

TED: It's recording?

MORRIE: Yeah.

TED: Can you see my feet?

MORRIE: No. It goes down to half way up your shin.

TED: Right.

> (*TED leans over to the bed and picks up a sheaf of papers from which he starts to read.*)

> (*Reading.*) War, pollution, bigotry, over-population, interpersonal violence…

MORRIE: – You're reading!

TED: Yes, yes. Right, OK. You're right. It won't work like that will it, no.

MORRIE: It looks terrible.

TED: Right! OK. Do you want to wind the tape back and I'll try again?

MORRIE: That's not a problem.

TED: Sorry, matey, I'm just a bit nervous. It's just that this is going out to ten thousand people. Will you have enough tapes?

MORRIE: Tapes are not a problem. I know this bloke in Notting Hill, he used to be a wrestler…

TED: Great! Good, I knew I could rely on you. Some people you can rely on, and some fuck you about, but you, you…

MORRIE: Rolling!

TED: Pollution, starvation, poverty, personal crime, bad language in public places, war. These are a few of the things which have made me personally, in my own life…

> (*The phone rings.*)

> Oh fuck!!

> (*TED picks up the phone and answers it.*)

> What?… It's a company credit card…have Sumners gone bust while I've been sitting here?

> (*TED gets up and searches for his wallet.*)

MORRIE: That's two now.

TED: Tell me about it.

(*TED finds his wallet and takes from it a smaller credit card concertina wallet which he flicks out to unfold it revealing about 25 other cards. He says nothing but raises his eyebrows mischievously at MORRIE as the cards unfold.*)

What do you want? A blue one, a red one, a bloody goldfish?... Alright 491 zero zero zero 45 2346 6543 expiry seven, two thousand and two... Ring straight back alright!

(*He puts the phone down.*)

MORRIE: That's a good one is it?

TED: They're all bloody good ones. Let's get something to eat.

(*TED picks up the platter of sandwiches from the side and puts it on the coffee table. They both sit on the end of the bed. TED tucks into the food furiously. MORRIE doesn't eat and looks straight ahead.*)

Not eating?

MORRIE: I'm sick of food. (*Beat.*) Will this one go through?

TED: (*With a full mouth.*) Course it bloody will! Trust me. Tut!

MORRIE: No breakfast eh?

TED: No time mate.

MORRIE: What – Kath let you out the house without a breakfast? That's not like the Kath I know.

TED: She's in Bridlington. At her sister's.

MORRIE: What's the matter Ted, nervous?

TED: Public speaking. I'd rather jump out of a fucking aeroplane.

(*MORRIE stands and opens the mini-bar.*)

MORRIE: Beer?

TED: Champion.

(*MORRIE pours a beer and prepares himself a bacardi and coke.*)

I didn't know what to talk about a minute ago, you know – testing the sound. Ha, I could never have been a barber, eh matey?

MORRIE: Very true. What people don't understand, is that your barber is your friend and your confidant. Talking, always having something to say, is as much a skill as your styling. Talking...styling. Two skills, one job. Shoulda charged twice as much. Which is why I kept my customers even after my hands went. They came to listen.

(*He holds up a shaking right hand.*)

TED: Who cut the hair then?

MORRIE: Cetin. Have you met Cetin?

TED: I don't know which is he?

MORRIE: Young lad. They like me, young people. I keep myself young, you see, mentally.

TED: Yeah, you like people, don't you. Me, I'm not so keen. I wish she'd bloody ring. How long's it take to do a card?

MORRIE: Every person is like a new book. A book you haven't read. Funny innit how me, who don't like reading, likes people, and you who does like reading, don't like anyone. I liked having a shop. New people every day. Maybe a fuck.

TED: Maurice Calvert! You don't change, do you?

MORRIE: The last girl I had, Katrina, she'd set herself up in the shop doing these oil paintings of people she saw in magazines. Painted me a few times. Nude, of course. You see, I don't have a problem with that.

TED: Ha! I know that much!

MORRIE: I've got quite a good body for my age. And she liked that. I helped that girl in many ways you know. Her father had played with her you see...

TED: You're kidding!

MORRIE: She'd not been able to do it for years, but I helped her back into it. I'm gentle you see. Some blokes with a young girl are like a bull at a gate, but me I take my time, talk, massage the scalp. Do you want a scalp massage now Ted? Calm your nerves.

(*TED looks at his watch.*)

TED: Not right now. Katrina eh?

MORRIE: Yeah, she did two films for me. A natural actress, and very comfortable with the camera. Not at first, obviously, after what her dad had done, but after she knew she could trust me, bleeding hell, you couldn't stop her. In a previous life she'd been an aviator – female aviator. She's whatsanamed the globe.

TED: Circumnavigated?

MORRIE: No. The Globe Cinema, down Lea Bridge Road. She's done it up.

TED: Renovated?

MORRIE: Yeah. She sells carpets in it now.

TED: Are you still seeing her?

MORRIE: Her husband's got a court order out on me.

TED: Bloody hell!

MORRIE: He came in the shop and went into one. He'd set her up in a flat off Stamford Hill you see, on the game, you know, and had started smacking her about a bit, so when he came into the shop I let him have it.
(*MORRIE stands and demonstrates his attack.*)
I feinted with the left and followed up with an uppercut right, came in with the left knee, and then chopped down on his head with the left. He was on the floor begging for mercy in five seconds. I had a new customer in at the time. It must have looked terrible. Ha! That lad thought he'd sort out an old man, but he didn't know about my dad, and what he'd passed on.
(*TED stands and picks up the phone but doesn't dial. He's restless, frustrated.*)

TED: Terrific boxer your dad.
(*MORRIE sits back down.*)

MORRIE: He was the only British boxer to have boxed at every weight. He could put it on, lose it, and then put it on again. Chips.

TED: They don't make them like that anymore. What is taking so long! Come on!

MORRIE: He invented the mini skirt my dad – did you know?

TED: Here we go.

MORRIE: He'd have been rich, he would, but he made the fatal mistake of inviting Mary Quant to one of his parties. Eileen was the first girl ever to wear a mini-skirt.

TED: Oh Eileen eh! Kaw! She was a bit special eh!

MORRIE: She was in love with me.

TED: I know.

MORRIE: She didn't like sex though. Not with me anyway. She's my only failure. Girls have always liked me. I must put them at their ease. Touching people. Running a car fleet it's probably not the same is it?

(*TED looks at his watch, stands and paces about.*)

TED: Different world. Physical contact like that would be frowned upon.

MORRIE: It's about trust. If you start with a warm wash of the hair and a gentle scalp massage – you're home. Obviously, if you then go and lop off a load of hair willy nilly you're not going to do yourself any favours but as long as what you do is not a million miles away from a recognisable style you can move it on a stage, because you've got their trust. But that trust can be abused. I should know I've done it a few times.

TED: With all that talent around, I don't know why you bothered getting married.

(*TED sits down again.*)

Oh come on!

MORRIE: I thought it was love.

TED: Fag.

(*MORRIE gives him a cigarette, takes one for himself and lights them both.*)

MORRIE: I've completely forgiven her. But she took my little princess. The bitch.

TED: Yeah.

MORRIE: I never loved her. She took the poor child away before she knew the difference between right and wrong. There's only one sort of love. Your love for your own blood, your offsprings. There is no love between a man and a woman. I don't miss her. Why do I want to see

her? I'm getting enough young ones, always did. Ah, fuck 'em.

(*TED bangs his fist against the wall.*)

TED: Why hasn't she bloody rung!

(*TED rings reception.*)

They're not answering.

(*Beat.*) They're not picking it up!

(*Beat.*) They want me to stew on it, don't they.

(*Beat.*) They're playing games with us.

MORRIE: Maybe it's gone through.

TED: Yeah! That's it. OK let's crack on.

(*Phone down.*)

MORRIE: You ready china?

TED: I look alright, yeah?

MORRIE: Yeah. Tip. This is what they do at the BBC. Imagine you're talking to someone, one single, individual person, sitting there, in their own living rooms, in their favourite chair. (*Beat.*) Rolling.

(*MORRIE sets the video rolling and leaves it and TED to their own devices. He goes over to the mirror and plucks out a nasal hair, checks himself over, then sits and lights a cigarette. He pays little attention to what TED is talking about, having heard it all before, and begins – towards the end of the speech to nod off. TED's speech is interrupted with nervous coughs at first and desperate pauses, but then he flows and is unstoppable.*)

TED: War, poverty, corruption, spiralling taxes, bad behaviour, inter personal violence, and over population. Do these things worry you? I think they do. They worry me too. Like you, I've probably tried meditation, alternative foods, even Buddhism for a couple of weeks. They didn't work did they? That's why you answered my ad in the national press, and that's why you're watching this video now, in your front room, in your favourite armchair. Hello. My name's Edward Oswald, Ted. I'm a fleet manager with Sumners Industrial Cleaning Products out of Loughborough, but that's not important right now, it's not the whole of me. I'm here to tell you

that there's no need to change human nature in order to end inhumanity and injustice. Being inhumane, injust, wasteful and destructive is not something people 'are' it's something people 'do'. That's right, it's behaviour. But let's start at the beginning, because I godda feeling that I'm asking you to run here before you can walk. The story for me begins at 23 Wharfedale Road, Chingford, London, England, the home of my mother-in-law number one, Elizabeth Rose Dexter. My son of that time, by my first marriage – obviously, Mathew Oswald, was knocking down her garden shed and in amongst the rubbish and ruin of that shed he found a book. Not just any ordinary book, but a book that has changed my life, and could change your lives.

(*TED reaches out to the bed and picks up a hard back novel.*)

Walden Two by Bhurrus Frederick Skinner. Now, the interesting thing about Fred Skinner is that he's not a writer, he's not even a novelist. He's a psychologist, was a psychologist – forgive me – he's dead now. And he's not just any tin-pot, sex mad pervert psychologist like most of the psychologists you've probably heard of, but is, was, being dead now, unfortunately, like I said. Huh, if he was still alive. Ah well, only the good die young, though in fact he was seventy, actually. Just an expression. Fred Skinner could have been, possibly the most influential psychologist on earth, ever. Skinner was pretty down on all the other psychologists. He called them the Mentalists, because of their totally misguided obsession with the mind, a line of scientific enquiry which has never produced anything of any use whatsoever, well nothing your average dinner lady couldn't work out for herself anyway. But the disgusting and unbelievable thing about the Mentalists, and I'm talking here about Sigmund Freud and all his junkie mates, cos he was a junkie, let's face it, cocaine, that's well known, and all the other Mentalists of the nineteenth century, er…sorry twennieth century, yeah, always get that wrong, ha! where was I? er…that whole

century was ruined because of Mentalist thinking, and Mentalist-influenced policies. Look, I'll try and make this clear. The Mentalists were only interested in the mind, they didn't give a monkey's about behaviour, and that's where the whole century went down the pan. Think about it, if you're sitting on a bus you don't give a damn what the bloke next to you is thinking about, do you? It's what he's doing with his hands that makes you nervous. Mind / behaviour. Two different kettles of fish. Freud's main contribution to the destruction of our society was that personality is fixed. Course, that's the perfect excuse for every criminally inclined retard. 'I steal cars, murder and rape old age pensioners because my cat died during the anal stage' – the kid's anal stage, that is – not the cat's, that would be silly. Do you see? Of course you do. But Skinner, thank God, ignored the mind and looked at behaviour, and dedicated his lifetime to working with rats and pigeons, and writing down the rules of behaviour modification. These rules, these jewels, are explained in *Walden Two*. He's given us a gift, you a gift, a way of living which is non-destructive, based on community, and fulfilling. How does that sound? Interested? Of course you are. Skinner discovered that behaviour could be controlled by the design of the environment, rewards and punishments. That lousy, anti-social behaviour could be gotten rid of, and good, useful behaviour could be encouraged, so that every member of that designed community could be happy. Ask yourself – are you happy? Are you truly happy? How happy has that new car made you? Mmm? So, you went to B&Q and spent thousands on thousands on a new kitchen. And did that make you happy? Did it change your life? No, it changed your kitchen, and there's a difference. I recently visited a radical community in Peru, on the North West side of that wonderful country and stayed at a *Walden Two* community. I found people there successfully applying the principles of radical behavioural psychology to

create an environment where good behaviour was
rewarded and lousy, selfish, anti-social behaviour was
punished. And, believe you me, it was working. I had the
best two months of my life before I had to leave because
of a minor misunderstanding, mainly the result of a
language problem. What I say is, 'If a bunch of
foreigners can do it, why can't we?' Let me make this
crystal clear. In *Walden Two*...
(*MORRIE finally drops off to sleep. TED leaps to his feet
and jumps onto the bed.*)
Bloody hell!

MORRIE: (*Leaping up in fear.*) What's happened?

TED: I said...bloody hell!

MORRIE: What's happening?

TED: You're bloody happening that's what's bloody
happening?

MORRIE: Eh?

(*TED backs MORRIE up to the mirror stage right.*)

TED: You just sat there, in full view, and fell asleep on me.
I'm not very good at this. I mean, how's that supposed to
make me feel eh?

MORRIE: I have heard it all before china. There's nothing
new is there?

TED: Yes there is as a matter of fact. I was just getting to
that bit.

MORRIE: You could've woken me up for that. I wouldn't
have minded.

TED: That's not the point is it! Look this is difficult for me.
Some people...some of the people I've spoken to about
this treat me, well you know, you can feel them pushing
you away, keeping their distance, like they're dealing
with a bloody headcase or something. They're polite, oh
yes, most of them, but the way they talk to you is
different. I've put in a lot of time and bloody effort into
this...

MORRIE: I've cancelled an appointment.

TED: You've postponed an appointment. You'll be cutting
his hair tomorrow or some other day.

MORRIE: Her hair.

TED: Who's she then?

MORRIE: Consuella. She comes from Mexico. She lives in Stamford Hill. I was going to go round during her siesta.

TED: Have you met her?

(*MORRIE relaxes and sits on the end of the bed.*)

MORRIE: Oh yes. She's a beautiful girl, you know in that Mexican sort of way they have.

TED: Raven black hair?

MORRIE: She's blonde now after the last time I saw her but she does have dark skin.

TED: I'm sorry mate. I thought people would be interested, you know…and they're not. Real happiness. Ha! And no-one's bloody interested!

(*TED sits on the end of the bed next to MORRIE.*)

MORRIE: Well, you're asking people to give up their lives, everything they've got, and go and live with you. It's a bit of a wrench.

TED: I'm asking them, initially, to give up twenty-nine ninety-nine. Thirty quid for a ticket to paradise. That matey, in anyone's book, is cheap.

MORRIE: And you want a thousand people?

TED: I need a thousand to set up the community, but more than a thousand will ring up. I'm confident of that.

MORRIE: That's a lot of money, isn't it.

TED: Minimum twenty-nine thousand nine hundred and ninety pounds. Enough to get started.

MORRIE: They might have thirty quid, but I don't know about giving everything up.

TED: Most people don't have anything to give up. Things. That's all they've got. That's not living that's… storekeeping.

MORRIE: Most people are happy doing that.

TED: (*Leaping up. Uncontrollably.*) No they're not! That's the whole fucking point!

MORRIE: No need to go into one! This is so like you. Going into one for nothing.

TED: (*Going into one.*) I am not going into one!

MORRIE: What's that then if it's not going into one?

TED: I'm just sick and tired of people treating me like a bloody headbanger. I can't tell you how exciting this it.

MORRIE: People don't like cults.

TED: Ah! Now, you're bang bloody spot on there. All those lefty bollocks 'end of the world', woo woo, ra ra, sex twenty-four hours a fucking day societies. I come along wanting to set up a community based on cleanliness, good behaviour, and sleeping with your own wife, and it's too late. Someone's already had a shit on the patio. (*Beat.*) Morrie?

MORRIE: Yeah.

TED: Are you alright in the maisonette? On your own?

MORRIE: I don't miss her. This bloke Bob's started coming round. Stays in the spare room sometimes. Uninvited. He thinks I'm Ralph. You know Ralph, used to be a trackside marshall at the Speedway. Bob's making a terrible mistake, but he's good company. Saws a lot. Wood.

TED: I need a thousand people. You could be one of the first. A planner.

MORRIE: 'course. In there like a shot. You get it set up china. A thousand new people. Keep me amused that would.

TED: You're a pal. I'm sorry I lost it earlier.

MORRIE: You're a passionate man. Now, why don't we start again and maybe I'll do a bit of camera work, you know, zoom in and out a bit, break it up for the punters.

TED: Right. Good idea, matey.

MORRIE: Go and wash your face, you look like a kid.
(*TED goes to the bathroom, as MORRIE changes tapes, and lights a cigarette, he checks his watch.*)

TED: (*Off.*) This is the future you know. The next century is gonna be about personal action. Politics in the sense of voting for someone is dead and bloody buried mate. They're all the same. If you want to change the world you do your own thing.
(*TED appears rubbing his face with a towel.*)

I just want taking seriously, that's all. Sometimes I lie awake and I can see the community, a thousand people, happy, well behaved, you know, clean.

MORRIE: In the country?

TED: Ah! Doesn't have to be. That's a common mistake of the romantic elements of your lefty communities. They all wanted to get into farming 'cos of all the spirituality crap about getting close to the earth, but when push came to shove, none of them had the bollocks to kill the chicken for tea. Consequently they spent all their time sitting around eating omelettes, getting depressed. Bingo – community fails.

MORRIE: I don't eat meat.

(*Footsteps are heard outside in the corridor.*)

TED: Shhh!!!

(*TED listens to the footsteps. They stop outside the door. TED goes to listen at the door. He presses his ear against the door.*)

MORRIE: What –

TED: Shhhhh!!!!!!

(*TED listens for a few moments. The footsteps retreat down the corridor.*)

He's gone.

MORRIE: He?

TED: Yeah! That was a he.

(*MORRIE listens at the door.*)

(*Beat.*) The manager. That was a bloke.

(*Beat.*) Oh God, it's so exciting Morrie! The ad goes in this weekend. *Sunday Times*, News of the Screws, the *Mail.* I haven't put it in the *Guardian*. Don't want any bloody *Guardian* readers fucking things up. Yup! They won't be happy until we're all as miserable as they are. Yup! Saturday, Sunday! See the ad, ring up, watch the vid, sign up. A new beginning.

(*TED sits down again and stares at the camera.*)

MORRIE: Is Kath joining up? Kath and the kids?

TED: (*Smiling.*) I don't think so.

(*They exchange glances to say that the tape is rolling and TED starts more confidently.*)

Crime, pollution, noise, racial conflict, litter, war and
TV filth…

(*To black.*)

Scene 2

*The same room, but it is now getting dark outside. They have moved
the camera to serve as a VCR to the television. MORRIE is sitting on
the stage right side of the bed smoking. A tape is rewinding in the
camera. TED is sitting with his back to him on the stage left side of
the bed, wearing only his underpants, and reading the* Daily Mail.

TED: Ha! A Scotsman's won the Scottish Open. Good. That
 should keep the bastards quiet for a while.
 (*Beat.*) Tut. Tut! Tut!
 (*Pause.*) Huh! Tut, tut, tut.
MORRIE: What is it?
TED: You wouldn't believe it. (*Beat.*) Tut! Oh no! Tut. She's
 from Middlesborough.
MORRIE: What is it!?
TED: She fucked seven Greek waiters in ten days.
MORRIE: That's going some.
TED: Swordfish they're called.
 (*TED chucks the paper aside in disgust.*)
 Fag!
 (*MORRIE offers him a fag and lights it for him.*)
 The Greeks eh? They peaked early. Your ancient Greek –
 Mathematics, geometry, astronomy, philosophy. They
 came up with the lot. But your modern Greek. Ha! What
 can he do, eh? Drive a taxi at ninety miles an hour in
 fucking flip flops.
MORRIE: I don't like the Greeks, but they're not as bad as
 the Romans. We were teamed up with the Romans once
 of course, for ages, until we found out they was all
 homosexuals. I might have been Roman. There's a bit of
 Turkey what's named after me.
TED: What? Calvert?

MORRIE: Myopola. Which is Turkish for Calvert. A lot of English blood in that soil. We had thousands of men but the Turks had machine guns. Kill a hundred men in a minute. Two men – that's all you need. One to fire and one to make the tea.

TED: War eh! We was lucky matey.

MORRIE: I would have liked to have been an anti-fascist like my old dad.

TED: Nothing left worth fighting for matey. Take Europe. We're fucked by being in Europe, but we're fucked if we get out. That's the only choice we've got left – how you wanna be fucked. (*Beat.*) What we doing now?

MORRIE: Rewinding. Lot of stuff there.

TED: Right, yeah. Too much?

MORRIE: Six hours. Can't get it all on one tape.

TED: Godda edit then?

MORRIE: You know all that scientific stuff about whatsaname.

TED: Classical conditioning and operant conditioning. That, that is the bloody key, Morrie!

MORRIE: Yeah? Well, it's clogged it up summat terrible.

TED: (*Realising he hasn't understood.*) A conditioned response is the Pavlov's dog thing. Look, let's do it. Look at me.

MORRIE: You what?

TED: Stand there and look at me.

(*TED winks at MORRIE. A big symbolic wink. MORRIE frowns. Pause.*)

MORRIE: Why are you winking at me?

(*TED says nothing, but winks again. MORRIE says nothing. TED winks again. After a brief pause he winks again. This time, after a two second pause, he follows the wink with a slap.*)

Ow! What d'yer do that for?

(*TED winks at him again.*)

Why are you winking at me!?

(*TED slaps him across the face.*)

Ow!!

(*TED winks at him again. MORRIE backs off.*)

TED: Do you see?

MORRIE: See fucking what?!

TED: See what's happening, what's been established.

MORRIE: Everytime you wink you follow it up with a slap.

TED: No, well yes, but that's not the important bit. What's important is I've conditioned your behaviour. When I wink now, you flinch. I've changed your behaviour. That's what's possible. Bloody hell, it's exciting isn't it?!

MORRIE: (*Quietly.*) Only cos you keep fucking hitting me!

TED: And Skinner proved that positive reinforcement using operant conditioning is twice as powerful as punishment. That's why love's so powerful and fucks us all up Morrie. Love is…it's…look all it is is mutual positive reinforcement. Yeah, you didn't know that did you? Skinner trained a pigeon to guide a nuclear missile. Bloody brilliant. In the Peru community constructive behaviour is rewarded whereas posing about like a twat is punished. Unlike in this country where the government pays you to sit on your arse all day tied to a dog, looking like a fucking muppet. Just think what we could do in a properly designed society. (*Beat.*) D'you know who I blame for the lousy, indolent attitude of today's youth. Eh? Woodwork teachers. Woodwork teachers, day in and day fucking out, teach our kids that it's perfectly acceptable to take three months to make one lousy cheeseboard. Three months! (*Beat.*) Japanese kids are turning out twenny cheeseboards every fucking hour! But you mention these ideas to your average *Guardian*-reading aromatherapist wet fart of a Teddy Bear and they look at you as if you was Adolf bloody Hitler!

(*A key turns in the door. TED flattens himself against the wall ready to challenge whoever comse in from behind. Nothing happens, except the catch on the lock is seen to turn. He listens at the door. The key turns again, and TED watches as the catch moves.*)

MORRIE: Good hair Hitler. Difficult obviously, but a very sensible compromise. A unique style. You'd think one of

those groups in the sixties would've picked up on it
wouldn't you.

(*TED turns the handle on the door, but it is locked.*)

TED: They've locked us in matey. Bloody hell.

(*TED tries the door again, and a third time. He inspects the lock.*)

MORRIE: Some barbers didn't like long hair, but I saw it as
an opportunity. I instigated, what you might wanna call,
a policy shift away from cutting towards the styling. I
was the first barber in Walthamstow to do the mop,
which of course, led on to the Unisex thing.

TED: Will you listen to what I'm saying!?

(*MORRIE approaches TED as he stands by the door.*)

MORRIE: If you said 'Unisex' to anyone, didn't matter
where, you could be down West in a swanky bistro, but if
you said the word 'Unisex hairdressing' whoever it was
you was talking to would say 'Maurice Calvert', and only
then could the conversation continue.

TED: They've locked the fucking door!

(*MORRIE tries the door. He then turns and looks at TED.*)

MORRIE: We've got a key. Unlock it.

(*TED picks up the key and goes to the door.*)

TED: No keyhole. There's no fucking hole! Stand back!

(*TED makes to kick the door down. He makes space for himself
but MORRIE stands in front of him.*)

MORRIE: What have you done?

(*TED manhandles MORRIE out of the way and then he
attacks the door and bashes it with his fists. During the next
TED tries several strategies of opening the door – feet, shoulder,
fists etc.*)

Hotel doors open inwards.

(*Beat.*) I miss the shop. Personal visits. It's not the same.
Cutting hair in a kitchen. With a shop you don't know
who's gonna walk in. Who will walk through that door
today?

TED: Shutup! For God's sake knock it on the head!

MORRIE: I had to listen to you.

(*TED picks up the trouser press, assesses it, and approaches the door intending to use it as a battering ram or axe.*)
Ted? Not a good idea.
(*TED puts the trouser press down, and sits on the bed, pulling his head down between his legs in frustration.*)

TED: (*Sighing.*) Sorry!

(*TED sits at the foot of the bed.*)

MORRIE: The Beatles' manager came in one day.

TED: Oh no! Not the fucking Beatles manager. You told me, you told me a thousand times!

MORRIE: They were nothing then, not at that time. Just another covers band. I'd seen them at the Palais, third on the bill, doing Elvis songs, but I spotted something in the big fellah...whatsis...

TED: (*Quickly.*) – Lennon, John Lennon.

MORRIE: – something not everyone could see, because, as you know I'm...

TED: (*Quickly.*) – psychic.

MORRIE: Psychic? Are you sure that's it.

TED: Yes! It means you get a feeling about things.

MORRIE: I do get a feeling about things.

TED: No Morrie, no!

MORRIE: I knew that night that the Beatles were going to be enormous, but only if they did one thing. Next day the Beatles manager walked into my shop out of the blue and I just said it, I gave it away, I said to him, 'You wanna let those boys sing their own songs.' Next minute – whaddyaknow – Beatlemania. (*Beat.*) I'll keep my ideas to myself in future.

TED: Look mate, we're in a bit of a fix here...

MORRIE: You know those ocean going tankers – the ones what take five miles to stop? Well, I've invented a system what lets 'em stop in five hundred yards. I'm not gonna tell nobody! Not after that Beatles business, oh no.

TED: You told me already!

MORRIE: Told you what?

TED: About the fucking tankers!

MORRIE: Well, keep it to yourself then.

TED: I've been trying to tell you, they've locked us in.

MORRIE: What the bleeding hell do you expect? You haven't paid the bill have you. You ain't got the money to pay me later on either have you? Eh?

TED: Course I have. When have I ever let you down?

MORRIE: Well, for a start…

TED: Alright!

(*Silence.*)

MORRIE: Someone's asked me to find them a shed. Did Mathew, you know knock it down, or did he like, take it to bits.

TED: What?!

MORRIE: The shed. What happened to the shed?

TED: Oh bloody hell!!

MORRIE: There you go. See. You're getting excited over nothing. Two people having a conversation about a shed and one of them starts steaming up.

TED: I am not steaming up! It's just…what are you talking about the shed for?

MORRIE: Someone's asked me to get them a shed – that's why!

TED: What about me? Eh? They've gone and bloody locked us in!

MORRIE: I'm here aint I?

(*TED grabs his own head and pulls it down into a severe head lock. MORRIE shuffles round and sits on the foot of the bed to be next to him.*)

Oh bloody hell, china! You're not going to do that one on me are you. You're like a bloody woman. Look I'm all yours. I brought me camera, me tapes, me acquired knowledge of cinematography. I could be shagging a Mexican now. But no, I'm here cos my mate, my old china, rang up and asked me to be here. Remember when them lads from Shoreditch knifed you down the Regents Canal, eh? I was there then. Did I run away? And Sandy, eh? I sorted you out with her didn't I. Put my head on the block there dint I? Specially since her dad was my 'eadmaster. Did my fucking life in, that did! My whole bloody life – education-wise. Ted!

TED: (*Through snuffles from below.*) I know.

MORRIE: And the book, eh? Whose money was that?

TED: (*Coming up for air.*) I haven't forgotten.

MORRIE: I wouldn't have given you the money if I hadn't have thought it was a good book. I never met anyone who's written a book, apart from my old dad of course, but you'd expect that of him, wouldn't you? Only you could pick a bleeding astronaut as a hero. Ha, ha! What was it called again?

TED: *Black Hole – the Return Journey of Starship VII.* With the seven in Roman numerals.

MORRIE: Mmm. Why did they wanna go there in the first place? That's what I wanted to know. I think you should have dealt with that.

TED: (*Angry.*) You've said that before!

MORRIE: Good descriptions in it. Anyone would think you'd actually lived in a black hole. Could you do me a favour and take a thousand copies back up with you? I haven't been able to get in the lock up for nearly ten years now.

TED: OK. Sorry, I had a go.

MORRIE: Everybody's got something wrong with 'em, Ted.

TED: Yeah?

MORRIE: 'Course.

(*There is a firm knock on the door. They stand and stare. A slip of paper is pushed under the door. TED stands and goes over, picks it up and reads it. Having read it he screws it up into a ball and throws it at the door, before sitting back down on the bed. MORRIE stands and goes over to the ball, picks it up, unscrews it and reads it, screws it up and throws it at the door.*)

That calls for a fag.

(*MORRIE offers a cigarette to TED and lights it for him.*)

MORRIE: Are you gonna tell me? I can wait you know.

(*Pause.*)

TED: Two tapes eh?

MORRIE: You were very good china, for someone who's not a natural.

TED: I miss you Morrie. We've always had a laugh haven't we? And I don't make friends easily, I compare everybody to you and they always fall short. We're like brothers aren't we. Two cots side by side. Twins even.

MORRIE: Here we go.

(*TED sits on the stage right side of the bed. MORRIE presses play and goes to the mini-bar and gets a can of beer for TED and mixes himself another Bacardi and Coke. The screen shows first a snow storm and then a girl is shown in lingerie on a bed, the camera wobbles and refocusses. The girl rolls over and begins to undo her bra strap. At this moment TED cuts in and is talking to camera: 'Crime, pollution, noise, racial conflict, war and TV filth.'*
TED stands and turns the video off.)

TED: Who the fuck was that?

MORRIE: Katrina. That's the second one I did with her. People said it was too much like the first which, to be truthful, it was. There's only so much you can do you know, and once you've done it, you either do it again or stop.

TED: Yeah, yeah, yeah, but what I'm saying matey is we can't have that bit at the beginning of the tape. I'll end up looking like a bloody pervert!

MORRIE: This is the master. I'm gonna tape from this ain't I. Don't get so bleeding excited!

(*TED paces the room.*)

TED: I'm not getting excited!

MORRIE: (*Standing.*) You're going into one.

TED: (*Going into one.*) I am not going into one!

MORRIE: You're at top pitch!

TED: I am not at top pitch!! I need to look respectable. People won't sell up and join a radical socially engineered community if they think the leader is a fucking pervert. I've got to look clean, responsible, you know, nice.

MORRIE: No-one will see Katrina. So stop going into one.

TED: (*Calmly.*) I was not going into one.

(*TED sits on the end of the bed.*)

Sorry.

MORRIE: You don't change do you?

TED: I've put everything into this. Money, time, energy, other people's money.

(*MORRIE starts the tape again and sits next to TED.*)

TED: (*On tape.*) May, nineteen-ninety-six. My son, by my first marriage, Mathew was halfway through knocking down a shed when he found this hardbacked novel.

(*At this point on the video TED leans over and picks up the copy of 'Walden Two' from the bed and in moving back into camera involuntarily crosses his legs revealing to the camera his bare feet. On seeing this TED stands, snatches the remote from MORRIE and approaches the video and stops it.*)

TED: What in God's name, was that?

MORRIE: What?

(*TED rewinds the video and plays it again, frame by frame, freeze framing on his naked foot.*)

TED: (*Pointing at the screen.*) That!

MORRIE: Your foot.

TED: My bare, fucking, nude foot! What are you?

MORRIE: You lifted your feet into shot. If you'd kept your feet –

TED: A stupid fucking cunt!

(*TED rewinds and has another look in real time.*)

MORRIE: If you play it at normal speed people will just think you're wearing sandals.

(*TED exits to the bathroom. We hear the taps running as TED washes his face.*)

TED: (*Off.*) A business suit, a good, expensive, business suit, dry-cleaned yesterday, and bloody sandals. That is so Maurice Calvert!

MORRIE: (*Standing.*) Me?

TED: (*Off.*) You were doing some fancy camera work weren't you?

MORRIE: (*Advancing towards the bathroom.*) I wanted to sit down and have five minutes, but you wanted me to listen – even though I've heard this crap before.

(*TED slowly appears from the bathroom. MORRIE backs off slowly.*)

TED: Crap? Crap? It's all coming out now isn't it Morrie.

MORRIE: I don't mean crap crap. It's just a figure of speech.

TED: What are you doing here?

MORRIE: You asked me. I'm your china.

(*TED paces the room. MORRIE sits on the end of the bed.*)

TED: Do you think I'd make all the sacrifices I've had to make if I didn't think I hadn't not discovered possibly the holy grail of how to live. How we could all be?

MORRIE: People won't like all that control stuff.

TED: (*Intense.*) It's benevolent control! Morrie, do you think you're free now? You bought a lottery ticket today. Do you know why?

MORRIE: I could do with a small injection of cash. Small, or large.

TED: No. You bought a lottery ticket because you are permanently locked into a scientifically designed schedule of variable reinforcement. You didn't know that did you?

MORRIE: Never heard of it.

TED: You don't win every time, but every thirty times or so you win a tenner. That's a variable schedule of reinforcement. And the power of a variable schedule is that you never stop. That's Skinner. Misused. The most influential psychologist of the twentieth century.

MORRIE: What nobody's heard of.

TED: You're just like the blokes at work.

MORRIE: They taking the piss?

TED: More than that. Yeah. I got one of those written warnings. Disciplinary procedure. They sent me to see the Personnel Manager. Bastard.

MORRIE: What did he say?

TED: Made me pay the phone bill.

MORRIE: Ringing Peru every day? (*Beat.*) Well you should've thought of that earlier, you stupid prat!

TED: I've had to take time off. Research. Travel.

MORRIE: Oh no, a good job like that and you go AWOL?

TED: I told them Kath's mom had died, and we had to go to the funeral in Cerro de Pasco, Peru.

MORRIE: But Kath's mom lives in Melton Mowbray.

TED: Alive and bloody well. Anyhow, the fucking Personnel Manager's fucking secretary saw Kath in the vets.

MORRIE: What was Kath doing at the vets?

TED: The rabbit. The secretary says to her – 'Sorry to hear about your mother getting swept away in a flash flood.'

MORRIE: Bleeding hell. Kath must've gone into one? Did she?

TED: Dunno. I was in Peru.

MORRIE: She wouldn't be lost for words when you got back though.

TED: Worst day of my bloody life. But it'd been too much for her before that. She couldn't get the hang of the fax. I'd be at work talking to Peru and I'd give out my fax number. They try and send a fax to me at home and Kath would pick the bloody phone up. 'Course she doesn't speak Peruvian. Fucking embarrassing. She made me look unprofessional.

MORRIE: How is Kath?

TED: It's all over.

MORRIE: She get sick of all this? Huh! You're prone to obsessions aren't you. Obsessions that go bleeding wrong. Remember them whatsaname eggs!

TED: Pathogen free eggs.

MORRIE: Bleeding hell, what a fuss that was. Pathogen free eggs!

TED: Pathogen free eggs from a pathogen free flock.

MORRIE: Worked out about five bleeding quid an egg. God knows how much for half a dozen!

TED: Twenty-nine pounds ninety-nine.

MORRIE: How much money did you piss down that one china?

TED: It's this bloody country! They don't like anything new. Leave it alone though Morrie, please!

(*MORRIE stands and starts pacing around, deep in thought. MORRIE pushes a chair up against the door and jams the handle securely. TED watches but doesn't move.*)

What are you doing?

MORRIE: Locking us in.

TED: We're already locked in!

(*MORRIE puts the kettle on.*)

MORRIE: Alright then I'm locking them out – until I've finished with you. Look the way I see it is – right, let's start at the beginning. There's three things what can be going on here. One – you've come across an old novel what has the holy grail of good living in it and you want me to help you make a video which shares this knowledge with the world and what helps you set up this whatsaname community.

TED: Utopian.

MORRIE: That's the one. (*MORRIE finds an empty coke bottle and puts it on the coffee table. Touching the coke bottle.*) Right, this is what we'll do. One. This is number one. The coke bottle means utopia, that's what all this is about. You, Ted Oswald, have got the answer what humanity has been scratching about for since Adam was just a twinkle in his dad's foliage. And I mean, truly, no messing you've got it. The answer. The coke bottle. Three.

TED: What about two?

MORRIE: I'm coming to two. Three. The pepper pot. (*MORRIE picks up the pepper pot and places it on the table.*) The pepper is, this is all a scam.

TED: No Morrie, no –

MORRIE: Give me a chance. A scam. Ad in the Sundays. A thousand people send in thirty quid. You're thirty grand ahead. That's the end of it.

TED: Please! You know me!

MORRIE: Yeah, I know. Which brings us to three.

TED: Two.

MORRIE: Thank you. Two. The fruit.

(*MORRIE places the fruit bowl between the coke bottle and the pepper.*)
Now two is the most difficult one from my point of view. In two, you've found an old novel in a shed in Chingford and you've gone off on one, like you do sometimes. You screw up in your job, nick a car and a load of company credit cards, fall out with a lovely girl, Kath, your wife, abandon your beautiful children, pull the plug on your marriage, and end up where the only people interested in you are the Old Bill. In two, basically you're off your trolley. You've got on the District Line, fallen asleep, and woken up at Barking.
(*Beat.*) Now the difference between one and three, and number two is that in one or three you can be a sane man, but in two – you've lost it.

TED: Which one do you think it is matey?

MORRIE: I know which one it is. That's not the point. You're the one who has to choose.

TED: I don't think I want to do this.

MORRIE: Well there's fuck all else to do before the Old Bill take you away.
(*MORRIE sits at the end of the bed. After a short while TED stands and starts circling the table. Having circled it once he sits back down.*)

TED: What's the pepper again?

MORRIE: Thirty grand scam.
(*Silence.*)
Look I'll just shift it down a bit so you can get a good look.
(*MORRIE stands and moves the coffee table down stage. He then sits down and they both continue to stare at the three objects in silence.*)
Cup of tea?

TED: Smashing. Have you got a ciggie?

MORRIE: Course.
(*MORRIE gives him a fag and lights it for him. He lights one for himself too.*)

TED: Nice lighter that. I noticed it before.

MORRIE: Lovely innit. Nigerian bloke with one leg gave it to me.

TED: They've got their own barbers haven't they?

MORRIE: I know. Every time he hopped into the shop I nearly shit myself. I mean what could I do for him. I could shave it all off or go and buy him a hat. Anything in-between I was scuppered. But he liked me. He got deported in the end. Turns out he was illegal. He was virtually running Hackney Council. Yeah. I liked him. It's made out of a man-eating tiger's tooth.

TED: Is that how he lost his leg?

MORRIE: Na! He was a good dancer. Yeah, watching him dance, you'd never know he only had one leg.

TED: Ha! You're a card Morrie.

(Pause. TED stands and goes over to the coffee table and stands before it thinking. He then sits down.)

MORRIE: Not easy is it?

TED: I thought you said you knew which one it was?

MORRIE: I do! I'm saying it can't be easy for you.

(TED sits.)

TED: I can't do it.

MORRIE: Alright, we'll make it easier. Process of whatsaname.

TED: Elimination?

(Pause.)

It's not the pepper.

(TED moves the pepper pot.)

MORRIE: Shame. I was hoping it was a scam. I might have come in on that.

(Pause.)

TED: *(Standing.)* Lose the fruit!

MORRIE: I'm not touching it.

(TED stands and approaches the coffee table.)

Here's your tea.

(MORRIE hands him his tea. TED is transfixed, staring at the fruit.)

I'll tell you what I'll do, I'll make it harder, but in a sense easier. Take your cup of tea.

TED: Eh?

(*MORRIE picks an apple out of the bowl.*)

MORRIE: I'm going to say something and if you think it's true, then you throw the tea in my face. Look, for example, if I say, 'This is an apple,' and you agree, you have to throw the tea in my face. Alright?

TED: (*Close to tears.*) I don't want to do this.

MORRIE: Here we go, pick up your tea. Come on!

(*TED, though looking down, picks up his tea. MORRIE puts the apple back in the bowl.*)

You ready? Right, here goes.

(*TED nods, reluctantly.*)

You, Edward Oswald of Ashby de la Zouche, are a sane man.

(*Pause.*)

If you think that's true, you have to throw your tea in my face.

(*They hold the position for a while. TED holding the cup of tea prone. He looks up and looks into MORRIE's eyes, looking for clues, direction, sympathy. Slowly he begins to cry, until there are big sobs, big gut-busting convulsions. MORRIE takes the coke bottle and puts it in the bin.*)

TED: (*Through sobs.*) I er...I don't know how it started Morrie.

MORRIE: Even I know that. It started with your Mathew knocking the shed down.

TED: Mathew knocks that shed down and finds that book. It's so bloody, incredibly exciting. To know that you have found treasure.

(*Suddenly hopeful.*) This technology can change the way we live.

MORRIE: You couldn't change a light bulb Ted. You'd find a message on the ceiling.

(*Beat.*) When did you fuck off with the car and the credit cards?

TED: Couple of weeks ago.

MORRIE: Did you get any cash?

TED: Bit.

MORRIE: And Kath's chucked you out?

(*TED looks out of the window and surveys the yard.*)

TED: Kath didn't want to take the kids out of school. Didn't want to give the kids the gift of a new life. That's when I got to thinking about what your old dad said.

MORRIE: I never had a dad! I made him up! You know I did!

TED: I know, I know! What you said then. The perfect murder. For years I've been thinking about it, and you know what? It's duck's arse tight matey. Bloody hell it's so exciting!

MORRIE: What are you talking about?

TED: The perfect murder plan.

MORRIE: What? The wino, the teeth, did he ever do it, we'll never know?

TED: Yeah! I just need a blank piece of paper Morrie. A new life. I'd be murdering me. I'd get a new life.

MORRIE: You gave your real name on the tape.

(*Pause.*)

TED: Fuck! You can edit that out, can't you?

MORRIE: Course.

TED: I've done it. The plan. Well, half of it. The easy bit. The wino.

MORRIE: (*MORRIE starts backing away from him.*) Oh no.

TED: He's in the boot. My size. Perfect. No teeth. Dead.

(*MORRIE has now backed almost into the bathroom where he stops.*)

You know me. I've started so I'll finish.

MORRIE: Who's the tramp Ted?

TED: I dunno. I found him under a tree. Near Quorn. The Vale of Belvoir. Fucking about with one of his mates.

MORRIE: Did his mate see you?

TED: No, I was behind a wall, watching.

MORRIE: And what…you killed him?

TED: Yeah. His mate fucked off, this one fell asleep, and I suffocated him with a pillow, like you said.

MORRIE: You had a pillow with you?

TED: Yeah.

MORRIE: And his mate didn't see you?

TED: What if he did? He's a fucking wino. He wouldn't remember.

MORRIE: He might remember a man in a business suit wandering about in a field in the Vale of Belvoir carrying a pillow.

TED: No, no. He didn't see me. No way.

(*TED opens the sash window. He looks at his car. He looks at the drop. He looks back into the room. Then he tears the sheets off the bed. Through the next he makes a blanket rope.*) We've got to act quick now.

MORRIE: We?

TED: OK. OK. It's my thing I realise that, but I need your help matey. The next bit. Well, I'm not sure I'm up to it.

MORRIE: Kath. Little Ben, and Leslie.

TED: Yeah. I mean I'll do it. I just need a bidda moral support. (*Beat.*) They get back from Bridlington on Saturday night. We can't hang around – the wino's going off. He keeps farting. How long do they fart for?

MORRIE: What am I? I'm a barber.

TED: That's the sort of thing you know. If we get back to Ashby for four tomorrow we can stick the wino in the deep freeze. Kath gets back about six; do the business; get the wino out the freezer; string him up, then, I thought best leave it till night-time before we start chucking petrol about. Whaddyer think? Only you can help me Morrie.

MORRIE: You don't know when you've been helped. You brainless wanker.

TED: You're the only person I trust Morrie.

MORRIE: I tell you what I'll do. I'll do the only thing I've got left. I'll give you a haircut.

(*MORRIE moves to the video player, extracts the cassette from the player and throws it out the window into the kitchen bins. He does the same with the copy of* Walden Two *and the papers. Looking out of the window he surveys the streets to assess the situation. At that moment the phone rings. TED*

*drops the blankets and makes to answer the phone but
MORRIE stops him.*)

I'll take that.

(*On the phone.*) Hello…no, no, I'm not Edward Oswald…
Yeah…yeah, he's here. We're locked in… Maurice
Calvert… Hostage?… I'll ask him. Ted, am I your
hostage?

TED: What?

MORRIE: No, I'm his friend… Don't do anything stupid?
What do you mean by that? …No?!… I don't believe
it… I told you, I'm his friend… I won't!… I don't know,
I'll ask him, hang on.

(*MORRIE puts his hand over the receiver and speaks to TED.*)

Have you got a gun Ted?

TED: You what?

MORRIE: (*On the phone.*) No he hasn't… Me? What do I
want a bleeding gun for? …I can assure you officer I
have no intention of doing anything stupid…

(*MORRIE slams the phone down on them.*)

TED: Police Morrie?

MORRIE: No, Interflora.

(*Phone rings again. They let it ring.*)

TED: Oh shit!

(*TED paces, he opens the window and looks out.*)

Fifth bloody floor. Bugger! You could break your neck.
Shit!

(*He tries the door again. But it is locked from the outside.
Phone rings under.*)

Bloody hell!

MORRIE: I spent the first fifteen years of my life wiping
your bum, and bleeding hell I'm still doing it.

(*MORRIE picks the phone up and slams it down.*)

TED: I just need a fresh start. A blank piece of paper.

MORRIE: Get your clothes off. When did you last have a
trim?

TED: Two months ago.

MORRIE: Nice hot wash, and a scalp massage. I'll trim it if
you like. Nothing else to do until the Old Bill make their
move.

TED: They're supposed to think I'm in Exeter.

MORRIE: The credit cards Ted. Technology innit.

TED: They're clever aren't they?

(*MORRIE produces his scissors from a pocket.*)

MORRIE: I've got my scissors. I'm mobile now, aint I. Take
'em everywhere.

(*TED gives up the idea of escape and takes his shirt off and
goes over to check out the shower unit. MORRIE follows.*)

I've seen it all before. Come on.

TED: You couldn't find brothers closer. Fifteen years
together in Barnardo's.

MORRIE: Best years of my life.

TED: No secrets.

(*MORRIE turns on the shower and adjusts the temperature
and tests it. TED strips completely and stands in the shower
tray.*)

MORRIE: That's lovely. This'll wash all that shit out of
your system china.

TED: Those bastards at Barnardo's did a good job at the end
of the day, you know when all's said and done. You a
finalist in the world championships that time in Soho,
and me, well you know, I've got six blokes under me at
Sumners and the lowest proportionate labour turnover
percentage in the whole division. You don't get that by
scratching your arse. Personality. Wife, and two kids.
Yeah.

(*MORRIE begins spraying water all over TED who shuts his
eyes and enjoys it.*)

MORRIE: Sit on the edge there china – I'll give you a
shampoo.

(*TED sits on the edge of the shower tray. During the next
MORRIE shampoos and rinses his hair.*)

I blame your old man. And I blame my dad too. Pair of
cunts. Bleeding irresponsible. Couldn't happen
nowadays. They'd have the government on their backs. If
I'd have had a dad. Kaw! I could have done anything,
diplomatic corps possibly. You too, in your own way.
You've got a talent for…stubborn, sort of bulldog, dog at

a bone persistency. 'Course you're unreliable, emotional, destructive, but that's cos you never had a dad neither. Why am I not like that then? Why am I not off me trolley like you?

TED: You made one up. Bloody superman dad you had. And Girls. You always had the girls.

MORRIE: Kaw! They loved me. All that time in Barnardo's, I never slept in my own bed.

TED: I used to like it in the morning when you came back to the dorm and told me about it matey.

MORRIE: Ha! I've never told you this, but I made a lot of those stories up.

TED: I guessed you had. Some of them.

MORRIE: Come and sit over here.

(*MORRIE dries his hair and guides him over to a chair. TED sits with the towel over his lap.*)

Now this is my scalp massage. Tell me if, at the end of it if you don't feel as randy as a teenager.

TED: Oh. Mmmmm.

MORRIE: That's it china. Let it go.

(*A police siren is heard approaching, a second one follows. They get louder and louder until they both pull up in the car park under the window.*)

I gave Andreas one of these one day. He's a bubb-Cypriot, though he hangs out with the Kurds. Do you know what the Turks call the Cypriots?

TED: No.

MORRIE: English bastards. We, Britain that is, used to have Turkey but we gave it to the Turks just to keep 'em quiet. The Turks don't like the Cypriots, nah! Mind you we don't like the Turks, and neither do the Cypriots. No-one likes the Turks much. The Greeks can't stand 'em, mind you they don't like the Greeks much either. I don't like the Greeks much, but they don't mind us. That's cos we gave them Cyprus. We could've given Cyprus to the Turks but we'd already given 'em Turkey earlier on, so we gave Cyprus to the Greeks just to wind 'em up – the Turks that is.

(*Telephone rings. MORRIE takes it.*)
(*On the phone.*) What now? …he's having a haircut…
me… I'm a barber…he'll come out in a minute…cos he
hasn't got any clothes on.
(*MORRIE puts the phone down.*)
(*To TED.*) He said he wants to have a little chat with you.
I mean, what do the police know about the art of
conversation?

Andreas, the contract killer, he come round one day,
been on manoeuvres with his guerrilla movement, the
Kurdish lot. I give him my special, this. Next day half
the Pesh Merga guerillas in Stoke Newington come
round wanting scalp massages. They're all international
socialists too, though to be honest their sphere of
influence don't go much beyond Manor House. There
you go.

(*MORRIE finishes the scalp massage.*)

TED: Kaw! That was smashing.

MORRIE: Now just a bit of a trim.

TED: What about your hands?

MORRIE: I'll stay clear of the ears. Stick to the wide open
spaces.

TED: I wish I could help you out Morrie, you know, if ever –

MORRIE: You stood in the witness box that time.

TED: All I said was – what did I say exactly? 'Your honour,
I cannot envisage a situation where Mr Calvert would do
such a disgusting thing.' It was nothing. Just a white lie.

MORRIE: I got my problems an' all you know. This Bob
who's moved into my maisonette. The one who saws. He
thinks I'm Ralph.

TED: You said. Yeah, tell me.

MORRIE: It all started when Ralph started looking like me.
Ralph's nose started to shrink and then his ears got
wider, and he even got a scar on his neck like mine from
when I was hanged in a previous existence. Then Bob
stops me in the garage, I was getting my electricity key
done, and he says, 'Ralph?' I said, 'I'm not Ralph, I'm
Morrie.' Now this Bob spends his afternoons in my

kitchen cos he thinks I'm Ralph. And he saws everything up. If it's made of wood he'll saw it in half.

(*Telephone rings.*)

(*On the phone.*) Yeah?... There's a chair against the door... yeah, we're coming out now... No, no, don't do that... he's coming out. Give us a minute.

(*Phone down.*)

They were gonna break your door down.

TED: Tut! We got a lot done today.

MORRIE: Yeah. It'll be prison.

TED: You know what they don't like? I've had a dream, that's what I've done, that's what they bloody well can't handle!

MORRIE: You killed a man.

TED: A wino Morrie. A stinking, filthy, pickled piece of useless scum. I mean, I know I shouldn't have done it, now, I've come round to that, but I mean, it's not as if I've knocked off anyone of note is it? You know, a bloke with a wife and kids, or a midwife, I don't know, Galileo or someone who's actually, you know, making some sort of contribution to this fucking sick society.

(*Pause.*)

I shouldn't have killed him should I. Shit! You know, if you lived up in Ashby I – shit! How long will I get? Murder.

MORRIE: Dunno. Five years maybe.

TED: (*Disappointed.*) Is that all?! What is this country coming to?! You kill someone in cold blood, premeditated murder, and all you get is five years! (*The trim ends.*)

MORRIE: There we go. That looks a lot neater.

(*TED stands and goes to the bathroom and looks in the mirror.*)

Now then. Small matter of the agreed sum.

TED: (*Off.*) Looks good.

(*TED comes back in.*)

Fifty quid?

MORRIE: Fifty. Cash.

(*TED goes into his jacket pocket and picks out his wallet. He looks through various compartments before producing five £10 notes, which he gives to MORRIE who counts them.*)

MORRIE: Why didn't you pay for the room with this?

TED: That was your money, all along.

(*MORRIE starts packing the video away. A sledgehammer smashes through the door revealing its chipboard and veneer structure. Immediately MORRIE's there and shouts through the hole.*)

MORRIE: Stop, we're coming out! He's coming out. He's unarmed.

(*TED goes over to inspect the damage.*)

POLICE: (*Off through megaphone.*) Walk slowly into the hall! With your hands in the air!

MORRIE: (*Head poking through the hole.*) Alright, alright, keep your hair on, he's coming out.

TED: You see Morrie, I told you – veneer.

MORRIE: Ready?

TED: Don't tell Kath eh, you know, about…?

MORRIE: What? You planning to kill her?

TED: Yeah. That wouldn't go down too well.

MORRIE: 'Course not.

TED: Look on the bright side eh? They've got a good library service, inside haven't they, won't be too bad as long as I don't have to share a cell with a nutter. I'm not coming here again. Forty quid! You go to France. They have like motels, yeah, on the *péage*, their motorways? Guess how much for a family room? That's me, Kath, Ben and Leslie all in one room. Roof, bed, secure parking. Go on, guess!

MORRIE: (*Angry.*) I told you, I don't have a car. Haven't you been listening!?

TED: One hundred and fifty francs. Fifteen quid. That wouldn't get you two slices of fried bread here. It's this country Morrie, that's what it is. OK. I'll go first. (*Shouted.*) We're coming out! We're not armed. Repeat, no arms!

(*TED unlocks the door and looks out. He sticks his head back in.*)

Fucking hell! There's hundreds of them.

POLICEMAN: (*Megaphone.*) Walk slowly! Put your hands in the air!

(*TED walks out with one hand in the air, the other holding his suit.*)

TED: (*Off.*) I'm Ted Oswald.

POLICEMAN: (*Off.*) Put that down! Slowly! Now, both arms in the air! Now!

TED: (*Standing in the doorway.*) Alright, alright. My mate here, he's got nothing to do with it. Eh, Morrie! Come on! (*To the Police.*) You've made a bit of a mess of this door. There was never any need for that you know.

(*TED moves forward, off. MORRIE contemplates the room, and turns the light out.*)

(*To black.*)

UNDER THE WHALEBACK

Set

The crew's quarters in the forecastle, under the whaleback of a 1950s-built 800-ton sidewinder trawler. Eight bunks are arranged on two tiers, stage left being the starboard side and stage right the port side. The bunks are made of varnished plywood. Each has a curtain which can be drawn across. Centre stage is a table fixed to the floor and around it, and again fixed and built in, are upholstered benches. There are tell-tale differences for each ship but the basic structure is the same.

Characters

The Kingston Jet

CASSIDY
a deckhand, aged fifty-five

DARREL
a deckie learner aged seventeen

The James Joyce

DARREL
a deckhand, aged twenty-four

NORMAN
a deckhand, aged twenty-eight

ROC
a deckhand, aged thirty-one

BAGNALL
the third hand, aged thirty-six

BILL
a deckhand, aged fifty-five

The Arctic Kestrel

DARREL
fifty-four
(*to be played by Cassidy from Act One*)

PAT
twenty-nine
(*to be played by Norman from Act Two*)

ELLY
nine

Under the Whaleback was first performed at the Royal Court Theatre Upstairs on 10 April 2003, with the following cast:

The Kingston Jet

DARREL, Iain McKee

CASSIDY, Alan Williams

The James Joyce

DARREL, Iain McKee

NORMAN, Matthew Dunster

ROC, Richard Stacey

BAGNALL, Ian Mercer

BILL, Sam Kelly

The Arctic Kestrel

DARREL, Alan Williams

PAT, Matthew Dunster

ELLY, Sophie Bleasdale

Director, Richard Wilson

Designer, Julian McGowan

Lighting Designer, Johanna Town

Sound Designer, Gareth Fry

Casting, Lisa Makin

The Kingston Jet

1965. The forecastle of the Kingston Jet. On the bulwark is a large black and white centrefold pin-up. The ship is in dock and there is a slight list to port. The sound of a ship's horn off. A different ship's horn replies, long and mournful, a different note. A third horn, very deep, joins in. Pause. The first horn sounds again in two short blasts. The second horn sounds in one short blast. Pause. The third horn sounds deep, long, and mournful. Voices off.

CASSIDY: (*Off.*) Eh Ray! Where we going?! Where yer tekking us this time yer shitehawk?!

RAY: (*Off.*) Mind yer own fucking business Cassidy!

CASSIDY: (*Off.*) Godshaven! Greenland! Get mesen a nice little tight arsed Eskimo. Show this lad the northern lights! Ha, ha!

RAY (*Off.*) Where's that dog of yours?

CASSIDY: (*Off.*) She's not coming this trip.

RAY: (*Off.*) No dog?!

CASSIDY: (*Off.*) No dog! No fucking wuff, wuff, wuff!

RAY: (*Off.*) Get yersen under that whaleback Cass, yer pissed.

CASSIDY: (*Off.*) Gerroff me Ray!

RAY: (*Off.*) Alright! Eh, Snacker, give him hand down that companionway.

(*CASSIDY falls down the companionway with a crash.*)

(*Off.*) You alright Cass!

CASSIDY (*Off.*) Yeah! I'm dead!

DARREL: (*Off.*) He's alright sir.

(*Enter CASSIDY holding a tube design kit bag, sea boots, and a mattress. He is a 55 year old man. He wears a suit and a lemon coloured shirt, the collar of which is over the lapels of his jacket. The shirt and cuffs are covered in blood. He is drunk.*)

CASSIDY Dead! And gone to a better place. Ha, ha!

(*Enter DARREL. He is 17 and dressed in the fashions of the day. He has the same gear as CASSIDY, but his is brand new.*)

DARREL: 'Ave you hurt yersen?

CASSIDY: Banged me fucking head dint I.

DARREL: You're bleeding.

CASSIDY: Aye! Look son, you can call me dad. Father and son. Wa, they'll all tek the piss, but let them I say, you can't break the bond of blood, blood is thicker than water. Call me 'dad'. And I'll call you – 'son'. Don't call me daddy.

DARREL: I'd prefer Darrel, or Daz. Me mates call me Daz.

CASSIDY: Blood! Blood's different. I'll call you son. And I'll learn yer all I know about fishing. Distant water. Right, for starters, them stairs out there, them int stairs, alright? – that's fishing for yer, and ships, everything's gorra different name. 'Companionway.' Remember it by thinking of yer 'companions' using it as the 'way' – down or up. Now, the right way to come down a companionway is facing the steps with yer toes in the gaps.

(*He mimes it.*)

If yer try and come down facing forrard, forward, forrard, yeah? Yer wimme?

DARREL: Forrard.

CASSIDY – you'll likely as not go arse over tit.

DARREL: Like you did.

CASSIDY: Brilliant! That's my boy. Two. If yer carrying owt, carry it in one hand only, and leave one hand to hang on with. 'One hand for you, and one hand for the ship.'

DARREL: 'One hand for you, and one for the ship.'

CASSIDY: Oh lovely, you're getting the hang of it now.

(*CASSIDY takes a bottle of beer from his kit bag.*)

Next! This ship right, it's a fucking shit ship, alright? It's like a Grimsby ship. Shit.

(*He puts the bottle of beer on the table and it rolls to port, stage right.*)

It's gorra list.

(*He opens the bottle and drinks.*)

Here we are in Hull, in dock, a thousand miles from the Arctic and we already gorra fucking list.

(*He takes a second bottle from his bag and hands it to DARREL.*)

Here, have a go.

(*DARREL puts the bottle on the table – it rolls to port.*)

That is a list to port. That's port, over there, and that's starboard. That's forrard, and that's aft.

DARREL: (*Pointing.*) Port, starboard, forrard, aft.

(*CASSIDY goes towards him and hugs him.*)

CASSIDY: Oh my son, my son! Ha, ha! I knew it! You got the salt in yer blood. You gorra be born to this you know. It's the worst fucking job in the world and only those what is born to it, what has gorrit in the blood, can do it. It's a terrible, terrible hard life and no-one should ever ask a man to go through what we have to go through but, you know –

(*He burps.*)

– someone's gorra do it.

(*CASSIDY opens the second bottle and hands it to DARREL.*)

DARREL: Are we allowed to drink?

CASSIDY: No! Definitely not! Very dangerous. No spirituous liquor allowed on board.

(*CASSIDY drinks. DARREL drinks.*)

Or swearing. Merchant Shipping Act of 1894.

(*Tenderly.*) Look at yer. Yer look a deckie. Put yer collar over yer jacket. Go on son.

DARREL: I'm gonna tek me jacket off.

CASSIDY: No, no. Go on son. Go on. Just give it a go. For me. Yer collar.

(*CASSIDY arranges DARREL's collar over his jacket.*)

There. Yer look good. That looks good. Here.

(*CASSIDY offers DARREL a cigarette.*)

DARREL: I don't smoke. Meks me feel sick.

CASSIDY: (*Laughing.*) No, no, no. You gorra smoke. Here. Tek it.

(*CASSIDY lights the cigarette and gives it to him. DARREL takes a drag.*)

You're a natural, born to it. I'll bet yer mam dint want you to go, but if you've gorrit in the blood, huh, *que sera* fucking *sera*. Whatever will be will fucking be.

DARREL: She cried.

CASSIDY: The women eh?! They say they don't want you to go to sea, they'd rather you gorra job, I dunno, mekking fucking caravans out at Brough. Caravans. Ha! What sort of a man is proud to stand up and say, 'I make caravans for a living.' A puff that's who. A caravan puff. She dunt want yer to go to sea, does she?

DARREL: I said, she cried.

CASSIDY: Ha, ha, ha! Don't believe a fucking word of it son. They can't get shot of us quick enough. At home, what, we're under their feet aren't we? Houses – I don't trust them, never have. I like a floor to move. You know you're alive then.

DARREL: Which bunk can I have?

CASSIDY: I'll learn yer everything son. Give me a chance to mek up for, you know. I'm fucking sorry kid. I ant bin much of a dad have I? I've tried son, I did try. But... I have to go to the pub you see.

DARREL: *(Indicating a bunk.)* Can I take this one?

CASSIDY: They call us drunks, but who can judge us eh? No fucking body! Three weeks gutting, gutting, gutting. Cawld, fucking cawld, eh! There int a word for how cawld it is. There's one for yer. When yer hands is frozen, when yer can't fucking feel them no-more, piss on them. It's hot, fucking boiling water, brings the blood back. Yeah, you're gonna enjoy this trip. Piss on yer hands. Write it down, that one. We're gonna do this proper. Yer gorra pen?

DARREL: Somewhere. I'm sure you're bleeding.

CASSIDY: Another thing! I aren't gonna call yer Snacker.

DARREL: What's a Snacker?

CASSIDY: Deckie Learner. Me, I'm gonna call you son, and you can call me dad.

DARREL: Please don't call me 'son'.

CASSIDY: Fuck 'em! I don't care what they say. Bastards. They'll call you Snacker, but I'm gonna call you son. Fucking hell, I've got the right!

DARREL: I don't want you to call me son!

CASSIDY: Oh no. No, no, no. It's blood. It's love. My only son!

(*CASSIDY approaches him as if to hug him again. DARREL backs off and holds him at arm's length.*)

DARREL: (*Angry.*) Don't touch me! You're not me dad! I've never met you before in my life! I don't know you. I just met you out there, on the dock. You're not my father. You're drunk.

CASSIDY: Oh no, no, no, yes, yes, it's true, yes, I'm drunk but –

DARREL: You're Cassidy. I've heard about you.

CASSIDY: I'm really sorry son.

DARREL: Me dad's called Malcolm. He's a carpet fitter.

CASSIDY: A carpet fitter?

DARREL: That's his job, yeah. Malcolm Ascough. He fits carpets.

CASSIDY: What sort of carpets?

DARREL: Fitted carpets.

(*CASSIDY sits and laughs at this.*)

CASSIDY: I promise, on my mother's life, God bless her soul, I'm your father.

(*DARREL turns away and throws his mattress into a bunk, and climbs in.*)

DARREL: I've heard about you.

CASSIDY: What do they say?

DARREL: Dunno.

CASSIDY: Headbanger? Headcase? I've heard the talk. Do they say I ride horses into pubs, eh? Yeah, well, I've only done that once or twice, mebbe three times. I like horses. I coulda bin a horse jockey, but I was too big, and I was fishing – me whole fucking life. What else have you heard?

DARREL: They say, what I've heard is, that for a laugh you stick fireworks up your arse.

CASSIDY: I can't deny it. At sea you've gorra make your own entertainment. Snowy Gordon took a photo last time but Boots wunt print it. Miserable bastards. I've gorra Catherine wheel in me bag as it happens.

(*DARREL climbs out of the bunk.*)

DARREL: Everyone in Hull knows about you.

CASSIDY: You've got to understand one thing son. Me father died at sea and his father died at sea, and his father afore him. Fishing, distant water.

DARREL: Your father, your grandfather, and your great grandfather?

CASSIDY: All three of them, yeah. But me great, great grandfather...he's still alive.

(*They both laugh.*)

He's hiding. Ha!

(*They laugh.*)

I like you.

DARREL: I'm not your son.

CASSIDY: What's the 'carpet fitter' say about me?

DARREL: He ses yer a one man circus.

CASSIDY: Aye, I've gorra few tricks.

DARREL: He ses you live in Rayners.

CASSIDY: I've gorr house, but our lass won't let me in. Rayners banned me once. The horse I was riding took a shit, in the snug bar. Fucking hell. It's not a big snug is it, Rayners, and the horse was that big un of Northern Dairies, the brown Galloway with one eye. They banned me. Not for long. I started going in Criterion dint I, and I took everyone with me. So Rayner begged me to go back. He's changed the doors though. You can't get a horse in there now.

DARREL: Why do they call you Cassidy? Me dad ses it's not your name.

CASSIDY: Cos I'm wild like Butch Cassidy, but I ant never killed no-one. You heard of Butch Cassidy?

DARREL: No.

CASSIDY: He was wild but he dint never kill no-one, like me. He's in the cowboy books. Here.

(*He slings DARREL a cowboy book from a pile propped up on the bench.*)

You'll need to know me real name. It's Arthur Duggleby.

DARREL: I'm gonna take this bunk. Will that be alright?

CASSIDY: Fuck 'em! My lad can have any bunk he likes. I coulda been a skipper you know son. Oh aye, I've got the ability but I'm colour blind aren't I. Can't be a skipper if yer can't tell red from green y'see. Ship's lights innit. Red light's port, green light's starboard. Much the same as not knowing yer arse from yer elbow. But I could've done it. Oh yeah.

(*He points to his arse and then his elbow.*)

Elbow. Arse. See. Easy. Ha, ha!

DARREL: (*Quickly.*) I'm not colour blind.

CASSIDY: That dunt mean nowt. Colour blindness yer catch off the mother. Fishing, yer got from me. Yer here aren't yer? Ha, ha! Course you are! The rest of me's A1. Had a full check up last year. Blood, piss, shit. I had to take in three separate samples of shit. Each one from different whatsanames.

DARREL: Different movements?

CASSIDY: No, different arseholes.

(*They both laugh.*)

You're alright kid.

DARREL: Me dad ses you've been in prison.

CASSIDY: Aye, I punched some bloke.

DARREL: Who?

CASSIDY: The Archbishop of York.

DARREL: Why?

CASSIDY: He'd had it coming.

(*Beat.*) I hate that fucking song of his! I'd told him aforehand I dint want it. At a funeral you gerr a choice of songs like a wedding. 'Eternal Father Strong to Save.' Huh. When's he done any fucking saving, eh?

(*Singing.*) 'For those in Peril on the Sea.'

Crap. I told him I dint wannit. Meks dying at sea sound like summat to be proud of. Fish and fucking chips! That's what my dad died for. The fish half of a fish and

chip supper. But no-one dare say that dare they? They have to dress it all up with words, and music.

(*Beat.*) I went to the hospital after, see the bishop, and apologise. I thought I'd broken his nose, burr it was already broken, cos he used to be a boxer in the army, can you believe it? A boxing bishop. Fucking hell, what next?

DARREL: Did he forgive yer?

CASSIDY: Oh aye. He's a Christian.

(*Beat. Tenderly.*) I got three daughters, all girls. Our lass lost a couple. It turned her that did, but she was badly already. She's gone, her mind's gone. She dunt know who I am. She won't let me in the house. Daren't go out. I buy her a load of tins and leave 'em out the back. I can't wait to get to the fucking Arctic. By time I come back it might have sorted itself out, eh? She might be dead. But that's a bit much to hope for. I dunno son?

DARREL: Tut!

CASSIDY: Alright, alright, I won't call you 'son'. Darrel. Aye, I don't know where your mother got that. It's a lass's name int it?

DARREL: (*Momentarily angry.*) No! It int! (*Beat.*) Where are the others?

CASSIDY: They was in Criterion at dinner time, I saw them in there, yeah. We still got an hour afore the tide.

DARREL: Why are you early then?

CASSIDY: I couldn't stay in Cri. I went for a walk. I come across the ship's runner, Percy, talking to one of the coal teamers. He tawld me our Snacker had gone on the Implacable, and that we had a new Snacker this trip. Darrel Ascough. You. But Percy dunt know worr I know! I begged him son! I fucking begged him, burr he wunt listen to me. He wunt have none of it.

DARREL: None of what?

(*Pause.*)

CASSIDY: He dun't know about the dog.

DARREL: What dog?

CASSIDY: My dog! She's my lucky dog you see. I dint know you was on the trip! I swear, son, I dint know you was signed on! I knew you'd be early. Deckie learner, first trip, keen. Yeah, I've planned this. Having a word. Where were we up to?

DARREL: You what?

CASSIDY: Number four. Knocking out the blocks, or knocking out. Very dangerous. Pete Brough, nice lad, he had a skeg over the side when we was knocking out, warp jacknifed, took his head off, clean, like a dandelion. I saw this oilskin walking towards me, walking, fish in one hand, knife in the other, no head. His head went over the wall. So, remember – duck.

DARREL: Knocking out?

CASSIDY: Knocking out the blocks. Gerrin washed over. If you gerr a big sea and you get washed over – don't panic, keep calm. Can you swim?

DARREL: No.

CASSIDY: Good! Excellent. Cos them what can swim are only prolonging the agony.

DARREL: What do I do then, if I get washed over?

CASSIDY: Hang onto the net cos a good skipper never loses a net.

DARREL: What if I 'ant gorr hold of the net?

CASSIDY: (*Laughs. Beat.*) I've got summat I want you to have.
(*CASSIDY begins to empty his kitbag. It is full of beer, fags and fireworks, and little else.*)

DARREL: You've normally gorra dog with you then?

CASSIDY: Oh aye. Jip. She's very clean. Pisses off the same spot on the starboard side. Only had to show her once. Intelligent, you see. Border collie.

DARREL: I wunt mind a dog. Can I have another beer?

CASSIDY: That's more like it! You're gonna be alright Darrel. They'll like you now I've got you smoking and drinking.

DARREL: I dint say I dint like beer.

CASSIDY: Where do you do yer drinking son?

DARREL: Subway club.

CASSIDY: I'm banned from Subway.

DARREL: Yeah?

CASSIDY: I broke forty glasses. It's a trick.

DARREL: What, a trick that went wrong?

CASSIDY: No that's the trick. You pile them up like a pyramid and bang the top one dead hard and all the rest shatter. That's the night I met yer mam.

DARREL: You know me mam?

CASSIDY: Rita, yeah. She's a lovely woman your mother. (*Beat.*) Does she still work there? She was a beauty you know. She won a contest.

DARREL: Miss British Oil and Cake Mills.

CASSIDY: Nineteen-forty...fuck I dunno. How old are you?

DARREL: Seventeen.

CASSIDY: Nineteen-sixty-five tek off seventeen is – hang on – forty-eight. Yeah, so Miss BOCM nineteen-forty-seven. Bloody hell, time flies.

DARREL: Why forty-seven? And not forty-eight?

CASSIDY: She had to carry you for nine month dint she.

DARREL: What? You –

CASSIDY: I couldn't make it work. It was her fault, she'd let the contest go to her head. She ran off with some flash bastard from Scarborough with an Arial Square Four.

(*A ship's horn sounds twice, a tenor. A second ship's horn replies, a bass.*)

Where's yer dad from?

(*Pause. Beat.*) Did he have an Arial Square Four?

DARREL: I dunno.

CASSIDY: (*Tenderly.*) Does he look like you? Do you look like him?

(*Pause.*)

DARREL: No. Not at all.

CASSIDY: I look a bit like you. You look a bit like me. You're just a strip of a lad but –

DARREL: – Why are you telling me this? You're telling me you're my father. You're telling me me dad is not me dad, that me mother…that you're me real dad. Why? I mean, what I mean is…why now?

CASSIDY They'll be here soon, and once we're off, we'll get no privacy. I got summat for yer. I don't want them to see. This might be me last trip.

DARREL: What?

CASSIDY: Oh yeah. Old Father Neptune's been nipping at my arse for fucking years, and one of these days…well, yeah, you never know. And I've alles relied on me dog for luck.

DARREL: You're terrible drunk aren't yer?

CASSIDY: Hope I am. I spent enough money on it.
(*From out of the kitbag CASSIDY has found a small package, like a large purse, made out of rubber.*)
Here we are. I want you to have this.

DARREL: What is it?

CASSIDY: A duck suit. Navy issue survival suit. You wear it – look – if you're going down, and you know you're going down, so you have to gerr in a raft or go over the wall, then get in some dry long johns and socks and that and then put this on over the top. Water tight, air tight. You don't swim do yer? Well, mebbe if you fart a couple of times it'll keep you afloat, who knows. It's yours.

DARREL: Have you got one?

CASSIDY: That's mine.
(*Beat.*) Now there's another thing. There's summat I want you to have. A betting slip, it's worth three hundred quid. Yeah! I live on North Hull estate, d'yer know it?

DARREL: Yeah.

CASSIDY: Twennie-first ave, number eleven, legs eleven, you won't forget. The betting slip's in a tin of creosote out in the scullery. Our lass won't let you in but go to the Bethel, take the priest with yer, she'll open the door to him, then just say that I'd said if owt ever happened to me I'd said you're to have the creosote. Alright? But don't open the tin indoors, tek the whole tin and fuck off.

DARREL: Don't open the tin in there?

CASSIDY: No! I don't trust that priest.

(*Noises off. The other lads are arriving. DARREL stands and faces the door and listens. CASSIDY stands.*)

The lads are here.

DECKIE 1: (*Off.*) Eh Ray! D'yer hear about Cassidy!?

RAY: (*Off.*) Yer late get yer arses below!

DECKIE 2: (*Off.*) He's killed the dog!

RAY: (*Off and a shouted whisper.*) Fuck! The mad bastard.

DECKIE 1: (*Off.*) He slit her throat in Criterion, in the lounge. Blood everyfuckingwhere.

RAY: (*Off.*) Jesus Christ!

DECKIE 2: (*Off.*) They've banned him again.

DECKIE 1: (*Off.*) He took his gutting knife, held her by the ears, and just ran it across her throat, stood up and walked out.

(*Silence. Broken by a ship's horn, a tenor. The second horn, a bass, replies.*)

DARREL: You killed the dog?

CASSIDY: Aye.

DARREL: In the pub?

CASSIDY: Aye.

DARREL: And you're me dad? Me father?

CASSIDY: Aye. Sorry.

(*To black.*)

The James Joyce

Blackout.

*The sound of the James Joyce head to wind and dodging in a Force
Nine. The engine is at half speed. At roughly two minute intervals a
big water breaks over the whaleback. There is the sound of two men
on the whaleback chopping ice from the deck and upperworks. Before
each big wave there is heard a scream of 'WATER!!' The chopping
stops on this shout, the wave breaks twenty seconds later, and then
the chopping resumes. This cycle is heard twice.*

Lights up.

*It is 1972. The forecastle of the James Joyce. There are clothes, socks,
and underpants drying all over the place. Books, and pornography on
the table. A large colour centrefold of a naked model on a bed in high
heels has replaced the 1965 black and white model. NORMAN's
bunk is downstage right. It is wallpapered with pornography. Directly
above him is ROC's bunk with no pin ups, but a large pile of cowboy
books. Upstage right on the bottom tier is BILL's bunk which is neat
and tidy. On the stage left side of the forecastle is BAGNALL's bunk
which is on the bottom tier upstage. The Snacker's bunk is downstage
left on the bottom tier. DARREL's bunk is downstage on the top tier.
DARREL has some novels and a picture of his wife and family.
BILL is sitting at the table carving and painting the jawbone of a
cod to form a decorative butterfly. Others, already completed, are put
to one side. He has a rollie tab stuck to the corner of his lip. ROC is
lying in his bunk staring at the ceiling. DARREL is sat at the table
smoking. NORMAN is pacing about. BAGNALL and the Snacker
are off. They're all in vests, singlets, long johns, underpants. NORMAN
has a David Bowie T-shirt and blue and white Y-fronts over a pair
of tan woman's tights.*

NORMAN: Daz?
DARREL: What?
NORMAN: Fag.
DARREL: Tut!

(*DARREL lights a cigarette for him and passes it over. NORMAN takes a drag. He slams his fist against the bulwark, then headbutts it.*)

DARREL: Whatsamatter Norm?

NORMAN: Nothing.

BILL: Ha, ha, ha, ha!

NORMAN: What makes you think there's owt up wi me?

DARREL: Dunno.

NORMAN: I wanna cup of cocoa!

(*NORMAN fists the bulwark a second time and then a third.*)
I want some fucking cocoa! Or tea. Pot of shackles. Anything! Eh!?

BILL: Shutup and sit yer arse down. Ha, ha, ha.

NORMAN: Let's draw lots for gonna get some tea. Big pot of tea, and cocoa for me. Eh! We'll draw lots.

DARREL: Sit down Norman. Canasta?

(*DARREL starts dealing from a double Canasta pack.*)

NORMAN: No! I want cocoa.

DARREL: (*To BILL.*) You in Bill?

BILL: No. I'm happy. Ha, ha, ha, ha.

NORMAN: And summat to fucking eat. When did we last eat? Fuck!

DARREL: Roc! You in?

ROC: No ta.

NORMAN: We'll draw lots, eh? What d'yer say?

(*ROC pulls himself up on one elbow and watches NORMAN and DARREL.*)

DARREL: So if you lose the draw, what you gonna do?

NORMAN: The loser er...fuck... I dunno. The loser gets all their gear on, and goes up and across the foredeck, to the galley, get the cook to brew up.

DARREL: That's my point. You, Norman. You lose, you get yer gear on, run across the foredeck, to the galley, get a pot of tea, some shackles –

NORMAN: Cocoa –

DARREL: Cocoa for yourself, and what...run back across the deck – hanging on with what, eh? How yer gonna hang on? Wrap yer knob round summat like a monkey.

BILL: Ha, ha, ha! Yeah, Norm, hang on with yer knob.

NORMAN: Shutup yer daft old git.

BILL: Monkey knob! Ha, ha, ha, ha. (*BILL makes monkey noises.*)

DARREL: You'd do that? If you lost?

NORMAN: Yeah.

DARREL: Next Sheffield flood you would. I've been four years with you in this ship Norman and I can tell you that you would not do that.

NORMAN: Are you calling me a liar?

DARREL: Yeah. You're banking on someone else losing.

NORMAN: You're a fucking clever git you. What school was it again?

DARREL: Archbishop William Temple.

NORMAN: Yeah, exactly. Fucking nuns.

(*To ROC.*) What're you looking at you big daft beswick?

ROC: You.

DARREL: You're starting to get on my tits Norman.

NORMAN: Tits? I wunt be surprised. You gorra lass's name.

DARREL: (*Angry.*) Fuck off. Wanker.

BILL: I like an happy crew. Ha, ha, ha, ha.

DARREL: (*To BILL.*) It's not on Bill, having the Snacker on the whaleback. Fuck, he's only a kid.

BILL: Na, he'll be alright.

DARREL: No-one ever asked me to crack ice when I was a Snacker. Not in owt as bad as this.

ROC: Bagnall will keep an eye out for him.

BILL: Ha, ha, I bet Baggy wishes he'd gone to that wedding in Fleetwood now, ha, ha, ha!

DARREL: Working with a line on is a bloody art, you know it is. Summat you gorra learn.

BILL: He'll be learning then won't he. Ha, ha!

ROC: He's got Baggy with him.

DARREL: Bagnall?! That Lancastrian bastard's only interested in number one.

NORMAN: Tut! Three days stuck down here, with you lot.
Rabbit, rabbit, rabbit. No cocoa. Fucking twat's lark this
is. I mean, where we going?!

ROC: We're dodging.

NORMAN: Dodging! Going bloody nowhere! We're
standing still!

BILL: Aye, many a time I've seen it as bad as this, and
there int nowt you can do but head to wind and –

NORMAN: Shut it will yer! Why can't we go in?!

DARREL: Sit down Norman will yer.

NORMAN: Find a fucking fjord!

DARREL: Yer know why.

NORMAN: I know fucking nothing. Not bin paid to bloody
think am I. My last trip this.

DARREL: What yer gonna do then Norm?

ROC: He's gonna be a bus driver.

(*BILL and DARREL laugh.*)

NORMAN: (*To ROC.*) Shut it!

DARREL: You can't even drive a car Norman. He can't
drive can he Roc?

ROC: Na. Course he can't.

NORMAN: Driving a bus is easier int it?

DARREL: How come?

NORMAN: Yer gerr a set route.

(*All but NORMAN laugh. BILL stops what he is doing and
laughs irritatingly longer.*)

BILL: Ha, ha, ha, ha, ha, ha.

(*Beat.*) Ha, ha, ha, ha, ha.

(*Beat.*) You gerr a set route. Ha, ha, ha, ha, ha, ha, ha.

(*A big wave hits and silences them all.*)

DARREL: (*To BILL.*) You'll have to use the buses when they
move you out of Flinton Street.

NORMAN: Yeah, well there'll be no laughing on my bus.

(*To BILL.*) You're not moving nowhere near me I hope?

BILL: Bransholme.

NORMAN: Fuck. That's just over the back. If I can hear
that laughing of yours I'm ringing the police.

BILL: Ha, ha! They're giving us a garden. Might gerr a shed. Na! Our lass likes to see what I'm up to.

DARREL: Gerra greenhouse then.

BILL: Aye, that's a possibility. Ha, ha.

NORMAN: What's wrong with the house you got?

BILL: It's onny a sham four. Two bedrooms for nine of us.

NORMAN: You're never there.

BILL: Corporation don't like it. Outside loo. No bathroom. They're gonna knock it down.

DARREL: It's insanitary.

BILL: It is insane, yeah. It's bloody madness. Perfectly good house.

NORMAN: (*To BILL.*) Kaw! I won't be fishing when I'm your age.

BILL: I've got seven daughters. Do you know how much tiaras cost?

ROC: How's your mortgage work Daz?

DARREL: You're just buying your house on tick that's all. Takes twennie-five years, and then it's yours.

BILL: In debt for twennie-five years. That's not manly.

NORMAN: What?! Gerr on with yer butterflies yer fucking headbanger. How did I get stuck with you lot? I coulda signed on the Faraday you know. You know where they've gone don't yer. Godshaven. Oh yeah.

DARREL: (*Sarcastic.*) Ooh Godshaven.

NORMAN: Yeah, Eskimo birds everywhere. Gagging for it.

DARREL: You believe all that do you?

NORMAN: It's a known fact. You see, it's illegal to be pregnant in Greenland.

DARREL: Bollocks.

NORMAN: Tis! Run by Denmark innit nowadays. If they get up the duff they fly them off to Denmark which is what they all want any road, and they spend the rest of their lives on the dole mekking slippers.

BILL: Aye, they do mek smashing slippers. Fur slippers. I've bought a couple of pairs for our lass over the years.

NORMAN: You dock in Godshaven and they surround the ship, begging for it. Twennie, thirty, forty Eskimo birds. All up for it.

ROC: Where are all their men?

NORMAN: The fuck do I know? Skiing.

DARREL: You've been to Godshaven Bill.

(*NORMAN sits and picks up his cards, and begins to sort them.*)

BILL: Many a time.

DARREL: Tell him it's not true.

NORMAN: Course it's true.

BILL: I always got a shag out of it.

NORMAN: (*To DARREL.*) Told yer!

(*To ROC.*) Are you listening?

(*To BILL.*) Bet your lass dunt know eh? Ha! She thought you was off fishing but there you are shagging your way round the arctic circle. No wonder she gets plenty of slippers.

BILL: Aye, I went in there once on the Kingston Jet when we'd snagged the prop. Five days we was in there. Ha, ha, ha. We had Cassidy with us –

NORMAN: Oh fuck, Cassidy! I shoulda known.

BILL: Cass gorrit all organised. We had a donkey hose rigged up in the fishroom and the galley boy's job was to hose 'em down, cos they used to stink you know cos they eat nowt but meat and fish, you wunt wanna kiss 'em.

NORMAN: They'd be disappointed then! Ha!

(*All laugh.*)

BILL: And then Cassidy'd sent 'em in here for the business.

NORMAN: What – an orgy?

BILL: No, no, no. It weren't an orgy. Ha, ha! It were like a big sort of endless piss up where everybody's on the job all over the shop.

NORMAN: That's an orgy! That is the word for that sort of a sex party come piss up.

BILL: Na, there wan't nowt Roman about it.

NORMAN: Who said the fucking Romans have to be invited? Daz? Look it up in that dictionary of yours will yer.

DARREL: 'Orgy'.

(*DARREL goes to get his dictionary.*)

BILL: Na, it wasn't an orgy. Just a big party with a lot of booze, and Cassidy playing the piana, and everyone fucking the eskimo birds.

NORMAN: That's an orgy!

ROC: How come you had a piana?

BILL: Cass was in Rayners the night before the tide and they was chucking out the old one. So Cass put it on a cart and took it down the ship, and we had on the portside of the foredeck all trip.

NORMAN: You expect me to believe that you daft old cunt.

BILL: I don't care what you think.

DARREL: (*Reading from a Penguin Paperback dictionary.*) Orgy. 'A wild gathering marked by promiscuous sexual activity.'

NORMAN: See, that was an orgy!

BILL: I was there! It wan't an orgy. There was a lot of shagging and drinking but...

NORMAN: – Shutup will yer! You see?!

BILL: Aye, I sailed with Cassidy a few times. Always had that lucky dog with him. Ha, ha, ha! All the arctic circle to shit in and where does she go? On my winch handle. Ha, ha, ha.

NORMAN: Happy days. Sharing a ship with the laughing policeman.

BILL: Aye, we won't see the likes of Cassidy again. One time I was with him on the Lord –

NORMAN: (*In BILL's face.*) – Shut it! Alright! No more fucking Cassidy stories.

ROC: Norman!

NORMAN: What!? I'm sick of him. It's like living with the seven dwarves.
(*A big wave hits with a bang. It throws them into a momentary list. They stop talking, and wait for the ship to right itself. SILENCE. The ship comes back.*)
Let's talk about...I dunno...horses. Race horses. If I win the pools I wunt mind a racehorse.
(*Pause.*)
Horses.

BILL: Cassidy wanted to be a jockey you know.

(*NORMAN turns and starts to head for BILL but ROC sticks a hand out of his bunk and holds him back by the collar.*)

NORMAN: Gerroff! I'll brae hell out of him.

(*NORMAN goes over to the stage left bulwark and presses his head against it.*)

BILL: You wanna get yersen a nice little lass and get married. And stop paying for it, and stop talking about it, stop thinking about it and gerr on and do it proper for a change.

ROC: Leave it Bill, yeah? The two of yer.

BILL: Forget the pools. I could save you a load of money.

NORMAN: Oh yeah, what would you do?

BILL: Cut yer chopper off.

NORMAN: I'll do what I fucking like. It's my knob.

BILL: Monkey knob. Ha, ha, ha, ha.

NORMAN: I'll have you.

BILL: Get yersen a nice little lass. Settle down. Like Daz here.

DARREL: Yeah, a family Norman.

BILL: Family. That's all there is.

NORMAN: Tut!

BILL: I'd had three daughters by the time I was your age. You, huh, you're still living with your mother, buying them magazines from Lollipop.

NORMAN: I'll shut your mouth for you soon grandad.

BILL: You should tell him Roc, you're his mate.

NORMAN: He ant gorr owt to say on the subject.

BILL: (*To Roc.*) You still going out with that Maureen from up National Ave?

ROC: Yeah.

BILL: She'd be good for you Roc. Mek a good wife. Aye, looks aren't everything you know.

NORMAN: That int nowt.

ROC: Yes, it is.

NORMAN: No it int!

ROC: What am I doing then?

NORMAN: You're not like going out with her are yer. You just know her.

BILL: Maureen. It's a lovely name.

ROC: Yeah.

NORMAN: (*To DARREL.*) What you reading?

DARREL: Fuck off.

BILL: (*To NORMAN.*) I've never had to pay for it you know, me whole life I've…

NORMAN: Shurrup Cassanova.

ROC: I'm gonna ask her to marry me. When I get back this time.

BILL: Oh smashing.

NORMAN: You what?

ROC: I'm gonna marry Maureen.

NORMAN: No you aren't! You don't love her! Tell him Daz, he dunt wanna be going around gerrin hissen wed to women he dunt love.

DARREL: Do you love her Roc?

ROC: I dunno. How do you tell?

NORMAN: How do you tell? You don't have to think… when…for Christ's sake! You don't love her! And that's that.

ROC: How do you know?

NORMAN: You don't know the first thing about owt when it comes to women.

ROC: I'm gonna ask her to marry me. When I get back. Have a family.

DARREL: Good on yer Roc. You do what you want. Don't listen to Norman.

NORMAN: Shutup you. Who's side are you on? He doesn't fucking love her! Stop encouraging him will yer. Fuck. I'm the one who's got to live with the consequences.

DARREL: What's it got to do with you?

NORMAN: Tut! You…you don't understand. It's just this shit we're in. It's turned his mind.

(*To Roc.*) Med you all thoughtful.

BILL: Do you really love her Roc?

NORMAN: For Christ's sake!

ROC: I dunno. I think I might do. Like I say, I'm not sure.

BILL: Would yer use her shit as toothpaste?

NORMAN: You what?

DARREL: Would you use her shit as toothpaste?

(*ROC is thinking and all of them look to him for an answer.*
ROC takes the question seriously.)

ROC: No. No, I wouldn't.

BILL: You don't love her then.

NORMAN: (*To BILL.*) That's the first sensible thing you've said for three days, now shut it, and get on with yer butterflies. How many of them bloody things are yer gonna do?

BILL: Seven, eight. Eight. One for each of me daughters and one for our lass.

NORMAN: Seven daughters. And no sons. You must be doing summat wrong.

ROC: I'm still gonna ask her. I'm gonna get wed.

DARREL: She might say no Roc.

NORMAN: You're kidding aren't yer. Who the fuck else is gonna marry her?

(*NORMAN pulls a grotesque face.*)

BILL: What heats a room? The fire or the mantlepiece? Knowhatimean?

(*Pause. They're confused.*)

NORMAN: He's on gas.

ROC: Yeah. North Sea Gas.

NORMAN: (*To BILL.*) He's on gas.

BILL: (*To NORMAN.*) Least he's gorra woman. That's your lass there. A picture. You can't fuck her, she can't mek a pot of tea, and she an't even got the manners to tek her shoes off afore she gets into bed. If she was here, on this table, now, then she'd be worth tekking note of. I'd gerr interested. But a picture. Ha, ha, ha, ha, ha.

NORMAN: Oh aye, she'd jump on a stinkie old shellback like you, yeah?

BILL: I could give her a good time which is more –

NORMAN: I know about women!

(*To DARREL.*) Fag.

DARREL: That's twennie-seven you owe me now.

(*DARREL lights a fag for him and passes it over.*)

BILL: You don't learn owt about women, or what they want, when you're paying for it.

NORMAN: I know enough. The love button.

(*DARREL and BILL laugh.*)

What? That's all you need to know. Find that little bald headed bastard and yer laughing.

(*DARREL and BILL laugh again.*)

DARREL: What I like most about being married, and back me up on this one Bill, if you agree, is, you know, just lying in on a morning, say you've had a good trip, settled up, everything's alright, you've given her a good night out in a club or summat, and then in the morning, she's got the kids off to school and then she comes back to bed, you know, and you're all cuddled up like, and yer just loop yer arm round and cup a tit, just hold it, and then yer drift off to sleep again.

BILL: Smashing.

DARREL: Lovely.

(*NORMAN gets into his bunk which is down stage right on the lower tier. He starts to read a pornographic magazine but throws it to one side as a big wave hits. He grips the side of his bunk in fear. The ship rights herself.*)

I'm not saying the sex int important it's just that –

NORMAN: Fuck! I'll be glad when I'm back on that whaleback cracking ice.

(*To ROC.*) When's our watch?

ROC: Half-hour yet.

BILL: Get yer head down. Get some sleep.

NORMAN: Huh.

BILL: Who's gonna be yer best man Roc?

NORMAN: He's not gerrin' married.

BILL: Norman int it. Stands to reason. Yer best mate's always best man.

NORMAN: I aren't backing you up marrying someone you don't love. What kind of a mate is that?

ROC: I haven't asked you yet.

NORMAN: Who else is there? Bloody hell I've been wiping your arse since you was a kid. I mean, I've fucking earned the right ant I?

DARREL: You said you wunt do it!

NORMAN: I mean, earned the right to be asked. I gorra few jokes.

ROC: I don't want any mucky jokes at my wedding. Her mother dunt like deckies as it is.

NORMAN: Fuck her mother.

BILL: Where you gonna have reception? In, you know, in like an ideal world.

ROC: Subway club.

NORMAN: Subway? In an ideal world you'd like to have your wedding reception in Subway club? D'yer hear that Daz?

DARREL: Yeah.

(*NORMAN gets out of his bunk.*)

NORMAN: In an ideal world, you know, money no object, Frank Rocco chooses Subway. Tut! This is the sort of shit I have to put up with.

ROC: I like Subway.

NORMAN: No, no, no! You're not fucking listening. Bill said in an 'ideal world' – like dream world – win the fucking pools world.

ROC: I don't do the pools.

NORMAN: (*Sighs.*) Oh fuck. Get more sense out of a fucking shovel.

BILL: I'll sing at the wedding if yer like.

(*Singing.*) Ave Maria. Ave Maria. Ave Maria.

I've gorr an LP with fifteen different versions of Ave Maria on it.

ROC: What's the LP called?

BILL: Ave Maria.

(*A big bang as a big wave hits. It throws the James Joyce into a momentary list to starboard. The engines are heard to scream on full ahead as the skipper drives it out of the list and back to dodging. A list to starboard remains. The crew in the forecastle are aware of it. Silence.*)

ROC: Does your mam still work in Subway Daz?

DARREL: Lunch times, yeah.

ROC: Do you think that'd be possible? A wedding reception.

DARREL: Are you a member?

ROC: No.

BILL: You can do better than Subway Roc. I've been to receptions in there. They hardly put themselves out do they? Stick a bit of plywood over the snooker tables, and pay the stripper to keep her clothes on. Ha, ha, ha.

NORMAN: I'm not standing up in Subway and mekking a fool of mesen.

DARREL: No-one's asked you to.

NORMAN: Oh come on! Who else has he got?

BILL: Are you a member Norm?

NORMAN: Subway? Fuck off.

ROC: He joined three clubs after the last trip. Andrews, Nash, and Stevedores and Dockers.

DARREL: (*With contempt.*) Dockers?

NORMAN: (*Getting out of his bunk.*) I was drunk!

DARREL: You dint pay full annual memberships?

NORMAN: I was pissed!

DARREL: You're at sea forty weeks of the year.

NORMAN: He shoulda bin looking after me, but he ant got the brains he was born with. I only joined so I can bona fide him in or we'd both be standing in the street all Saturday night.

BILL: But you dint join Subway?

NORMAN: I can't stand Subway!

(*BILL and DARREL laugh.*)

ROC: It's alright Subway.

NORMAN: Why dint you join it then?

ROC: I don't see the point of paying out for annual membership when I'm at sea forty weeks of the year.

(*BILL and DARREL laugh.*)

NORMAN: You coulda joined to bona fide me in for a change.

ROC: You don't like Subway.

(*BILL and DARREL laugh.*)

NORMAN: Alright, alright! Come on gerron with yer butterflies. How many have you done now?

BILL: Five.

NORMAN: We'll be running out of fish soon. What is that?

BILL: Yeah, Red Admiral.

NORMAN: Who's that for?

BILL: My little lass. Lizzie. The youngest.

NORMAN: How old's she then?

BILL: Thirty-two.

NORMAN: It's a fucking zoo this.

(*He stands and paces again.*)

Where are we?!

DARREL: Same place we were yesterday, and the day before, and the day before that.

BILL: Aye, you don't go no place when you're dodging.

NORMAN: Why don't we go in? East coast of Iceland. That's near enough int it?

DARREL: We're off the West Coast.

NORMAN: East, West – what's the difference?

DARREL: You know why we don't go in.

NORMAN: We're dodging. I'm not the old man, I'm not saying I am, but why can't we just sort of edge towards the coast.

DARREL: Stop dodging you mean?

NORMAN: I don't mean…oh fuck…I dunno. What're you reading? Cowboys?

DARREL: A novel.

NORMAN: You're a clever arsed bastard aren't yer? Are you gonna go for yer skipper's ticket?

DARREL: Yeah. Got me medical when we get back.

BILL: Cassidy was the best seaman I've ever met but he was colour blind, couldn't be a skipper.

NORMAN: Shut the fuck up! If I hear one more thing about Cassidy I'll fucking do you.

(*To DARREL.*) Yeah, I can see you hiding away up in that glass sowester. Not much point staying in this game if yer can't work your way up.

(*NORMAN snatches a paperback novel from DARREL's grasp. He looks with contempt at the arty cover.*)

Let's have a look at this crap then.

(*He flicks the book open and starts to read to himself.*)

Ha! Fucking hell! *A Portrait of the Artist as a Young Man.* James Joyce. Oi! James Joyce! 'Once upon a time…' Yeah! Once upon a fucking time. Do they all live happily ever after?

DARREL: I an't finished it, 'ave I…

NORMAN: (*Tossing the book back to DARREL.*) Shite! (*Beat.*) How long can it keep this up?

BILL: I've seen worse than this. I was in Isafjiord that night in sixty-eight.

DARREL: (*Sharply.*) Alright, Bill. We don't need that.

BILL: The wind was coming off that hill at hundred, hundred and ten, and the air was cawlder than the sea, cos it's not an hill it's a glacier –

NORMAN: (*Desperate, to DARREL.*) Are you gonna stop him?

DARREL: Sit down Norman.

BILL: Forty ships, all iced up like Christmas trees. Then the Ross Cleveland started heeling over. She was only half a cable off to port. But there was nowt you could do. Ah, but that wind was a hundred and ten. This is nowt.

NORMAN: I could put up with this shit if I had some cocoa, knoworrimean?

ROC: Yeah.

NORMAN: (*To BILL.*) You finished?

BILL: He knows what he's doing does the old man. Yer just gorra sit it out.

NORMAN: Yeah, well I've been sitting it out for three days now and me arse has gone on strike. I want summat to eat, and summat to drink.

(*To DARREL.*) This wunt have happened if your lass hadn't waved.

DARREL: Crap.

NORMAN: It's unlucky. Women – waving at ships.

DARREL: (*Miming.*) It's a medical condition she's got. Goodbye elbow.

NORMAN: I wun't let any wife of mine come down dock and wave.

DARREL: You don't have a wife.

NORMAN: If! They'll be alright on that submarine won't they? They'll just go under this. Tut! They have women on board you know, the Ruskies. Big Russian birds with hairy tits. They catch summat off the engines.

BILL: Radiation.

NORMAN: That's it. If you're a bloke it'll give you a pair of tits. A hairy pair. Had to go into Murmansk once for the hospital. Kaw! Prossies everywhere. I speak a bit of Russian you know. Yo cocho fuck. I'd like a fuck. Ostar Oshno Ya epileptic. Take care I'm epileptic.

BILL: Cassidy was based in Murmansk during the war. Running ball bearings on them motor gun boats.

NORMAN: (*To DARREL.*) You know what I mean!

BILL: He got the Conspicuous Gallantry medal for that. Victoria Cross, as good as, that is. Ha, ha.

NORMAN: (*Shouting at BILL.*) It's 1972! Chicory Tip are number one! Inside his head Cassidy's still fighting the second world war!

BILL: Aye, you won't see his like again. Best skipper I ever sailed with was –

NORMAN: – oh God!

BILL: – Phil Waudby. He could find fish in a fucking farmyard! Ha, ha! Yeah, fascinating Phil we used to call him, ha, ha, ha.

ROC: What d'yer call him that for?

BILL: Cos he was a really interesting man. Aye, they're all gone, them, proper trawlermen. You sailed with Cassidy dint yer Darrel, when the Kingston Jet went down?

DARREL: What about it?

ROC: They say Cass went back for the dog.

NORMAN: Oh don't encourage them.

DARREL: I was in the other raft.

BILL: Na, not the dog, it was Eggy Barrat's wedding ring.

NORMAN: That's what I heard. Is that true?

DARREL: I said. I was in the other raft. It was night.

(*Big wave hits. The ship comes back. A period of silence.*)

BILL: They all got out and got in two rafts when Eggy Barratt pipes up, 'I've left me wedding ring in me bunk, our lass'll kill me' – so Cass dives in and swims back to the ship, climbs on board, a sinking ship remember, and he waves at everyone like the daft bastard he was and goes down into the forecastle, comes back up on top, chucks the ring to the raft, goes back down under the whaleback, and then she slips under.

ROC: That right Daz?

DARREL: (*Pedantically.*) I was in the other fucking raft!

BILL: They never found his body. I wunt be surprised if he don't walk in Rayners one night, or ride in on a bloody hoss of course. Lived by different rules did Cassidy, so mebbe he's gorr his own rules in death. Aye, I knew Cassidy, they brock the mould there. Ha, ha, ha, ha, ha. A one man circus.

DARREL: Come on then! Let's draw lots. I'm fucking starving. Eh?

NORMAN: Yeah.

DARREL: Bill?

BILL: What?

DARREL: Someone go and get a pot of shackles. Draw lots.

BILL: That cook can't mek shackles.

NORMAN: (*To DARREL.*) Just deal the cards!

(*DARREL deals four cards.*)

Aces high. Lowest card loses.

(*They take their cards.*)

BILL: Ace.

NORMAN: Jammy. King.

ROC: Three.

DARREL: Five.

NORMAN: Fuck!

(*NORMAN fists the bulwark.*)

Best of three? Don't go Roc.

ROC: I lost.

NORMAN: Fuck that! Oh shit Roc, come on!

ROC: I'm gonna get your fucking cocoa now shurrup.

(*NORMAN grabs hold of ROC's shirt.*)

NORMAN: No Roc, no, no! You don't understand! Just forget it Roc, eh!

ROC: I lost.

DARREL: I'll go. I don't mind going.

(*DARREL goes to his locker and gets his kit bag out. During the next he takes out his duck suit, changes into clean dry gear and puts the duck suit on. NORMAN continues to hang onto ROC's shirt.*)

BILL: Eh, come on, let's just forget the whole idea, eh?

DARREL: There's a lifeline to the winches. I've bin listening. There's a big sea every two minutes or so. Just a matter of timing int it.

BILL: (*To DARREL.*) What the fuck's that?

DARREL: A duck suit.

BILL: Where'dyer gerrit?

DARREL: Me dad give it me.

BILL: He's a carpet fitter in't he? Does he do a lot of damp basements then?! Ha, ha, ha.

NORMAN: Shutup you fucking half wit!

ROC: Was he navy?

DARREL: Reserves.

(*A big sea hits. NORMAN grabs a hold of his bunk in fear.*)

NORMAN: Oh God!

ROC: Alright Norm. The old man knows worr he's doing.

BILL: These is the best sea ships there is these you know. It's them big stern trawlers that can't tek a sea. We just go up and down like a cork.

(*ROC puts a hand out on NORMAN's shoulder. He is shaking.*)

NORMAN: (*To ROC.*) Gerroff. I'm alright.

DARREL: Quiet!

BILL: What is it son?

DARREL: Wait!

NORMAN: What?!

DARREL: They've not gone back on top.

ROC: You what?

DARREL: They're not chopping no more.

BILL: Wa, they'll have the donkey hose on by now.

DARREL: You'd still be chopping. One with the hose and one chopping.

NORMAN: What are you gerrin at?!

ROC: Calm down Norman.

(*ROC puts out a hand to NORMAN, but NORMAN pushes it away.*)

NORMAN: Gerroff. What do yer mean?!

ROC: Norm. It's alright.

DARREL: Bagnall and Snacker have been on the whaleback past couple of hours cracking ice, same as we were, and now, they've stopped.

(*Silence. They listen. There is no chopping, no banging.*)

BILL: Dunt mean nowt.

DARREL: No, it dunt mean nowt. I'm not saying it does. The old man's probably got them working on the upperworks, or the wheelhouse, or some place else.

NORMAN: That's not what you're saying!

ROC: Shutup Norman!

DARREL: (*To Roc.*) Get him calmed down will yer!

BILL: This int nowt much.

(*DARREL goes out to the drying room and returns with his boots, sou'wester, and oil frock. He puts them on.*)

DARREL: (*To NORMAN.*) I'll get you some cocoa Norm. It'll be alright. Sugar, yeah?

NORMAN: Yeah. Two.

DARREL: Alright.

(*DARREL exits up the companionway.*)

ROC: I shoulda gone.

NORMAN: No!

ROC: I could mek a ship to shore. Talk to Maureen. Propose.

NORMAN: You don't wanna marry her you big fucking stupid lump! Whatsamarrer with yer? Look…she's a tart.

BILL: Oooh! Now then, ha, ha, ha!

NORMAN: (*To BILL.*) Shut it! This is private!

ROC: It's not fair on Maureen that. She's quiet. She's not really been with anyone. She dun't dye her hair.

NORMAN: She's a filthy, filthy, fucking slag! She's trying to get you Roc, can't you see that. Whatsamarrer with yer?

ROC: Stop saying whatsamarrer with me. There int nowt wrong with me.

NORMAN: She's trying to trap you, she's gonna...

ROC: What? What is she gonna do? I can see what she's trying to do and mebbe that's what I want!

NORMAN: She's a slag, she's...

ROC: I know what you did. She told me. We talk.

NORMAN: What did she tell you?

(*Beat.*) She fucked me! I wasn't interested!

BILL: Oh bloody hell.

NORMAN: She forced me, you godda believe me. I wan't gonna touch her!

ROC: It's nice to have someone you can talk with.

(*BAGNALL enters down the companionway. He is the third hand and has an air of authority. He is wearing full sea gear, sou'wester, oil frock, gloves, sea boots. He goes straight in the drying room and takes his gear off. ROC lights a cigarette for him and takes it in.*)

(*Off.*) Here you go Baggy.

BAGNALL: (*Off.*) Ta.

(*ROC comes back in.*)

NORMAN: Snacker?! Snacker?! Where's the kid?!

ROC: Don't say nothing.

(*BAGNALL enters. He's down to his long johns. He is carrying a bottle of rum.*)

Is he gonna go in?

BAGNALL: In where?

ROC: Dunno. Isafjiord.

BAGNALL: We're blind now. We've lost the scanner.

NORMAN: Ohhh!

BAGNALL: What's the matter with him?

ROC: He's alright.

BAGNALL: Block of ice came off the upperworks.

NORMAN: (*Quiet but intense.*) Oh fuck!

(*NORMAN begins to rock.*)

BILL: What you doing down here Baggy? You gorr another bell yet?

BAGNALL: The old man has sent me down with this here bottle of rum.

(*ROC starts gathering the tot glasses and takes the bottle from BAGNALL.*)

BILL: We've had our rum, this watch.

BAGNALL: Don't want none then? The old man ain't having no-one on't whaleback. He ses he wouldn't wanna be doing that himself, quite rightly, and so he ain't got the heart to tell no-one else to do it. Any road, you can only work for so long, and then you gorra get yourself out of the way. There's a greener every couple of minutes. We weren't doing no good as it happens.

(*ROC distributes the tot glasses. They drink.*)

BILL: Sweethearts and wives. May they never meet. Ha, ha.

(*No-one laughs. It's an old joke.*)

BAGNALL: He's got Spud and Jimmy working the donkey hose on the boat deck. Trying to clear the rafts. They're about three foot under with ice.

ROC: Where's Snacker?

(*Pause.*)

BAGNALL: He went over the wall.

NORMAN: (*Quietly.*) Ohhhhhh!

ROC: He got washed over?

BAGNALL: Aye. It were a big un. I thought you'd have heard it.

ROC: We did.

NORMAN: Ohhhhh! I need a shit.

ROC: Go on then. Tek a shit.

(*NORMAN maintains a constant low moan.*)

BAGNALL: The old man ses if any of yer wanna go up there, the wheelhouse that is, he'll let you do ship to shore. I've rung Fleetwood.

BILL: Have you now?

BAGNALL: Aye, rang me father. Couple of bits of business.

ROC: Can you get to the wheelhouse?

BAGNALL: I wouldn't bother trying, like I say, unless you've got some business.

BILL: Is Daz alright?

BAGNALL: Yeah, thank God. He got across the foredeck using the line to the winches. Bill? D'yer wanna mek a link call?

BILL: Na. This int much. No need.

BAGNALL: Roc?

ROC: Yeah, er…I'd like to put a call through to Maureen.

BILL: Proposal. Ha, ha!

BAGNALL: Yer gerrin wed?

BILL: Maureen.

ROC: Yeah.

BAGNALL: Everyone's going mad to get married nowadays. I'll not say nothing, but you do know you're making a terrible mistake don't you?

ROC: Yeah.

(*Silence.*)

BAGNALL: What about you Norman?

BILL: Ha, ring yer mother?

NORMAN: Yer what?

BAGNALL: Do you wanna mek a link call?

(*NORMAN gets out of his bunk.*)

BILL: He'll wanna ring his mammy.

(*NORMAN smashes the butterflies that BILL has been making.*)

NORMAN: (*Screaming.*) No, no, no, no!

BILL: (*Stands and advances on NORMAN who backs away.*) Yer fucking scummy bastard!

(*ROC and BAGNALL leap out of their bunks. ROC gets between BILL and NORMAN and holds NORMAN off.*)

ROC: That's alright Bill!

BILL: D'yer see him? He smashed me butterflies!

ROC: Alright. He dint mean it!

BILL: Yes he fucking did mean it!

(*BAGNALL backs BILL back into his seat. ROC has a hold of NORMAN from behind. NORMAN is sobbing, and trying to hide it.*)

I'll fucking do you! Look at them!

(*The two are separated.*)

ROC: It's alright Norm. It's alright.

NORMAN: I need a shit.

ROC: Go on then!

(*NORMAN leaves to the drying room.*)

BAGNALL: You're gonna marry her then?

ROC: Yeah.

BILL: But Norman's fucked her. Ha, ha, ha.

BAGNALL: Tut! Kinnel! What is wrong with that kid?

BILL: Mebbe she's up the duff, have you thought of that? Ha, ha, ha.

ROC: She told me what happened. What he did to her.

(*A big sea hits. A loud bang. After a few moments it is clear that the ship is now listing.*)

BAGNALL: She's gorra list on.

ROC: Yeah. That's a list. Int it?

BILL: Na, na. She's coming back. Full ahead, come on!

(*They stand and will the ship to come back. BILL slips a hand under his pillow and finds his rosary beads. Enter NORMAN, with only his Bowie T-shirt on, ie: no underpants. He is carrying a fresh turd in his right hand. He is sobbing and shaking.*)

NORMAN: It's not as warm as I thought it'd be. It went cold real quick.

ROC: Jesus! Come on.

(*ROC leads NORMAN out to the drying room.*)

BAGNALL: He's not right upstairs is he?

BILL: Upstairs? Downstairs? Kaw!

BAGNALL: But Roc's gonna get wed?

BILL: Oh aye, ho, ho, ho.

BAGNALL: Be good for him. Norman's a terrible bad influence on that poor lad.

(*A big wave hits with a bang. BAGNALL and BILL grab on to the furniture.*)

Shit! Come on, full ahead, get her back! Full ahead, come on! For fuck's sake, full ahead, come on! She's going Bill, she's going!!

(The engine noise changes as she goes full ahead. She rights herself but with a list.)

BILL: That's it. That's right, there you go.

(The ship now has a significant list.)

See. Told yer. Aye, they're good sea ships these.

BAGNALL: That's a list. She's gorra list on.

BILL: It's onny the wind pushing her down.

(NORMAN and ROC enter. The turd has gone, and his hand is clean. ROC is leading NORMAN with an arm around his shoulder. NORMAN buries his head in ROC's chest. He is whimpering.)

BAGNALL: That's more than a fucking list. We're heeling over. We're going over Bill!

(BAGNALL heads for the companionway.)

(To ROC and NORMAN.) Come on!

(To BILL.) Next big un and we'll be over!

BILL: I'm gonna mek a start on these.

(NORMAN hangs onto ROC still sobbing. BAGNALL exits up the companionway.)

BAGNALL: *(Off.)* Rocco! Rocco!! Come on! She's heeling over! We're going over!

(They are caught in tableau for a few seconds. ROC holding NORMAN, still sobbing, to his chest. BILL sits and picks at his butterflies.)

(To black.)

The Arctic Kestrel

2002. The forecastle of the museum ship, the Arctic Kestrel. The bunk area and table is roped off from the public. The big girlie pin-up is now replaced by a poster of different kinds of fish. On the bulwark just inside the door is attached a cassette player wired to a speaker above. The tape is playing. It is the sound of a ship head to wind and dodging in a strong gale. A reprise of the James Joyce but the sound is much tinnier. It is obviously a loop tape.

Enter DARREL. DARREL is played by the actor who played CASSIDY in The Kingston Jet. He is carrying a museum dummy of a trawlerman. He comes down the companionway correctly, holding the dummy with one hand, feet into the rungs, and one hand on the rail. He does this slowly and carefully, because he has a smashed and rebuilt hip. He is now 54. He is dressed in a V-neck jumper and Terylene slacks, grey shoes, and a bland anorak. On his anorak is a badge declaring ARCTIC KESTREL – CURATOR. The dummy has been created especially to look like a young, 1960s deckie, ie: DA haircut, tattoos, dressed in a vest and Y-fronts. DARREL sits the dummy on the bench on the stage right side of the table. He studies him to see how authentic he looks. He takes out a packet of Silk Cut and puts a cigarette in the dummy's mouth.

DARREL: Champion.
> (*He puts one cig in his own mouth, thinks, and puts it back in the packet, and sighs. He opens a small, brown, buff envelope and takes out a cassette. He stops the loop tape cassette playing and replaces it with the new cassette. He presses play. The new cassette has the same head to wind and dodging sound as before, but has audio narration over. It is not DARREL's voice, but it is a strong Hull accent, and obviously an ex-trawlerman.*)

NARRATOR: 'You're now standing in the forecastle of the Arctic Kestrel and it's in 'ere under the whaleback –
> (*DARREL leaves up the companionway.*)

– where the crew's quarters was situated in the steam powered sidewinder trawlers which worked the distant water grounds of the arctic circle. Theirs were simple pleasures, cigarettes, cowboy novels, and o' course, story telling –

(*DARREL enters carrying a second dummy, which he positions on the bench.*)

Everybody had a tale to tell about Arthur Duggleby, Cassidy as he was known, you'lla seen his statue on dockside in front of the museum. Cassidy epitomised the spirit, bravery, and sense of humour of these hard worki–

(*DARREL switches off the tape. He arranges the second dummy and puts a cig in the dummy's mouth. Enter PAT, carrying a third dummy. PAT is played by the actor who played NORMAN in the James Joyce. He comes down with heels into the rungs facing forward. He is 29 years old, and small, about 5' 6". He has a hyperactive, fidgety manner. He wears casual clothes, cheap market stall copies of named brands. He has a pierced ear. He carries a bag, like a newspaper boy's bag, slung across his chest. DARREL stands.*)

DARREL: Hello?

PAT: Hiya. This is yours innit?

DARREL: Yeah.

PAT: There's some lads hanging about up there.

(*DARREL takes it off him and puts it into one of the bunks stage left. PAT gives himself a shot from an asthma inhaler.*)

DARREL: We're closed. How d'yer gerr on board? The gate's shut.

PAT: There's one more up on dockside. I'll gerrit in for yer while I'm at it, yeah?

DARREL: No, I'll go. Are you one of the lads what helped with the painting?

PAT: Yeah. D'yer wanna hand?

DARREL: No, that's last one.

(*DARREL exits up the companionway. Quickly, PAT goes beyond the rope, and feels the table, discovering that it is fixed, as he expected. Quickly, he takes out a battery operated nail gun from his bag. He places it carefully on a mattress in*)

*one of the bunks behind him. He goes into his bag again and
takes out a second nail gun. He puts it carefully on the bunk
next to the other one. He then gets back behind the public's
side of the museum rope. He is edgy, and looks around. He
puts his bag down against the bulwark. He presses the tape
and listens.*)

NARRATOR: – men. My favourite Cassidy story is the time
he was in Wilson's butchers shop when this old dear
comes in and buys a rabbit for her Christmas dinner and
Cass wan't having that so he bought her two turkeys, and
then the word goes up –

(*DARREL enters with the last dummy.*)

'Cass is buying turkeys' –

PAT: (*Simultaneously.*) Cass is buying turkeys!

NARRATOR: – and he spends all day in there buying
turkeys for anyone who pleads poverty. Ha, ha, ha, a
funny story, and –

(*DARREL turns the tape off. DARREL places the dummy in
one of the bunks downstage left.*)

DARREL: Couldn't see no-one.

PAT: Do you mind if I smoke?

DARREL: No smoking in here.

PAT: (*Pointing to a dummy.*) He's smoking.

DARREL: Huh. I'm locking up now.

(*PAT goes into his bag and hauls out a huge duty free box of
cigarettes. He takes a box of twenty out of the bigger box,
takes a cig for himself, but does not light it. He offers one to
DARREL.*)

(*Assertively.*) I said, it's no smoking in here son.

PAT: What school was that? The girls?

DARREL: Fifth form. Newlands High.

PAT: Me Uncle Ted ses that Hull is a divided city. East
Hull's Christian and West Hull's pagan. Do you think
any of them lasses were pagans?

DARREL: Why don't you go and ask them?

PAT: I'm already in a love triangle.

DARREL: We're closed.

PAT: I've bin round a mine museum near Donny wi school. Your missus took us round.

DARREL: You're one of hers are yer? Mally Lambert eh?

PAT: Was, aye. 'Two dogs' we used to call her.

DARREL: I won't ask. Come on. I'm off now.

PAT: Darrel Ascough.

DARREL: That's me name yeah.

PAT: Darrel. That's a lass's name in't it?

DARREL: Yes.

(*PAT holds out his hand to shake.*)

PAT: Pat. Or Ciggies Pat.

(*DARREL declines to shake hands, instead he bends down, with some difficulty because of his hip, and picks up PAT's bag.*)

DARREL: Here's yer bag, Pat. Offski.

PAT: Do you know how Adolf Hitler used to bend down?

DARREL: Do I know how Adolf Hitler used to bend down?

PAT: Yeah. He invented kinetic bending.

(*PAT drops his lighter on the floor. Then bends down kinetically and picks up the lighter.*)

Like that. Keep your back straight, bend yer legs. Meks you think dunnit. There was no need for the Third Reich he would've found immortality on the basis of kinetic bending alone.

DARREL: Is that what our lass taught you at school?

PAT: I liked her but she taught me nowt. This museum's crap an' all.

Everybody knows about Cassidy already, and all that fucking fishing stuff –

DARREL: – and what did you learn about coal mining?

PAT: You're not allowed to smoke.

DARREL: What do you want Pat?

PAT: Yer knew me dad.

DARREL: Oh aye. Shipmate?

PAT: Yeah. He's dead.

DARREL: He's one of them that died is he?

PAT: Yeah. Frank Rocco.

DARREL: You're Roc's lad then?

PAT: Yeah.

 (*PAT lights his cigarette.*)

 Why'd yer call him Roc?

DARREL: Rocco. Roc.

PAT: Right!

DARREL: I dint know he even had a son.

PAT: I'm a bastard – knoworrimean. My name's Sewell.

DARREL: I'm sorry son. A lot of them did die.

PAT: I don't know owt about Frank Rocco. Have you gorr
 an ash tray?

DARREL: Here. Sit down.

 (*DARREL waves him into the seating area. PAT takes a seat
 and uses the ash tray on the table.*)

PAT: Do you wanna ciggie?

DARREL: I'm giving up.

 (*He offers DARREL a cigarette. DARREL takes one. PAT
 lights it for him.*)

 Sorry I was a bit short with yer son, I didn't know you
 was Roc's lad. We get kids in here sometimes doing
 drugs, and that. Filthy buggers.

PAT: It's alright in here innit? Is it real or is it plaggy?

DARREL: Better not be plastic. Did me last trip in this.
 Bear Island. 1975.

PAT: Yer not bin fishing since?

DARREL: No. Ant worked neither, not till this. I went down
 the joke shop every Tuesday for twenty-five year but
 they never had no jobs. What do you expect? We don't
 even run our own country any more do we.

PAT: Me Uncle Ted ses you all got thousands in
 compensation.

DARREL: I 'ant had a penny yet. I might tell 'em I'm a
 farmer. Gerra million quid next day then don't yer.

PAT: You sound bitter.

DARREL: Two pints of bitter.

PAT: (*Laughs. Beat.*) What were he like?

DARREL: Roc? He was a real big man.

PAT: Big hearted eh?

DARREL: He was that yeah, but he was six foot four an' all.

(*PAT takes a packet of 20 Silk Cuts out of his bag and gives them to DARREL.*)

PAT: Tek 'em. Ciggies Pat. This is my vocation. I import ciggies.

DARREL: A smuggler eh?

PAT: Call it an introductory offer. Welcome to my world.

DARREL: No obligation?

PAT: No obligation. Me Uncle Ted ses this Frank Rocco, Roc, got in the raft.

DARREL: Yeah. Me, Roc, and Norman Bamforth.

PAT: This Norman Bamforth, he died straight away, yeah. Me dad lived for four or five hours, yeah? And you lived for another three days?

DARREL: I'm still alive.

(*Pause.*)

PAT: Have you ever purchased cigarettes on the grey market before?

(*PAT takes out his mobile phone and starts entering data.*)

DARREL: Yeah, big girl, goes in Rayners, ring in her nose.

PAT: Stella. She's had ear grommets fitted. Difference between me and Stella is that I can hear what you say. She's off to Bolton Art College an' all. Does sculptures out of lard. Melinda Messenger, Frankie Detori, Jesus Christ. She puts them on show under lights and they melt. It's a metaphor innit.

DARREL: Our lass wants me to give up fags.

PAT: How d'yer get off with her? I mean, she's poshish in't she, a teacher, and you, well, no offence but you're dead Hessle Road, aren't yer?

DARREL: Marfleet's ships was all named after writers. The Jane Austen, The George Elliot, The Charles Dickens. I always made a point of reading whoever I was sailing in. Aye, I enjoyed 'em all, except for one bad winter in the Virginia Woolf. When it all finished, I did nowt for ten years cept get divorced. Then I went to a night class – 'Irish literature'. I'd done four years on the James Joyce, so I was kinda on a different level straight away. Our lass was running the group.

(*Beat.*) What's your mother's name? Remind me.

PAT: Maureen.

DARREL: Ah yes, Maureen. I have a shot of rum about this time. Alright?

PAT: Sweet.

(*DARREL stands, PAT stands to protect the nail guns from view.*)

I'll get it. In here?

DARREL: Yeah.

(*PAT opens the locker and takes out a quart of red rum and two tot glasses. He gives it to DARREL. They sit down and DARREL pours, and PAT takes another shot of his asthma inhaler.*)

This was all a long time ago Pat, I mean, why are you...

PAT: Me mam's shagging this bloke on the Gower peninsula. He's got a JCB. She's easily impressed. She left me dad this week and has gone to live in Wales. Me Uncle Ted come round, her brother. He tells me all this about this Frank Rocco. I think I believe him. He's an AA man.

DARREL: These things...yer mam, Maureen...what...what did she have to say about Roc and Norman, and that time?

PAT: She were courting Roc, and then his ship sank. I've never thought me dad was me dad. Psychologically, in my opinion, he's a mental cretin. So genetically, you know...unlikely.

DARREL: Roc was six foot four.

PAT: What'yer saying?

DARREL: Nowt.

PAT: Me Uncle Ted ses you survived cos you had dry clothes on.

DARREL: I was wearing a survival suit over dry clothes.

PAT: Me Uncle Ted –

DARREL: Has this uncle Ted of yours ever been to sea?

PAT: No. He was with National Breakdown for ten years, and then the RAC for a month. They sacked him for tekking money for fan belts.

(*Beat.*) He ses that Frank Rocco and this mate of his were naked in the raft.

DARREL: Yeah, they were.

PAT: Why didn't you, like, take off some of your dry clothes...off, and you know, share them out?

DARREL: Because then, I would have died.

(*Silence. PAT stands and walks around. He takes his mobile phone out.*)

PAT: Phone number, brand preference, second choice – never needed, don't worry about that.

DARREL: 5 0 9 7 11. Silk Cut.

PAT: 0 1 4 8 2 – 5 0 9 7 11. Silk Cut.

(*DARREL pours himself another drink.*)

DARREL: I couldn't go in pubs for a long time after that. I thought I knew what people were thinking. 'That's Darrel Ascough, he was in the raft when Roc and Norman died, and he didn't die, and there's gorra be summat dodgy about that, an't there?' The lads at sea, they understand. But it's all the rest of Hull innit, the know it alls, them who get seasick on Picky Park boating lake. AA men. How I let them die and did nowt. Pat, trust me, Roc and Norman, they went fishing, distant water, and they din't come back, and there in't nowt original about that. (*Beat.*) Did yer see that plaque on the dock side? Tother side of the Cassidy statue. There's more than enough names up there.

PAT: I'm in a rock band. I play the computer. The band's called 'Cassidy'. Our Stevie, plays the drums. Cass is the only good thing that's ever come out of Hull. William Wilberforce – I'm not black am I, it don't move me; Amy Johnson – a woman; the Housemartins – students, communists, and not from Hull. But Cassidy, well, it's like if you're born in Nottingham it's gonna have to be Robin Hood in't it. I like the Cassidy war stories.

DARREL: Huh. Mekking the firing squad laugh?

PAT: Yeah. Tied up against a barrel, and they let him off, cos he could blow fag smoke through his ears. Do you think that's true?

DARREL: He could do it.

PAT: Yer knew him?!

DARREL: Yeah.

PAT: Cool. I'm impressed.

(*Beat.*) I'm twennie-nine and I've never seen a dead body. Cept on telly. What's it like?

DARREL: I kept expecting them to sit up and say summat.

PAT: Three days. With two naked, dead bodies.

DARREL: Aye, it weren't pleasant.

PAT: Someone's bought Napoleon's cock and balls you know. They're pickled. A hundred and forty thousand pounds.

(*Beat.*) Nicotine patches are cheaper in Belgium – d'yer want me to get yer a couple of hundred?

DARREL: Alright. Do you go to Belgium a lot?

PAT: Once a week. Big Fat Dave's. Did you know that the most popular hand rolling tobacco in Britain's prisons in 1999 was Drum? And it didn't even have a licence for sale until the year 2000.

DARREL: You're making money then?

PAT: I still sign on. Everyone's doing it you see. Lorry drivers, any old scab. Kurds, Albanians, street selling. Fucks me off that does.

(*Indicating the dummies.*) They should be playing cards.

DARREL: Aye, we played a lot of canasta.

(*PAT takes out a pack of cards from his bag. Shuffles them and offers them to DARREL.*)

PAT: Quick trick. Pick a card.

DARREL: Come on son, I've gorra go home now.

PAT: Pick a card. Look at it, and remember it.

(*DARREL takes a card and looks at it.*)

Now purr it face down on the table and put yer hand flat on top. I'm gonna suck the information up through yer hand.

(*PAT places his hand on top of DARREL's.*)

Relax. I'm not gonna get me knob out. We live in an information age Daz. This is one of our kid's tricks. Eh, up, I can feel it, summat's happening. Queen of Hearts!

(*DARREL turns the card over it's the Queen of Hearts.*)

DARREL: (*Genuinely impressed.*) Ha! Brilliant! That was good! How d'yer do that then?

PAT: Magic.

DARREL: That was very good.

PAT: Ta.

(*PAT shuffles the cards.*)

I don't know what he looked like, this Frank Rocco, me dad. Mediterranean they say.

DARREL: Roc wan't unlike him, but much bigger. Norman was...

PAT: – Fuck Norman. Bit like him then?

DARREL: Wa...a bit. But you know, I mean, it's nothing like him either really.

PAT: (*Frustrated.*) Tut! Fuck!

DARREL: If you go in the drying room there's –

PAT: – I'm sorry, man! I'm out of order! Scary.

(*PAT takes a swig of rum straight from the bottle. PAT stands and paces.*)

DARREL: I'd berrer get back. Our lass'll be home now.

PAT: Got another trick.

DARREL: It's gone five Pat.

(*PAT still standing, picks up the cards. During the next PAT is standing.*)

PAT: Choose another card. Last one, it's afuckingmazing this one. You seen Penn and Teller? Nowt! This is another one of our Stevie's.

DARREL: Last one.

(*DARREL takes a card.*)

PAT: Look at it, remember it, and put it under the thumb of your left hand, on the table, that's right. Spread your hand out.

(*DARREL does as he says.*)

Now, tek another card. Under your other thumb. Good. Did you remember them?

(*DARREL does the same with the second card.*)

DARREL: Yeah.

PAT: It's called the cold thumb trick this. Always works, it can't be explained. Now, shut yer eyes.

DARREL: Oh fucking hell.

PAT: Dunt work otherwise! It won't tek a sec.

DARREL: (*Resignedly.*) Shut me eyes.

(*DARREL shuts his eyes.*)

PAT: Right, keep them shut. Shut tight. Alright?

(*PAT stands carefully, trying not to make a noise, swings around and reaches into the bunks, carefully picking up the two nail guns.*)

Can you feel the temperature changing, on the skin of yer hands?

DARREL: No. There's nowt happening.

(*PAT is now standing before the table, hiding the guns behind his back.*)

PAT: OK keep yer eyes closed. Now tell me what yer cards were. I'm gonna swap them over.

(*During the next PAT lowers the heads of the nail guns onto the webbing between Darrel's thumbs and fingers.*)

DARREL: Nine of diamonds under the left and King of Spades.

PAT: Nine of diamonds and King of Spades. Remember keep yer eyes closed. Is it gerrin colder?

DARREL: Ha, I can feel something, now, bloody hell –

PAT: Keep your eyes shut, it's working!

DARREL: It's gone cold! It's like –

(*PAT fires the nail guns simultaneously. Nails are driven through both of Darrel's hands into the table. DARREL stands and screams.*)

Aaaaaaaaagggggghh! Agh! Agh!

PAT: (*Interspersed by Darrel's moaning.*) Oh fuck it worked! Jesus, bloody hell!

Alright, alright!

Shutup will yer!

Yer not gonna die!

(*PAT backs off still holding the guns, slightly amazed that it has worked so smoothly. PAT rushes up the companionway and closes the door at the top. He leaves the nail guns on the table. He snatches the rum, and swigs it. He paces. He gives himself a shot of asthma inhaler. DARREL continues to give*

voice to the pain. PAT is also extremely agitated, and nervous.
DARREL screams, stands, moans, and groans, but is helpless
to do anything. The following speech is spread over this period.)
Shutup!
Shutup will yer!
For fuck's sake.
It's not a main vein there you know.
Jesus. Knock it on the head will yer.
If you'd stay still, and stop riving about, it wouldn't hurt
so much. I mean, that's the fucking idea any road innit.
You're supposed to be a bloody hard case.
Big hairy arsed deckie.
Jesus, look at yer.
Like a fucking kid.
That's a clean shot that one. Pair of clean shots. You're
lucky.

DARREL: (*A quiet moan.*) Ohhhhhh. Jesus!

PAT: All them Roman bicycle thieves, shop lifters and sons
of Gods woulda bin nailed through the arm above the
wrist. You see, there's no cross bones in the hand is
there? You'd just fall off yer perch.

DARREL: Get a doctor!

PAT: You'll get used to it in a minute.

DARREL: I will never get used to this!

PAT: You're talking already. Mekking sense.

DARREL: Come on son. It's fucking killing me this!

PAT: Fost off, yer go white, yeah, you've gone a bit white,
good, and if you don't faint at that point then you're
alright.

DARREL: Gerr an ambulance! Jesus Christ! Aaaaagh. Jesus!

PAT: Yer not gonna die!
(*PAT goes in his bag and takes out a pair of safety glasses. He*
puts them on.)

PAT: Shoulda bin wearing these. I've ruined your table.
Mmm. Our Stevie'll bite a bird's arse just to start a fight.
He never does it on a Thursday night cos he goes to his
night class. Pet care. Hull's top of the violent crime
league you know. Champeeeyons! One person can mek a
difference. Cantona.

DARREL: Ring an ambulance son, come on!

(*PAT shows DARREL a photo.*)

PAT: If I was running this country I'd mek it illegal to tattoo anyone above the neck. You don't see many Kurds selling tabs any more. That's our Stevie. Muscle. But he's been banged up again. He's gonna get the tabs organised on the inside. If I can supply Full Sutton, Hull and Armley with Drum and Samson, I'll be well made up. He said he's gonna take the business off me when he comes out if I don't shape up.

DARREL: I've got nowt to do with your bloody business!

PAT: (*Manic.*) Fucking Kurds! Why does Hull gerrem?! We gorra lorra shit housing they can have. They've all got cars, mobile phones, money for clubbing. Hard-ons while they're dancing. Never seen a pair of tits before. All their women are bagged up all the time.

Mecca is nowt burra distant memory. Hull, this is paradise. Has the pain worn off yet?

DARREL: Don't be fucking stupid!

PAT: Now if the Kurds were to send us a boat load of their best talent, six hundred single girls, that'd be different! But Hull would never get them, oh no. Islington.

DARREL: What do you want son?

(*Pause.*)

PAT: Eddie Stobbart fell off a roof when he was ten, woke up with a stutter. Problem. On the phone people used to offer him big, difficult, haulage contracts, but he only had one lorry, but because of his stutter he couldn't quibble, he'd just say 'N...n...n... OK!' A problem turns into an opportunity. My problem, Stevie's inside. Opportunity to show that I can look after myself, not be fucked around.

DARREL: I've got nowt to do with your ciggies!

PAT: You killed my father!

DARREL: It wan't like that son!

PAT: (*Manic.*) Don't fucking patronise me! I want some respect here.

This place, that's what it's about isn't it, about how we're shit, and you're I dunno...men...brave, and we're...ah forget it!

(*DARREL continues moaning. PAT takes a shot of rum.*)

I don't do puff, speed, crack, H, nowt. I'm clean. I'm off the Ritalin. At school I was ADD which ain't as bad as ADHD. I never sniffed glue. I bought the glue cheap, and I sold it expensive. I'm an entrepreneur.

DARREL: Everyone gets a fair crack of the whip with me son!

(*Beat.*) There's gonna be a lot of people about soon. There's two new ships coming in on the tide. Big stern freezers. And our lass is expecting me home.

PAT: I'll ring her.

(*He looks at his mobile.*)

No reception.

(*PAT exits up the companionway. During the next DARREL stands and tries to prise the nails out with his teeth. He fails. He gets blood on his mouth. Pat's footsteps can be heard on the whaleback but not his voice. After a while PAT returns.*)

(*Singing.*) Like chicken tonight, like chicken tonight! Guess what's for tea Daz.

(*Singing and doing a chicken impression.*) Like chicken tonight, like chicken tonight. She said she'd keep it warm for yer. Like chicken tonight! Go on! Guess what's for tea!

DARREL: Stop fucking about will yer!

PAT: Guess what's for tea!!

(*PAT picks up a nail gun.*)

DARREL: Chicken.

PAT: You've got blood on yer mouth Daz.

(*PAT puts the nail gun down. PAT paces.*)

DARREL: I tried to pull the nails out. I've got false teeth.

PAT: I liked old two dogs. Big tits. I respect women. You godda nowadays ant yer, or you'd never get yer leg over. Catherine, she's a blonde, works for Reckitts, she's a chargehand on the Mr Sheen line. She's six foot two. I told her that I'd definitely marry her if she got herself

shortened. They take two inches off each leg. Private operation. Estonia. Melanie. She used to work in Hull parks and gardens, but then she shagged the Lord Mayor and now she works indoors in his office. Yup, she's a mayor fucker. You wimme?

DARREL: I'm listening.

PAT: Emma works on one of them big pig farms near Withernsea. She dunt have any person to person contact with the pigs, she's more on the Public Relations side. She eats too many pork chops for my liking. Whadyerthink about marriage?

DARREL: Family's all there is. I should know. I've got two of them.

PAT: (*Laughing.*) See, you're cracking jokes now.

DARREL: Are you gonna kill me?

(*PAT sits opposite DARREL.*)

PAT: I might have to. I'm having a difficult week. Me Uncle Ted ses you killed my father, and you've been lying about it for thirty years. The truth, that's all I want. Why were they naked?

DARREL: Norman and Roc, they were below…when it heeled over. I was on deck. You don't wear deck gear below.

PAT: (*Pointing to a dummy in vest and underpants.*) He's below. He's got clothes on.

DARREL: He wouldn't be wearing that much.

PAT: This museum's not realistic then is it?! Like I said crap!

DARREL: They took their wet gear off in the raft. Wet gear's worse than nowt at all. Norman doesn't last long, ten, fifteen minutes mebbe. He was as good as dead in the water.

PAT: I couldn't give a monkey's toss about Norman.

DARREL: Roc isn't so bad but after a couple of hours he starts mumbling. That's when you know they're going.

PAT: What did he talk about?

DARREL: It's just mumble, nothing, he –

PAT: (*Shouting.*) – I never spoke to my father, there was never a word between us, but he spoke to you! Now! I've treated you with respect haven't I Darrel? Eh? So far?!

DARREL: You've nailed my hands to the table.

PAT: Alright, apart from that! I've been reasonable with you haven't I?

DARREL: Yes.

PAT: So, just fucking tell me what he said! Alright?!
(*PAT bangs his fist on the table.*)

DARREL: Agh! Don't bang the table, please!

PAT: Shit, sorry!

DARREL: They mumble! It never meks sense. He mumbled and held on to Norman, and talked to him!

PAT: Norman's dead you lying twat!

DARREL: Roc held him. And talked to him. They was good mates, yer godda remember that.

PAT: Were they – you're telling me they were queers aren't yer?

DARREL: Oh for fuck's sake! They were kids! Younger than you, they were mates, they were dying together. What's the matter with you?!
(*PAT stands, and paces.*)

PAT: I have no respect for you, or your mates. What you learn going round these crappy museums is that you didn't have to think. You left school, went to sea, no thinking. No decision making.

DARREL: No son, you're wrong, you've got –

PAT: Cold, long hours on deck?! Fucking bollocks. You had it on a plate pal. No thinking, no decisions, no…no… thinking, there it is again! It's a definite theme in this situation. The almost total absence of thinking, thought. Eh?

DARREL: There was no choice, you…

PAT: That's my fucking point!
(*PAT bangs the table deliberately. DARREL groans.*)
That's mental work Darrel.

DARREL: Agh!

PAT: Brain fucking work. I'm alright, me, now sorted out. I
 mean I can stand up in any pub, I'm Ciggies Pat, but
 …agh, you, you don't know you're fucking born!

DARREL: No, no, no, you got it wrong son, you –

PAT: I'm buzzing! I've gorra pulse in me eyes. Do you ever
 gerr a pulse in yer eyes?

DARREL: No.

PAT: It's bang bang bang in there.
 (*Beat.*) My blood sugar's dropping an'all. You got any
 biscuits? Fig rolls?

DARREL: Sorry.

PAT: (*Manic.*) Me Uncle Ted he teks the piss, knoworrimean,
 cos I'm small, physically small. He's bin winding me up.
 He was saying how I was fucked now that Stevie's going
 inside. Last week, in our house there's me, Stevie, me
 mam, me dad, our Jenny. Jenny's gone off permanent
 with me dad, sorry, me step dad, up Orchard Park with
 his new sex option. I dunno what's happening. Just me
 now. I mean I was gerrin sick of 'em all rowing and that,
 and I was gonna move out anyhow, but…fuck, I dunno.
 (*Beat, then desperate.*) My dad bollock naked, on one side
 of the raft, and you all zipped up and toasty warm! Isn't
 there something fucking disgusting about that! You
 didn't do owt did you?! You sat there and you watched
 him die!

DARREL: Yes!

PAT: How does torture work? I mean, how do I know
 you're telling the truth?

DARREL: You don't.

PAT: Why didn't Roc have a survival suit?

DARREL: They wan't standard issue. Health and Safety
 hadn't been invented back then.

PAT: How come you had one then?

DARREL: Me dad give it me.

PAT: I've given mesen an headache. Have you got any
 paracetamol?

DARREL: No. Have a drink.
 (*PAT takes a swig.*)

PAT: What would Cassidy have done? What would Cass have done in your situation?!

DARREL: I dunno! I dunno!

PAT: Have you got mates?

DARREL: Yeah.

PAT: I'm gonna have to kill yer then aren't I.

DARREL: There's a photograph in the drying room, I want you to look at, in there. There's one labelled the James Joyce. Everyone sitting round the table, smiling.

PAT: What? The trip you sank.

DARREL: Don't be daft. Go on, have a look.

(*PAT stands and goes in the drying room.*)

(*Raised voice.*) You got it?

PAT: (*Off.*) James Joyce?! Yeah.

DARREL: (*Raised voice.*) Roc's in the middle of the picture.

PAT: (*Off.*) Someone's got him in an 'eadlock?!

DARREL: (*Raised voice.*) Yeah, that's the one.

(*Pause.*)

PAT: (*Off, quietly.*) Who is that?

DARREL: (*Raised voice.*) You what?

PAT: (*Off.*) Who's giving 'im the 'eadlock?

DARREL: (*Raised voice.*) Norman Bamforth.

(*PAT returns holding the picture in his hand, looking at it intently.*)

I think they both had a thing with your mother, but Maureen didn't like Norman over much. I liked Norman. You alright Pat? I say, I liked Norman a lot. He was good fun. Bit of a bad lad, but relatively harmless.

(*PAT returns to the drying room. He is heard to smash the picture.*)

Pat!

(*PAT enters and goes straight up the companionway and out.*)

Pat! Pat! You can't leave me here like this! Pat! Oh Jesus! PAT!!

(*Silence.*

Enter PAT. He stands near DARREL.)

PAT: I've rung Infirmary. I said there'd been an accident.

DARREL: Good lad. You alright?

PAT: Dunno.

DARREL: Gimme a shot of that rum.

(*PAT sits and feeds him a drink.*)

PAT: I want to make an official apology. I've been badly advised. Me Uncle Ted. He was a prefab baby. He's a bit chippy. Born in a prefab, still lives in a prefab, you know.

DARREL: It can twist yer mind.

PAT: They offered him a house but, you know what they're like…

DARREL: They're a breed apart.

PAT: Yeah, me mam ses me Uncle Ted could never get a girl. There'd always be a deckie throwing his money about. Easy to pull was it?

DARREL: Oh aye. Millionaires for a day we were. Three weeks away and three days home. We had summat about us. We'd been out there, and we'd come back. But he's not got a bad job your Uncle Ted. In my experience everyone's always pleased to see an AA man.

PAT: That's how he met me Auntie Barb. Half way down Sully Way she was, when the sub-frame on her Triumph Toledo snapped in half.

DARREL: If some welder, one day, in Coventry had done a better job, they'd never of met.

PAT: Yeah.

(*Beat.*) How do you know, I mean, how does anyone ever know what is the right thing to do?

DARREL: At sea there's rules for everything. You're right, I didn't have to think much.

PAT: Have I lost your respect?

DARREL: Come on Pat I…

PAT: I'm disgusted with myself.

DARREL: I…

PAT: Have I lost your respect?

DARREL: It's not a case of…

(*PAT puts his head in his hands.*)

PAT: I'm gonna get Stevie out of my life. I'm gonna be a pacifist from now on. I've always been against the death penalty, unless it's for something really serious. I'll stop

wearing leather. No animal products. Vegetarian. I'm me! I'm gonna be me from now on! They're our Stevie's nail guns. He does pub decks. He nailed this smackhead to a table once. The kid hardly batted an eyelid. Pain killer innit, heroin. He's been trying to nick Stevie's tools.

DARREL: You can't shut a window round here without trapping someone's fingers.

PAT: But you're coping better than I did. I passed out. (*PAT shows him the scars on his webbing.*) I forgot to feed his iguana.

DARREL: Yeah?

PAT: What do you think Cassidy would have done?

DARREL: He'd have swam to Norway towing the raft behind him. Dunno.

PAT: Can we talk about your mates?

DARREL: Don't worry about it. Just ring an ambulance and…

PAT: It's on its way. I'm gonna go now.

DARREL: Do you wanna know what my favourite Cassidy story is?

PAT: I've heard 'em all.

DARREL: No you an't.
The trip he died I was the Snacker, and before we sailed he'd told me he had summat in a tin in his house. Summat he wanted me to have on account of me being his only son.

PAT: Well why didn't you say! Bloody hell. You're Cass's son!? Bloody hell!

DARREL: You know he died that trip, the only one to die –

PAT: Yeah, yeah, he jumped out the raft and swam back to rescue Jip, his lucky dog.

DARREL: No, no, no. He'd killed Jip in Criterion *before* the trip. He swam back for no good reason. Come down here I guess. Had a lie down. They're not unlike coffins, are they.

PAT: Suicide?

DARREL: Yeah. I went round his house when we got back. There was no-one there. The next door neighbour said they'd taken his lass off to De La Pole.

PAT: The loony bin?

DARREL: Yeah. The neighbour let me in. I took the tin and left. I opened it up when I got home. There was his war medals, and a betting slip. A treble. Jackson's Daughter, Before Thunder, and Big Horse. All ticked.

PAT: Winners.

DARREL: Yeah. There was a map on the back of the ticket, like a treasure island map.

(*PAT gives him a drink of rum.*)

PAT: Here.

DARREL: There was a cross in a double circle, like a doughnut, and next to the cross a little bridge type drawing. The words 'Newbald' and 'Golf'. I know Newbald, it's a village near Beverley, and there's a golf course there.

(*The sound of a ship's horn at a distance. DARREL hears it but PAT is oblivious to it.*)

I bought a two and half inch Ordnance Survey map, and it was there, the little bridge thing, a stile. Yeah, they're dead good them big OS maps. If a cow stands still for long enough they'll draw it in. I got the first bus to Beverley.

PAT: Did you gerron the bus with a spade?

DARREL: I bought one when I got there. I found the stile easy enough. The doughnut thing's a circle of bramble briars with a clearing in the middle.

PAT: You hacked your way in. I'm there Daz, I'm with yer.

DARREL: Once inside it's terrible quiet, you know, cos I'm surrounded, no traffic noise, and the only way I can look is up at the sky, and there's a skylark, and it's watching me. And I dig. And I'm scared cos my ear is twitching which is this fear thing I have.

PAT: Did you find owt?

DARREL: Yeah. A trawlerman's oil frock – rolled up. I know there's summat inside but I can't look. I puke up.

PAT: A body?

DARREL: The police identified them as twin boys.

PAT: 'Kinnel!

DARREL: Killed, and buried on the day they were born.

PAT: Bloody hell. How do they know that?

DARREL: Shape of their heads. They get squeezed don't they, babies, on the way out, and then their heads go back into shape, well these poor little buggers dint gerra chance. He must've midwifed them himself. I can't bring mesen to think about it.

PAT: Why'd he kill them?

DARREL: Cos they were boys. Cassidy had three daughters. He let them live. His father had died at sea.

PAT: I knew that.

DARREL: And his grandfather, and his grandfather's father.

PAT: You didn't die at sea.

DARREL: I should've. I was gonna.

PAT: That is one big fuck off 'orrible story Daz. Who knows about that then?

DARREL: You and me.

PAT: Why did you tell me? You didn't have to.

DARREL: I thought it might help.

PAT: Did you get your money? You know, the betting slip.

DARREL: Yeah, two hundred and sixty. He hadn't paid the tax.

PAT: If I was a copper I'd wanna know what you were doing in a bramble bush with a spade.

DARREL: Nicking bluebells.

PAT: Cool.

(*A ship's horn, frighteningly near and loud. PAT stands, frightened.*)

Wassat?

DARREL: There's two brand new stern trawlers coming in. What's the time?

PAT: (*Looking at his watch.*) Nearly six.

DARREL: Yeah, that's the tide.

(*The horn's sound again, loud and close. Footsteps on the whaleback. PAT stands, now getting edgy. PAT is listening to the footsteps now and not to DARREL.*)

PAT: Who's that?

ELLY: (*Off and faint.*) Dad! Dad!

PAT: Who's that?

(*PAT puts the nail guns away in his sling bag.*)

DARREL: Our Elly.

PAT: Your daughter?

DARREL: Yeah.

PAT: Fuck!

(*PAT takes a towel and wipes up the blood from the table and finds another towel and covers DARREL's hands with it.*) What you doing? With your hands? Fuck. Help me, will yer?

DARREL: A card trick.

PAT: Course.

(*PAT takes the pack of cards. He sticks the Ace of Clubs on Darrel's forehead. Enter ELLY climbing down the companionway correctly. She is a girl of about 9. She wears a casual top with a large FCUK logo on it. She's carrying a key on a big lump of wood, which she puts on the table. She stands and looks at the the two men sitting stiffly with cards on their foreheads. An ambulance siren sounds, getting nearer during the next.*)

ELLY: Dad?

DARREL: Hiya Elly.

ELLY: What you doing?

DARREL: Card tricks. This is a friend of mine Pat.

ELLY: Hiya.

PAT: Hi.

DARREL: What you doing here love?

ELLY: Mam sent me to get yer.

DARREL: I thought I'd stay and see these ships in.

ELLY: They've come through lock already.

DARREL: Have they?

ELLY: (*To PAT.*) Are you a magician?

DARREL: His brother is.

PAT: Would you like to be a magician?

ELLY: No. I'm gonna be a trawler skipper.

PAT: Oooh!

DARREL: Have yer got a new top Elly?

ELLY: Yeah.

DARREL: Very nice. Where d'yer get it?

ELLY: (*Looking at the logo on the top.*) Next.

(*PAT laughs.*)

DARREL: Alright, alright.

ELLY: Mam ses you've gorra come now. She's gonna have a right chow at yer you know.

PAT: I'm off.

DARREL: Go on then. I'll be alright. Go on, fuck off.

ELLY: Dad!

DARREL: Don't tell yer mam.

(*To PAT.*) Elly'll stay with me.

(*PAT exits quickly. ELLY sits where PAT had been sitting.*)

ELLY: Have you been drinking?

DARREL: Yeah, we've been drinking, talking, you know, about your grandad, and that.

ELLY: Grandad's statue, he's gorra fish in one hand, and summat else, I can't work out, in the other.

DARREL: A firework.

ELLY: What's he got a firework for?

DARREL: Your grandad was famous for...you see, back in the old days, they used to light fireworks, you know, at night, to attract the er...haddock.

(*An ambulance siren is heard. DARREL turns his head. The siren is 'under' during the next.*)

ELLY: Have you got a card under the towel then?

DARREL: Yeah, two. Ace of Clubs and...

(*Pause.*)

ELLY: No! The ace of clubs is on your forehead.

DARREL: Is it? Bloody hell, he's done it! That's the trick! Well, half of it. So, er...only one to go then.

ELLY: He's gone with his card.

(*PAT enters. He puts a business card in DARREL's pocket.*)

PAT: Ciggies.

ELLY: He's giving up.

(*PAT gives his playing card to ELLY.*)

PAT: Don't look at it. Lick it and stick it on yer head.

(*ELLY does as he says.*)

If you're gonna play this game properly, you can't move
the towel, alright?

ELLY: Alright.

PAT: I'm not gonna change the name of the band.

DARREL: Tell your Uncle Ted from me, he's a bit of a twat.

PAT: Yeah. See ya.

(*PAT leaves.*)

ELLY: What's my card dad?

DARREL: I'm not supposed to tell you.

(*Pause.*)

ELLY: Come on dad, let's go and see the ships.

DARREL: There'll be plenty of time to see the ships.

(*She does so, and sits down opposite him. He looks at her
directly.*)

ELLY: There's a card under the towel, yeah?

DARREL: At the moment yeah. The Jack of Hearts. (*Or
whatever card is on her head.*)
We wait you see, it's a matter of patience, and er…at
some point the card on your head will change into the
Jack of Hearts, you won't know but I'm watching. And
then er…that's it.

ELLY: That's impossible.

DARREL: (*Matter of fact.*) It's a rigged pack innit.

(*The siren sounds close and stops. DARREL turns his head to
listen.*
Silence.
*The ships horns sound very close. ELLY turns her head to
listen. DARREL looks at her as she looks towards the sirens.*)

(*To black and the End.*)

Distant Water Trawling Glossary

Distant Water the Arctic fishing grounds

Sidewinder the type of trawler which shot and hauled the trawl over the starboard side; usually between 600 tons (gross) and 800 tons (gross) and about 170 foot long; crew of twenty; three week trips, three days at home

Shackles meat stew

Whaleback the curved deck at the bow

Forecastle crew's quarters

Knocking out the blocks separating the two warps ready for hauling

Dodging keeping head to wind in bad weather

The Old Man the skipper (could be as young as twenty-two)

Snacker deckie learner / apprentice trawlerman

Third Hand senior deckhand

Deckie spare hand / deckhand

Rayners trawlerman's favourite pub on Hessle Road

Criterion second favourite pub on Hessle Road, also known as 'Cri'

Lollipop newsagents with a wide selection of top-shelf titles

Sham Four two up, two down house

Greener big wave

Donkey Hose powered water hose

THE GOD BOTHERERS

Let us stop murdering one another. The earth is not a lair, neither is it a prison. The earth is a Paradise, the only one we will ever know.

Henry Miller, *The Air Conditioned Nightmare*

Characters

KEITH
forty-five

IBRAHIMA
twenty-three

LAURA
twenty-four

MONDAY
twenty-five

HARSHA
twenty-five

The God Botherers was first performed at The Bush Theatre, London on 21 November 2003 with the following cast:

KEITH, Roderick Smith

LAURA, Georgia Mackenzie

IBRAHIMA / HARSHA, Sunetra Sarker

MONDAY, David Oyelowo

Director, William Kerley

Designer, Bob Bailey

Lighting Designer, Tanya Burns

Sound Designer, Mike Winship

Deputy Stage Manager, Lorna Seymour

April

Somewhere in the developing world. The sound of cicadas. The back yard of a Non Governmental Organisation HQ bungalow. It is early evening and the light is beginning to fade. KEITH is listening to The Clash on his headphones and smoking a joint. He is a man of about 45 wearing shorts and a beach shirt. A muazzin calls the faithful to prayer. Enter IBRAHIMA. She is wearing a full black burqa with a netted over-eye slit and no flesh showing. She stops before him. He turns his walkman off.

Pause.

KEITH: You look different.
 (*Pause.*)
 The shoes?
 (*IBRAHIMA lifts the burqa to just above the ankle, revealing tarty, gold, strappy high heels. She circles him sensuously, brushing the burqa against him. Then she walks into the bungalow. He takes a swig of beer, stands, and follows her. Enter LAURA. She is 24 years old, dressed in GAP fatigues and a Moby T-shirt bearing the slogan* EVERYTHING IS WRONG. *On the back the T-shirt has a list of everything that is wrong – environmental pollution etc. A Gucci hijab covers her head. She is carrying a large travel bag and smaller rucksack bag with a copy of Cosmopolitan magazine sticking out the back.*)

LAURA: (*Out front.*) Dear Pip, I am here! I am fucking here! Everything is just, like, epic. I am in Tambia or is it 'The' Tambia. Who cares if I'm in the wrong country, I am definitely, definitely not in Burton Latimer. It feels weird writing a letter. I'm gonna die without email. I need my fix! I was stuck in Lakpat for three weeks. Pukesville! Every NGO in, like, the whole world is hanging out in Lakpat, it's just like Uni – 'Shagging *sans frontières.*' The place is infested with natural blondes, uuuughhh, bastard Scandinavian girls, with their long legs and their long naturally blonde hair, and they are all so fucking tedious, and naturally blonde. Agh!!! Kill, kill, kill! Met a real cute human rights campaigner from

New Zealand, half-Indian guy, really pretty. He's
married. Oh Pip, what is it with me? I'll tell you all
about him when I see you. I'm Mad! PS Can you send
me this week's copy of *Heat*, the one where Nicole
Kidman's stuck in a portaloo. My name's Laura and I'm
a *Heat*aholic. Please write babe!

(*Enter IBRAHIMA. She is walking swiftly but pauses before
LAURA.*)

(*To IBRAHIMA.*) Allahu Akhbar

(*IBRAHIMA giggles and walks off.*)

Fuck!

(*Enter KEITH. He stands upstage of her, watching.*)

KEITH: You're late.

LAURA: The bus blew a tyre.

KEITH: You're three fucking weeks late.

LAURA: Someone attacked a mosque, riots, hundreds dead.
It wasn't my fault.

(*Out front.*) I live in a really traditional bungalow thing
called an ibi. The design is exactly like all the local
indigenous people's houses, except I've got air
conditioning, carpets and a toilet. I share the ibi with this
guy Keith. The bad news is HE IS MY DAD!

KEITH: Burton Latimer eh? Weetabix.

LAURA: Yeah.

KEITH: Ready Brek – that's a Weetabix product isn't it?

LAURA: I don't know.

KEITH: Do they make Alpen in Burton Latimer?

LAURA: I'm not sure.

KEITH: You do come from Burton Latimer don't you?

LAURA: I worked there. I was born in Sevenoaks.

KEITH: They changed the name of Weetos to Minibix,
didn't they?

(*Beat.*) Or was it the other way round? Alpen nutty
crunch, that's my favourite, can't beat it. Bran, nuts AND
it's crunchy.

LAURA: Burton Latimer is fantastically boring, it stinks
like a permanent roast dinner, and its population is
dedicated to waiting, like, quietly, to die.

KEITH: It's very handy for Kettering.

LAURA: You're just like my dad. Do you like Motorhead? Punk?

KEITH: Motorhead were never punk. They started in '75, which is pre-punk, unless you count the New York Dolls as punk, which I never have. Motorhead were grunge really, but pre-grunge cos grunge was post-punk, obviously.

LAURA: (*Laughing.*) I came here to get away from blokes like you.

KEITH: Beer? I know a man, who knows a man, who knows a man. There are not many opportunities for women.

LAURA: Not yet. That's my job!
(*Out front.*) When we're not working we're basically, like lashed. We drink, literally, like, tons of this Sun beer.

KEITH: It's a wheat based German recipe made under licence in Morocco. Nigerian army deserters driving diesel Peugot 405s smuggle it through as far as Lakpat. It's got added sugar to suit the Tambian taste for sugar. I find it a bit sweet but it's better than a kick in the clems.

LAURA: (*Out front.*) We got drunk the first night, which is kinda risky cos we're living under, like, Sharia Law, yeah? but because we're 'Christians', in inverted commas, we're not like, covered by the same laws as the Muslims who live next door, yeah? It's mad!

KEITH: How the fuck can you expect to run a fucking country when half the fucking laws only apply to half the fucking population!

LAURA: (*Out front.*) I'm not doing VSO, this is an NGO. I get a proper salary. It's a job. Keith's been here three years. He's really positive about the project and the people.

KEITH: It's like herding fucking cats!

LAURA: (*Out front.*) The bus company is run by Christians. It's called 'Death is Certain Buses', and the toilet paper's called 'God is in Control'. Mad!

KEITH: Don't ever say that you don't believe in God, alright? They'll think you're mentally ill. You're Church of England.

LAURA: Cool.

KEITH: And a virgin.

LAURA: I am a virgin.

KEITH: Don't go out without a veil.

LAURA: Actually, it's kinda, liberating –

KEITH: – Crap.

(*Beat.*) Wash standing up. Catch the water in a bucket so we can flush the loo. When I was in the Philippines, '86, '87 we used to shit in the jungle. You had to take a spade with you, not to dig a hole, but to kill the snakes.

LAURA: 'Luxury.'

KEITH: I watched an NPA platoon kill a Filipino peasant with a spade. They could have shot him but with a spade you can all have a go.

LAURA: Couldn't you have stopped it?

KEITH: We were there to find alternatives to burning rice straw. Environmentally catastrophic.

(*Beat.*) Don't wash out here. The boys poked holes in the fence. Victoria.

LAURA: She came home early, didn't she. Something about er –

KEITH: – She got pissed at the army barracks and then, watched by fifty soldiers, half the kpelle, and me, she gave a German Aids Awareness Outreach worker a blow job in the car park.

LAURA: I'll try and remember not to do that then.

KEITH: She's gone back to live in Goole. She's training to be a drama therapist.

You're the only white woman for three hundred square miles so you get a twenty-four hour guard, a mimani.

LAURA: Is it that, like, totally necessary?

KEITH: Completely unnecessary. Unoka is not another Belle Yella.

LAURA: I hope not. Oh God. All the talk in Bracknell is about pulling out of Belle Yella.

(Enter MONDAY. He's a Tambian of about 25 wearing torn shorts, a blue fez, flip flops and a T-shirt which says DIP ME IN HONEY AND THROW ME TO THE LESBIANS.)

KEITH: You're late!

MONDAY: I collided with a huge python in the road and nearly got bitten.

KEITH: You're lying!

MONDAY: The python was hopping mad!

KEITH: You've been drinking!

MONDAY: I was thrown off my puk puk and didn't know what to do! I thought my days of cheese were over! Then I remembered the words of Richard Nixon – 'Defeat is never fatal unless you give up.' So I fell to my knees and prayed to that gentleman of Nazareth and BANG!, along comes the money truck from the Central Bank and runs over the python's head! The rest, as they say, is history.

KEITH: You're drunk.

MONDAY: I am going to divorce booze and marry Christ! *(To LAURA.)* I will be a great mimani, maybe the greatest ever. I have studied the habits of lions. You will not be killed – over my dead body!

LAURA: Hi. Laura.

(LAURA puts her hand out to shake.)

MONDAY: Oh no!

KEITH: In this province a man can't touch a woman.

MONDAY: Don't start! Or we might as well have it off and all go back to mini skirts!

LAURA: *(Out front.)* Monday is, like, a Missionary name, but he's a Muslim, but, Oh God, it's, like, really complicated.

MONDAY: I was born a Muslim, but in the orphanage Jesus Christ came to me one night when I was playing Scrabble and made me his lifelong friend.

LAURA: Right.

MONDAY: I am also technically Jewish, but that was a clerical error. I am circumcised, and a very poor job they did too. I could have done better myself.

LAURA: OK.

MONDAY: It is a great sense of shame to me that I cannot pee straight.

LAURA: Sure, yeah.

MONDAY: I am Kebbe and follow the Poro religion.

LAURA: Poro?

MONDAY: Oh yes! I have the big three – Christian, Muslim, and Poro. Manchester United, Arsenal, and Chelsea.

LAURA: Right.

MONDAY: I am also a witch, but we can leave that for a rainy day.

LAURA: I thought it was like, pretty much all Muslim round here.

KEITH: Poro and Muslim round here, Sunni Muslim that is; Poro and Christian five miles south, and pockets of Shia Muslim, and Poro all over the place. Everyone's Poro, except the women, who are Sande, which is the same as Poro but just another name because they're women.

MONDAY: Doesn't matter because my God is all the same man!

LAURA: Or woman. (*To KEITH quickly.*) Sorry!

MONDAY: Oh yes! Equal rights for women! I am a very modern thinking mimani, very western. God, oh yes, 'she' is bloody everywhere! Or he. But definitely not gay.

KEITH: This is a traditional hat of a Christian from the Egwome clan. His drinking hat.

MONDAY: My brother, Ifeamyi, calls me Mr Weakling! He is a fully qualified pharmacist. He has three wives and eleven sons. He is a good Muslim, he never drinks. One day I will ask him how he does it!

KEITH: (*Kicks the can of water.*) How much?

MONDAY: (*To KEITH.*) Two hundred doss! Full to the brim, no piss.

KEITH: Twenty doss.

MONDAY: (*Laughs hysterically.*) Look, it is not red water. One hundred and fifty.

KEITH: Twenty-five.

MONDAY: At the bore hole, many hungry lions, much hiding, many clever things.

KEITH: Forty.

MONDAY: Fifty.

MONDAY/KEITH: (*Together.*) Forty-five.

(*KEITH hands over some notes, MONDAY counts them, and pockets them.*)

MONDAY: Today we have a new Imam. Ali Bakassa. He is a student from the city.

KEITH: Oh shit!

MONDAY: Ha, ha! He is just a boy with a very short beard, but holy Moses, what a student! We are all instructed to stop our wives working in the Casino.

KEITH: You don't have a wife.

MONDAY: No wife of mine will ever work at that casino!

KEITH: They pay well.

MONDAY: Do they? Oh bugger, we could do with the money!

(*KEITH takes the jerry can into the ibi.*)

(*To LAURA.*) I am saving up for a twenty cow wife.

LAURA: Right! Would your wife be, like, a Muslim?

MONDAY: Oh yes! She would be very much like a Muslim. In fact she would be a Muslim.

LAURA: I think Islam, I mean, the whole veil thing, is actually, like, a way of showing real respect for women. Real respect, yeah? Not like women are treated in the west, like, in the porn industry, you know what I mean?

MONDAY: Oh yes! Christians think a Muslim beats his wife up black and blue, and cuts her ears off if she has a girl child, and of course, I'm not saying that doesn't happen, but there is no instruction anywhere in the Koran for behaving like a mad gorilla. No! The Prophet Muhammad, peace be upon him, never beat a single woman in the whole of his life, never! Not that anyone knows about anyway.

LAURA: Absolutely.

MONDAY: Islam is the top religion. Except Shi'a Muslims. They're all coconut heads.

KEITH: (*Off.*) He's Sunni.

LAURA: There's two sorts of Muslim aren't there, Sunni, and Shia, and then there's the Sufis. I'm reading the Koran.

(*KEITH re-enters.*)

MONDAY: It's unputdownable isn't it?

KEITH: Oi! Take these bags through.

(*MONDAY picks up the bags, taking an interest in the Cosmo, and takes them into the ibi.*)

KEITH: I'm gonna do a big Christmas dinner. Turkey. All the trimmings.

LAURA: What now? It's April.

KEITH: At Christmas. I am actually a Christian. Relax, it's not a heavy thing, OK. Are you gonna be here at Christmas?

LAURA: Here or John Lewis's. Here.

KEITH: Great. Is this mine?

(*KEITH opens a package which LAURA has brought with her. It's got customs stickers all over it.*)

Did customs want a dash?

LAURA: I, like, refused at first. But then they got really heavy. Said my malaria tablets had a heroin content, which is true, of course, pain killer yeah?

KEITH: A thousand?

(*KEITH takes out a battery-operated drill and inspects it.*)

LAURA: Fifteen hundred.

KEITH: Not bad!

LAURA: It does my head in. I, like, love the developing world yeah, I travelled in my gap year, Africa, South America, Nepal. Yam foo foo is, like, my all time favourite meal. I'm a giraffe girl. My dad always bought me little cuddly giraffes. But the one thing I'd change – bribes.

KEITH: That's the one thing you'd change about Tambia?

LAURA: Yes. And aids of course, and poverty, and famine.

KEITH: Your training plan is fucked.

LAURA: Three weeks late?

KEITH: I have to go to Kante in the morning. I'll be gone about a month.

LAURA: Oh God.

KEITH: Have you got a pen? This country's fucked, alright. Write that down.

(*LAURA writes it down, KEITH waits.*)

The borders don't make sense, the capital is on the coast, which is no fucking use to anyone, there's no rule of law, no running water, you never know when the electric's on, the last war's fucked everything, and the next war will fuck everything else.

LAURA: When does the next war start?

KEITH: January the third. I'm not gonna be here.

LAURA: I am. How can you be so, like, sure there'll be another war?

KEITH: The beards will win the elections again, but the government will reject the result saying that an Islamic administration would not be in the long term interests of Tambia, ie: not in the short term interests of Exxon Mobil, Chevron Texaco, Elf Aquitaine and any other western corporates who Tambia's self-serving fucking kleptocracy, also known as the People's Movement for Democractic Reform, are in bed with, or should I say, 'being shafted up the arse by'.

LAURA: Kleptocracy. Did you make that word up?

KEITH: I stole it. Nobody has any loyalty to Tambia as a nation state cos they're all Kebbe first, or whatever their tribe is; they're Muslim or Christian second; and only ever fucking Tambian when the football team's on telly.

LAURA: But the people are really, you know, so fantastic aren't they, I mean –

KEITH: – Crap. It's a male dominated, tradition oriented, patriarchal society, ie: it's fucked. In three years I haven't met a single Tambian who could organise a fart in an arsehole. Do you think I swear too much?

LAURA: No. It shows a, you know, passion for er…justice.

KEITH: 'A lot of people won't get no justice tonight.' The Clash? The Clash are one of the two reasons I'm here.

LAURA: My dad quite likes the Clash. His favourite band is Steely Dan.

(*KEITH looks at her with contempt.*)

KEITH: What did they tell you about me in Bracknell?

LAURA: Good things. They kinda warned me that you swear a lot.

KEITH: Peter Nicholson eh? (*Beat.*) He could wank for England. What's your music?

LAURA: Er...I don't really...The White Stripes? I like Radiohead?

KEITH: (*Evangelical.*) I saw the Clash twenty-three times.

LAURA: The oil must have made a difference?

KEITH: Yeah, there's a new drug. Megwe. Megwe is cloth dipped in diesel. Chew it and it eliminates hunger pangs.

LAURA: Right.

(*KEITH chucks over some thick documents to LAURA as he talks.*)

KEITH: Proclamation 35/97. Government statement on Micro finance initiatives. Proclamation 39/99 National Micro and Small Enterprises Development Strategy. Muslim women can't capitalise their businesses cos they've got no collateral and paying interest is haram. Haram?

LAURA: Yeah, er...halal good, haram er...not so good, bad even. I'm reading the Koran, I thought I'd –

KEITH: – how far have you got?

LAURA: I'm up to the bit where...page four.

KEITH: (*Chucking down a document.*) Here's your girls, they're mostly war widows. It's basic stuff, you don't need an MBA.

LAURA: That's lucky!

KEITH: Improve productivity. Cut costs. Find new markets. Who's the first?

LAURA: Omojola hairdressing.

KEITH: Three women, fuck knows how many kids running about, one pair of scissors, no running water, no work ethic and no fucking mirror.

LAURA: Right.

KEITH: They can't cut men's hair cos women can't touch
men. So they're left with boys, which is not enough of a
market to feed three families.

LAURA: Why don't they cut women's hair?

KEITH: Women like to have their hair cut properly.

LAURA: So, er...training and er...electric clippers. Hand
clippers!

KEITH: And a mirror.

LAURA: Three mirrors!

KEITH: Good, like it. And signage.

LAURA: Signage?

KEITH: A board outside.

LAURA: Oh signage!

KEITH: They don't want to pay their sign board taxes.
They need to establish 'personal contact with influential
officials'.

LAURA: I have to encourage them to pay a bribe?

KEITH: What did Peter fucking Nicholson teach you in
Bracknell?

LAURA: Work 'in' the culture, and 'with' the culture, not
'against' the culture.

KEITH: If you fly club class, you're paying a bribe in order
to be treated like a human being rather than a mollusc
with short legs. Poverty is the enemy. Not culture. Most
of these businesses are in the villages around Unoka,
none of them are on the phone. You ride a motorbike
don't you?

LAURA: Yes.

KEITH: I'm gonna bed. Early start. Difficult shit with the
French. I am this far away from dragging Unoka into the
nineteenth century. A tap. One fucking tap.

LAURA: Good luck.

KEITH: Good night.

(*Out front.*) The Diesel Boys. Four of them, dressed in
red, Ferrari red, Michael Schumachers. The motorbikes
are aerosol can sprayed red. Sunglasses, AK 47s, flip
flops. It's Friday, and the Shi'a faithful are at prayer. The
boys riding pillion kick off their flip flops. They're

Muslims too. Sunni. Allahu akbar. They fire, reload, fire, reload, fire and leave. Thirty-two dead. Riots, curfew. Six hundred, maybe a thousand dead. The Christians working on Casino island are cut off, too scared to cross the bridge. A journalist for the *Daily Telegraph* notices that the staff of the French water company Vivendi Environment now travel in armed convoy. She identifies their security guards rifles as FA MAS 5.56 millimeter assault rifles, the standard issue rifle of the French foreign legion. Jacques Chirac denies he has sent government troops. The journalist is arrested and deported. The *Daily Telegraph* pigs out on indignation. On the London Underground *Independent* and *Guardian* readers pick up discarded *Telegraphs* and are surprised and impressed by the quality of the writing. And Peter fucking Nicholson in his safe European home sends me a fucking idiot.

(*KEITH exits to the ibi. It is now dark, and there are bird and animal noises above the cicadas. Enter MONDAY, he is distributing lion turds around the compound.*)

LAURA: What's that?

MONDAY: Lion poo!

LAURA: Right.

MONDAY: Imagine you are a little runty leopard and you have the big idea – 'let's go eat the new whitey girl!' So! You nip over the fence but then you see this big lion poo sausage here and you say, Allah be merciful! That is one big fuck off lion! Let's go home now!

(*Beat.*) You see, I am clever, like an old fish.

LAURA: Do you have a gun?

MONDAY: I can get you one.

LAURA: No, I'm just not used to, like, everyone you see is carrying a gun.

MONDAY: You will not die tonight. Over my dead body!

LAURA: Do you stay awake all night?

MONDAY: I listen to the world service. It is beautiful.

(MONDAY winds up one of those self-generating wind-up radios and we hear Melvyn Bragg on epistemology or something similar.)

(To black.)

May

IBRAHIMA sucking from a can of Diet Pepsi beneath her burqa with a straw. Enter LAURA from the road in a veil and carrying post. One of MONDAY's jerry cans of water is set centre stage.

LAURA: *(Out front.)* Dear Pip. You haven't written! Did Trish go ahead and marry Theo? Everyone knows Trish is shagging Damien. Everyone but Theo. Doooh! I have to wear a veil. The veil is all about not getting the men sexually excited, and that's really sensible, isn't it, and yet another thing to respect about Islam. I bought a classic hijab in the duty free at Heathrow. It's plain charcoal with very small, very subtle Guccis all over it. I wanted to be able to say that I'd read the Koran, I mean, how cool would that be, but after four pages I was, like, crawling up the walls. I'm reading *The Complete Idiot's Guide to Islam*, so OK not the Koran, but I'm kinda up to speed, and it's such an amazing peaceful, loving religion and all those terrorists, they're not really Muslims at all it's kinda media shorthand. I mean, we would never describe Fred West or Adolf Hitler as 'Christians'. We would never say 'the Christian fascist', although he was a Christian, and a vegetarian actually, Hitler I mean, not Fred West – he was a builder. First day at work and I've never ever talked to a woman in a burqa, and I've never been any good at small talk. Go for it!
(IBRAHIMA gurgles on her straw.)
(To IBRAHIMA.) And stoning, yeah, well, you know, how is that any worse than the electric chair, yeah?
IBRAHIMA: *(Gurgles on her straw.)*

LAURA: In America, yeah, which is fundamentalist
Christian now, yeah, well, the state executes poor black
people all the time, Afro-Americans.

IBRAHIMA: (*Gurgles on her straw.*)

LAURA: I know they don't, like, execute you for, you
know, sleeping with someone you're not married to, but
it's all value judgements, and there is no such thing as an
absolute morality. We did that at Uni.

IBRAHIMA: (*Gurgles on her straw.*)

LAURA: Your culture values family, and promiscuity is a
threat, so getting heavy with anyone who threatens the
culture is, like, understandable cos the first responsibility
of any culture is for its own survival.

IBRAHIMA: (*Gurgles on her straw.*)

LAURA: Do you have to do that? My sister used to do that.
The thought of all that flob in the bottom of the can –
ugh. Sorry.

IBRAHIMA: Why are you not married?

LAURA: Me? I have nothing against marriage as a concept,
or kids. The survival of the species is what it's all about
in the end, and everything else is, like, self-indulgent
really, yeah? So, kids, yes, definitely. But not just yet.

IBRAHIMA: Your father must have a big farm.

LAURA: He's not a farmer. He's a cat plate artist. He paints
cats onto plates. He went to art school with David
Bowie? And he teaches.

IBRAHIMA: What does he teach?

LAURA: Cat plate art. What I would say though, and I
realise I'm out of order here – I think if you have to
stone the woman, you should stone the man too. I'm not
a feminist, no I mean, men are, like, important, still,
particularly over here, you know, where there's still a lot
of lifting. The turnover of the American porn industry is
bigger than Zambia's GDP. So, you have three
daughters. Are they at school?

IBRAHIMA: I don't want them to go to school.

LAURA: I respect that. One of the first things they taught
us at Bracknell was that's it's so important to accept
Tambia –

IBRAHIMA: – Tambekistan.

LAURA: Sorry! Tambekistan. Weird that isn't it, you know,
having a different name for the country cos you're a
woman? Not weird for you of course because you live
here. It's so easy to talk to you. There are so many
misconceptions about the veil. Do you love your
husband, or was it an arranged marriage?

IBRAHIMA: My father, and him, made an agreement.

LAURA: Of course. *Daily Mail* readers, stupid people, they
always think an arranged marriage is like a licence for
the husband to hit his wife. But your husband doesn't
beat you does he?

IBRAHIMA: Yes.

LAURA: Any particular reason?

IBRAHIMA: I give him only girls.

LAURA: OK.

IBRAHIMA: I am pregnant again.

LAURA: Congratulations! I mean, oh shit.

(*IBRAHIMA starts crying.*)
Don't cry. Please.

IBRAHIMA: I must wait until the eighth month before I
can go to the Earth Spirit. He will decide if it is to be a
boy.

LAURA: Is that Poro stuff?

IBRAHIMA: Sande. I am a woman.

LAURA: Right. But you're a Muslim as well?

IBRAHIMA: The Earth spirit did not leave when
Muhammad came.

LAURA: Peace be upon him.

(*Enter MONDAY reading Cosmopolitan. LAURA whips on
her hijab.*)

MONDAY: (*Turning pages of Cosmo.*) Skinny! Skinny! Very
skinny, ha, ha!

(*Turning the pages again.*) Skinny. Skinny. Skinny.

LAURA: Sorry, that's my magazine.

MONDAY: I was hoping to find a nice fat woman!

IBRAHIMA: Kwa coche, phut, phut, phut. [You're a wanker. Wank, wank, wank.]

MONDAY: (*Shouting.*) Umeooa! Kwa shumo! Konde! [Cow. You're a whore. Slag.]

(*MONDAY puts the magazine down. IBRAHIMA picks it up and leaves.*)

IBRAHIMA: (*To MONDAY.*) Yazid! Coche! [Yazid. Unmarried man.]

MONDAY: Fornicator!

IBRAHIMA: Phut, phut, phut. (*Giggles.*)

LAURA: Please!

MONDAY: There is no history of fornication in my family! They call us the iron family!

(*MONDAY sticks two fingers up at IBRAHIMA then taps the can.*)

Water. Today – big thirsty rhino. Three hundred doss.

LAURA: Er…two hundred doss.

MONDAY: Ha, ha! No, no you say thirty.

LAURA: Thirty doss.

MONDAY: Thirty!? Are you crazy woman!

LAURA: Why can't you just have, like, a set price?

MONDAY: Every can of water in Tambia is different. Today it is hot, sticky, and my puk puk has a plastic seat.

LAURA: Fifty.

MONDAY: One hundred.

LAURA: Ninety.

LAURA/MONDAY: Eighty-five.

(*They involuntarily shake hands.*)

MONDAY: Now we are both happy and my heart is a bullock of joy!

LAURA: No touching.

(*LAURA counts out money.*)

MONDAY: Also, I sell anything Russian. Kalashnikovs, second hand heart attack defibrillators, Pringles.

LAURA: Pringles aren't Russian?

MONDAY: The ones I get are.

LAURA: Vodka?

MONDAY: I will get you vodka, but you must not be friendly with 'the fornicator'. She has converted her legs into business premises.

LAURA: She's a prostitute?

MONDAY: She is useless to her husband! But I am not a Mary Whitehouse! NO! God tells us that sex is good, very good! And I have no intention of spending my life hiding behind the curtains, but fornication is the work of the devil!

LAURA: You will soon have a twenty cow wife.

MONDAY: Or two ten cow wives.

LAURA: You can have three wives can't you.

MONDAY: Two is enough. Three in a bed and you can still be romantic. Four is just a mad Olympics!

LAURA: Right. Monday, advice, the post. Am I supposed to open it?

MONDAY: (*Laughing.*) You are asking me?!

LAURA: I'll open everything addressed to the project, yeah?

MONDAY: I am the mimani!

LAURA: (*Inspecting the postmark.*) It's addressed to Keith. CSA Oldham. Is Keith married?

MONDAY: He has two wives. Two 'money grabbing bitches'.

LAURA: Right. Let's go. I lied on my application form. I can't ride a motorbike.

MONDAY: No?! You are grade five piano aren't you?

LAURA: Did I put that? If you ride the motorbike I'll put my arms round you. I've done that before.

MONDAY: You are always trying to touch me!

LAURA: How do you get anything done in this country if there's no touching?!

MONDAY: You can sit behind me in my puk puk box.

LAURA: People will think I'm your wife.

(*MONDAY grins.*)

(*To black.*)

June

KEITH is reading project reports. LAURA is down stage with a handful of photographs.

LAURA: (*Out front.*) Dear Pip. Trish looks such a tart! She might be wearing white but you can see her nipples! And what is that tattoo? It looks like a lamb chop! Your hair! You're gorgeous! You look like Debbie Harry, you know, when she was young and still on heroin. I've learnt to ride a motorbike – see photo. But where's my *Heat* magazine. I just need some 'Courtney Love wins the Miss Cellulite competition at China White.' This isn't VSO. I work for an NGO. It's a job. It's been a totally incredible month and my clients, the women, are fantastic, dignified, unbelievable. I just hope I'm helping, they giggle so much I get paranoid, and then I can't sleep for worrying about whether they can feed their kids. I realise now how incredibly important my work is. (*To KEITH.*) Did you get your post?

KEITH: No.

(*LAURA goes into the ibi.*)

Who is Lookout Masulu?

LAURA: (*From the window of her room.*) PS I've met someone Pip. He's Tambian. Black. Sorry! If you shut your eyes he could be English. He did media studies at Southampton Institute. He looks like Seal, but with good skin. He works for Tambia Cell. More people have Aids in Tambia than have mobile phones. He's married. I'm just so 'the other woman'. Four stars, occasionally five. Older men! They are such better drivers!

KEITH: (*To himself.*) Lookout Masulu.

(*LAURA gives KEITH two items of post, both A4 size serious looking envelopes. Pause during which LAURA expects KEITH to open his post and share it. He looks at her.*)

LAURA: Sorry! I'm so desperate for post myself, I –

KEITH: (*Looking at first envelope.*) – Child support agency –

LAURA: – No, it's OK. Sorry.

KEITH: (*Looking at second envelope.*) Decree nisi, hopefully. Pauline. My first wife.

LAURA: That's really pants of me!

KEITH: If it is we'll have a celebration drink.

LAURA: I apologise.

KEITH: Don't. I spent all of 1993 up to my knees in shit in Cambodia. Literally, it was a sewage project. She spent the whole year in bed with an award winning butcher from Pateley Bridge.
(*Ignoring the post, going back to the project reports.*) Lookout Masulu, Lookout Masulu. Who the fucking hell is Lookout Masulu?

LAURA: He's, like, the contracts manager at Tambia cell.

KEITH: All your girls have got mobile fucking phones!

LAURA: Not all of them.
(*Enter IBRAHIMA, talking on a mobile and carrying a copy of Elle.*)

IBRAHIMA: Eeeee! Agi kwondo...agi...agi. Eeeeee! Ik kom kwefi gim, agi! Bloody silly ring tone!
(*IBRAHIMA off into the ibi.*)

KEITH: What the fuck has been going on here?!

LAURA: None of the villages had any telecoms, yeah? Lookout gave me fifty phones.

KEITH: 'Gave?'

LAURA: They're leased. My girls charge the user about a hundred per cent mark up per call. It's like every village having a public phone. People check out the price of milk or beans in the markets, save themselves a trip, or go to a different market, where they get a better price. I've fucked up haven't I?

KEITH: I've been trying to get Tambia Telecom to commission an exchange for three fucking years, but every time they put a bit of cable in the ground it gets dug up and nicked.

LAURA: Didn't you consider mobiles?

KEITH: How do they recharge the batteries?

LAURA: Little solar panels.

KEITH: They're expensive.

LAURA: I started a credit club. They can borrow ten thousand doss at seven per cent interest, and pay it back over a year.

KEITH: They're Muslims. They can't pay interest.

LAURA: They don't pay interest. They pay the bank a bill for financial consultancy, the equivalent of interest.

KEITH: That's crap. The bank would never go for that.

LAURA: I had to pay him a dash.

KEITH: You're very lateral aren't you?

LAURA: Fish!

KEITH: Where did you get the idea of getting into bed with Tambia Cell?

LAURA: I don't know. It just came to me.

KEITH: We tried this kinda collective use thing in Gaza in '82. Worked well, for a while.

LAURA: (*Hugely disappointed.*) Oh.

KEITH: They were all communists in them days.

LAURA: The Palestinians?

KEITH: Then the Soviet Union went tits up, they swapped their clapped out red flag for a nice shiny green one.

LAURA: Have you spent your whole life in, like, development work?

KEITH: Yeah, pretty much.

LAURA: Are we getting a tap then?

KEITH: Huh, long story. The Tambian official has been off for two months because his cousin's poorly. Not 'his mother's dying', or 'his father's having a complete fucking skeleton transplant', but 'his cousin is poorly'. You're supposed to hate your fucking cousins! You want them to die!

LAURA: We're getting a tap aren't we?

KEITH: Next month.

LAURA: Fantastic! A tap!

(*She hugs him. Enter MONDAY. He watches with open jealousy.*)

KEITH: That's been a pretty long Friday prayers?

MONDAY: Today we must seek out any women human rights workers and marry them on the spot! That way

they will all get a bun in the oven and will spend the rest of their lives indoors!

KEITH: The student with the short beard?

MONDAY: It is growing at a phenomenal pace. Either God is with him or he's using anabolic steroids.

(*To LAURA.*) Will you marry me?

(*KEITH laughs.*)

LAURA: I'm not a human rights worker.

KEITH: How many cows?

MONDAY: She is old, like a big tree.

LAURA: I'm twenty-four!

KEITH: Come on, how many cows?

LAURA: I don't want any cows.

MONDAY: Are you a virgin?

LAURA: I am a virgin.

MONDAY: Off the mark with five cows! Are you open or closed?

LAURA: (*Not knowing what he's talking about.*) I'm not... open, I'm shut, I think.

MONDAY: Closed. Did they sew you up nice and neat or is it all to cock?

KEITH: She's not been circumcised.

MONDAY: That is so English! You spoil the ship for a ha'porth of tar!

KEITH: A Muslim girl who hasn't been spayed gets a low bride price.

LAURA: I'm sorry, but you're wrong OK? FGM has got absolutely nothing to do with Islam.

KEITH: FGM?

LAURA: Female Genital Mutilation. It's common in Christian countries like Kenya, too. It's a cultural tradition which, like, totally pre-dates Islam.

MONDAY: Very popular though! Especially with the ladies!

LAURA: Yeah, because women are, like, disempowered. Don't look at me like that. I haven't read the Koran, but I can't imagine Mohammed –

MONDAY: – peace be upon him –

LAURA: – peace be upon him, yeah, er...where was I?

MONDAY: Mohammed, peace be upon him.

LAURA: Yes, I can't imagine Mohammed –

MONDAY: – Peace be upon him –

LAURA: Yes, alright, just don't do that. (*Louder.*) I can't imagine… –

KEITH: – Him.

LAURA: Him being in favour of it.

MONDAY: He said, 'If you cut, do not overdo it, because it brings more radiance to the face and it is more pleasant for the husband.'

KEITH: Know thine enemy.

LAURA: I'm sorry! Who's my enemy?

KEITH: Anyhow, she hasn't been FGM'd so what does that make her worth?

MONDAY: Two cows.

LAURA: I've got a first in Business Studies from Loughborough University.

MONDAY: One cow.
(*To KEITH.*) But have you heard? Every village has a cell phone!

KEITH: I know.

MONDAY: Great Britain is still sticking up telegraph poles. Ha, ha! Tambia is now the lion, and England is a wildebeest with a limp.

KEITH: We are in the middle of a meeting.

MONDAY: She learnt to ride a motorbike very quick!
(*A sharp glance from KEITH to LAURA.*)
They all love her! Lemonade Fatima, you know the one you fancy, the one with the arse? She now has ice!

KEITH: Ice?!

MONDAY: Oh yes! Laura told that arab bugger in the bakery to let Fatima use a corner of his big fuck off gas industrial freezer!

LAURA: For a little dash.

MONDAY: And Mahjabeen?

KEITH: What about Mahji?

MONDAY: Laura goes straight in there! Ha! 'Mahjabeen, your mats are crap! No bugger wants your crap mats!'

Mahji borrows the money, buys a Singer sewing
machine, beautiful, and is now mending torn curtains.

LAURA: The hotels on Casino Island always have torn
curtains.

MONDAY: From their wild and sinful nights.

KEITH: You went to the island?

LAURA: We took all the girls from the pottery out there
and sold nearly seventy night light pots. Night lights,
like candles, yeah.

KEITH: I know what night lights are.

MONDAY: They have taught her to dance. Show him! Go
and get the fornicator, you can dance with her, show him
how you dance.

(*LAURA exits to the ibi.*)

She is a one woman locust storm! But very skinny.

KEITH: She's not gonna marry you. Look, Monday, I go
home after Christmas, Laura stays for maybe another
year. In the long term you're gonna need to find some
kinda alternative income.

MONDAY: I will go to America then and be big in motor
parts!

KEITH: When I was in Mali in 1985, I was leaning against
a three ton maize crib sharing a joint with a bloke when
he said, 'Why is all the maize in this maize crib fucking
rotten?' Yeah, he swore. He was that sort of bloke. He
was angry. He was Bob Geldof. For eighteen years now
I've been thinking about what he said and I've noticed
that the big maize cribs round here are exactly the same
design as those in Mali, ie: crap. Design a maize crib
where the cobs on the bottom don't rot and you could
make a living as a joiner.

MONDAY: I know the Kebbe. They will never pay money
for something they can do themselves.

KEITH: You're on my payroll Monday, think about it, talk
to farmers, do a design. Homework. Yeah, Geldof. He
wouldn't like you.

MONDAY: Why not?

KEITH: He dun't like Mondays.

(*Simple music is played by IBRAHIMA and LAURA, and they dance on wearing burqas.*)

I've seen this dance before.

MONDAY: Yes, it is the dance to celebrate the joys of female circumcision.

KEITH: Oh that one.

MONDAY: It is soon to be the festival of the day of the longest sun.

KEITH: Clitoridectomy day.

(*The dance ends. They applaud.*)

MONDAY: This year it will be different. There will be many tourists.

KEITH: What?

MONDAY: Laura has made a clever deal with the tour operators. Many buses! It will be like a white horse Wembley!

KEITH: Tourists want to see a big black bloke prancing about like a deranged acid casualty, caked in cow shit, with a dead chicken nailed to his head. They don't want to see nine year old girls getting butchered!

MONDAY: We will sell many nick nacks.

(*To black.*)

July

LAURA is crouched puking. KEITH stands by watching, not helping.

KEITH: I hear it went well.

LAURA: (*Quietly.*) Fuck off.

KEITH: (*Laughs.*) Three buses. Japanese, Germans and –

LAURA: Fuck off!

KEITH: Is it still those two old women? Laurel and Hardy. Three hundred clitoridectomies in two hours with one razor blade – that's almost western efficiency.

LAURA: Shut the fuck up!

(*Enter MONDAY with a towel and a drink of water.*)

KEITH: How about Miss World next year?

LAURA: Fuck off.

(*Exit KEITH. MONDAY gives LAURA a drink and she uses the towel. MONDAY extends his hand to help her stand. She looks at him, he nods, she takes his hand to help her stand. Exit MONDAY.*)

(*Out front, through pukes.*) Dear Pip, Everything is going really well here. I'm really enjoying it. It is difficult sometimes because you have to constantly remind yourself that what you value, the things you believe in – (*Pukes.*) Stephanie?! *I* introduced Damien to Stephie. She won't stick him long, he's such a two star shag. I've had a council tax reminder from Hackney Council, which is weird, cos I've never lived in Hackney. PS HEAT! PPS My mimani, Monday has got the hots for me. He's very beautiful and sweet, but he's so innocent.

MONDAY: Will you marry me?

LAURA: Who's got my Cosmo?

MONDAY: I have many powers. I am a witch don't forget.

LAURA: What? You could, like, make me marry you?

MONDAY: Yes. I walked out of the forest, two days old, trailing my cord behind me, singing God Save the Queen in Welsh!

LAURA: I want my Cosmo back. Now!

MONDAY: I was chosen. It is a great thing to be a witch.

LAURA: Your parents had twelve children already. The whole witch thing round here is about poverty. You're not a proper witch!

(*Exit MONDAY, shocked.*)

Oh shit! Monday! Monday! Come back!

(*LAURA follows him.*)

(*Off.*) Monday!

(*IBRAHIMA enters from the ibi. She is reading Cosmo and is on the phone.*)

IBRAHIMA: (*On the phone. Reading/giggling.*) Eeeee! Agi, agi. Cho kwole wa. 'Women instigate sex forty-seven per cent of the time… (*Giggles.*) …an earth moving fifty-two per cent tell their lovers exactly what to do to make them come… (*Giggles.*) Thanks to *Cosmopolitan* women

are enjoying luxurious and aspirational sex. Eeee! Agi. Kwa?... Tips? Games?

(*She turns a page.*)

Games. American hot pizza! A chilli pepper hot role play game guaranteed to deliver extra pepperoni! Tell your man to go out and get a pizza. He must dress in pizza delivery boy clothes, if he's got a Honda 50 all the better. Whilst he's gone, dress in your most sensuous –

(*Enter LAURA. IBRAHIMA rings off, guiltily.*)

LAURA: You've got it!

IBRAHIMA: I was reading about Mary Robinson.

LAURA: What?

IBRAHIMA: She was running Ireland and the United Nations and she's got three children.

LAURA: Oh her. Yes. Very impressive. Did you read the survey?

IBRAHIMA: No. I like looking at the cars for women. Muslim women are allowed to drive in England?

LAURA: Definitely, yes, there's absolutely no discrimination.

IBRAHIMA: That could be very dangerous if they're wearing the full burqa.

LAURA: Maybe not big lorries.

IBRAHIMA: Can I borrow it?

LAURA: No! It's, like, puerile, crap. I only bought it for...I normally buy *Marie Claire.*

IBRAHIMA: I'm half way through reading about the whore. She has two daughters –

LAURA: – She's not a whore, she's a lap dancer. She has an autistic child! How can you say that? I'm not judging you. OK. But you were judging the lap dancer. A friend of mine did a porn shoot once in Mexico.

IBRAHIMA: You? Your friend is you.

LAURA: I'm not ashamed of it. It was really quite celebratory, you know, of the female form, and I paid for my own flight to Rio, yeah? I know about you and Keith.

IBRAHIMA: Keith is a generous man and a good lover.

LAURA: Really?

IBRAHIMA: Oh yes. He's very quick.

LAURA: Is there any chance that Keith is the father of your child?

IBRAHIMA: He wears a rubber.

(*Enter KEITH. He goes to get a beer, comes back with two.*)

Can I borrow it please?

LAURA: I can't lend it to you.

KEITH: Oh go on.

LAURA: But –

KEITH: Read it! Memorise it!

(*IBRAHIMA goes into the ibi with the magazine.*)

LAURA: Peter 'fucking' Nicholson said we should avoid –

KEITH: – Her sister used to clean at the refinery apartments. She used to pick the *Playboys* out of the bins, pass them on to Ibrahima who would sell them to me. What? Two thousand Tambians go to University in the West each year. What do you think they bring back? HP sauce?

LAURA: I dunno.

KEITH: In 1993 I was living with the Irrawaddy river Indians, Myanmar yeah? Burma?

LAURA: Burma, yeah.

KEITH: They had electric guitars. No shoes, no schools, no hospitals. Electric guitars. No electricity. I taught them reggae. Is that wrong?

LAURA: What were you supposed to be doing there?

KEITH: I can't remember.

(*KEITH sits.*)

LAURA: Did you get your post?

KEITH: Letter from Denise.

LAURA: Does all your salary go straight to the bank then?

KEITH: It goes into my bank, hangs around for five minutes, then disappears again into her bank and the other half into Pauline's. My wife. I never see any of it.

LAURA: You live off your Tambian allowance then?

KEITH: Yup. Without that ten quid a week I'd be fucked.

LAURA: Have you got a good job to go back to?

KEITH: Part-time lecturing. I'm not a graduate. Development studies. It's not the job. I miss the kids. I want to be a dad.

LAURA: Not a husband?

KEITH: We'll get married.

LAURA: Have you got a house?

KEITH: No. Pauline's got my house. D's got a decent place. Small but everywhere's small when there's kids.

LAURA: What's the letter?

KEITH: Our Jacob's getting bullied at school.

LAURA: Do all your kids have biblical names?

KEITH: They're very popular nowadays.

LAURA: How many kids are getting called Herod?

KEITH: There's a renewed interest in God.

LAURA: My sister's had her daughter christened so she could go to a Catholic school. They're not even Catholics. She says the school is a 'good' school. Her husband's more honest, he said 'Is the Pope a Paki?'

KEITH: Where's Monday?

LAURA: He went off. In a bit of a huff. I said I didn't think he was a witch.

KEITH: (*Laughs.*)

LAURA: Where will he have gone?

KEITH: Which hat did he have on?

LAURA: His drinking hat.

(*To black.*)

August

KEITH and LAURA sit. They have a bottle of vodka between them. It is evening. KEITH is reading The Idiot's Guide to Islam.

LAURA: (*Out front.*) Dear Pip, I'm drunk. We now have a tap in the village! It's totally, totally fantastic! The women used to have to spend five hours a day walking to the bore hole. I've enclosed a photo of the tap. I saw a giraffe today! Gorgeous! I'd never get away with eye

lashes like that! Unoka's kpelle, the old men, have met and decided not to let the women vote in next month's elections, even though they have the right under Tambia's constitution. Aaagghhh! 'Keep calm, and carry on.' Damien's dumped Stephanie? Never!? Tell Stephie to get herself down the well woman clinic and have a scrape. Forget diamonds, a girl's best friend is a bent coat hanger. Sorry! I'm absolutely trolleyed.

KEITH: I know why this is called *The Idiot's Guide to Islam*. It's written by a fucking idiot. It's politically correct, mendacious, lying crap.

LAURA: It's an approved text in Tower Hamlets.
(*Out front*.) I've just been dumped. Remember Lookout Masulu. He's gone back to his wives. Three of them. That's the trouble with men nowadays, they want it all.

KEITH: (*Reading*.) What! 'Jabir Ibn Haiyan is considered to be the father of modern chemistry!' Crap!

LAURA: You're funny when you're angry.

KEITH: They're claiming trigonometry, astronomy, mathematics. Ha! What were the Greeks doing a thousand years earlier? I suppose Archimedes was running a tourist moped franchise?!

LAURA: Don't bend it!

KEITH: A Muslim did not invent algebra! They conquered the Byzantine empire by war –

LAURA: – I know that.

KEITH: They nicked all the learning of the Greeks and translated it into Arabic! Since when has nicking been inventing?!

LAURA: Can I have my book back please!!!

KEITH: Burn it!
(*LAURA giggles. Enter MONDAY.*)
Just come in. Don't knock.

MONDAY: I have spoken with the earth spirit.

KEITH: Oh fuck.

MONDAY: Many days and many nights, and many pots of palm wine. He is angry that I do not have a bride. He say's a person's character is what he or she does when the

lights go out. I have promised to apply myself to my labours in order to raise a bride price. I will sell twice as much water! All the money will go into a pot with a narrow top, so I can't get my hand in. Also, better late than never, I will stop drinking. I am no longer going to be a Christian of an evening!

(*He crushes the hat and throws it away.*)

LAURA: Monday, the...er...whilst you've been away, er...there's like a –

KEITH: – There's a standpost in the village now.

LAURA: A tap.

MONDAY: But who will buy my water? Now I will never raise a bride price.

(*MONDAY picks up the drinking hat, dusts it down, and puts it on.*)

Don't wait up!

(*He walks off stage left.*)

KEITH: Wupsadaisy!

LAURA: Has he really been in the bush for two weeks?

KEITH: (*With contempt.*) Na. They all think the Earth Spirit is dead. That's their explanation for why this country's up shit creek.

LAURA: So where's he been then?

KEITH: Where do you think?

LAURA: Is he an alcoholic? Like us?

KEITH: Na. Binges. Benders.

LAURA: He's lovely. Like a child.

KEITH: That's a fucking act.

LAURA: Did you get your post?

KEITH: Denise.

LAURA: Is whatshisname still getting bullied? Mathew, Mark, Luke –

KEITH: Jacob. He's got sticky out ears. They call him 'wingnut'. She wants the money for a private operation. I'll give her the money and next time I go home, he won't have had his ears done, and I won't get me money back.

LAURA: This is the woman you're gonna marry?

(*Beat.*) I was 'Screw' at school. Laura Bolt. Bolt / Screw. That's girls for you. Sex that's all we think about. You've got five kids by Denise? Have you never heard of condoms?

KEITH: They're not all mine.

LAURA: Whoever's fucking your wife should be wearing condoms then.

KEITH: You're drunk.

LAURA: Yeah. Why aren't you drunk?

KEITH: You've got very crude recently.

LAURA: Fucking Ibrahima, is that charity? Is that aid work?

KEITH: You don't know the first thing about that.

LAURA: I thought the hoovering had a kinda manic, itchy edge to it, know what I mean. When do you and Ibrahima do it?

KEITH: How much have you had to drink?

LAURA: Do you wait for me to go on my rounds?

KEITH: You should find someone to fuck.

LAURA: My dad's favourite word. Should.

KEITH: When I was in Bangladesh in '95 I organised a three day seminar to discuss the whole concept of sex and the NGO worker. Difficult for you girls, you can't fuck the locals or you become a whore, but you know, most of you are in your twenties and –

LAURA: – up for it.

KEITH: Yeah.

LAURA: What did the 'three day seminar' conclude?

KEITH: There were no conclusive conclusions. Truth is, for casual sex, your choice is pretty much restricted to your colleagues.

LAURA: Are you offering?

KEITH: In this job, you have to stop being idealistic and become a pragmatist.

LAURA: You're so romantic. What's it like with Ibrahima? A circumcised woman? Can she enjoy sex?

KEITH: I thought you girls talked.

LAURA: What's she had, a little nick, or the full pharonic clitoridectomy with flaps off?

KEITH: Oh bloody hell.

LAURA: Why's it called pharonic? Is that after the Egyptian Pharos?

KEITH: No, the Faroe Islands.

LAURA: (*Spits out drink.*) PPPPVVVVVAAA!

> (*LAURA now has the serious giggles, which is a mixture of drunkenness and focussing on the stupidy of naming a full clitorodectomy and labia removal after the Faroe Islands. KEITH joins in the laughter. During the next they've both got the giggles.*)

KEITH: There's Irish medics working on the delta to try and...what's the fucking word?

LAURA: (*Through hysterical giggles.*) Stop?

KEITH: That's it. Stop it. Shh! Listen! They call a pharonic a short back and sides.

> (*They laugh. And then KEITH tops up the drinks. LAURA recovers.*)

LAURA: Oh God. Na zdravie!

KEITH: Cheers!

LAURA: How many women have you had, you know, in your life. Ten, twenty?

KEITH: I've been doing this job twenty years.

LAURA: Fifty, sixty?

KEITH: Three hundred.

LAURA: Three fucking hundred?! Ha, ha! Do you like sex?

KEITH: Yes.

LAURA: Do you like women?

KEITH: Yes.

LAURA: Yeah?

KEITH: Yes.

LAURA: You left your wives.

KEITH: Yeah, but fucking hell. What about you? How many blokes?

LAURA: Fourteen.

KEITH: Not bad going.

LAURA: What's the weirdest place you've ever had sex?

KEITH: Hull.

> (*They laugh.*)

LAURA: I mean, like, in a combined harvester or at the
dentists, or –

KEITH: – what about you?

LAURA: Me? In a tree.

KEITH: A tree?!

LAURA: Yeah. It wasn't easy. Oh, fuck. I was… Alan…
there was a big power station and a…
(*Basically gone, but still talking.*) …duck…one of them
mallards…I was…I need an umbrella…no, he's
not…only when…everybody listen up!…speedboat
regulations…Tuesdays and Thursdays…
(*LAURA slips into unconsciousness. LAURA slides off her
chair, and goes into a drunken sleep on the floor.*)

KEITH: I think I've got this one.
(*Out front.*) The vestry of Winchester Cathedral. I'm
twennie-two. Black bikers jacket, 'White Riot' in white
paint. Frown. Winter. A challenge to God. If you exist,
fucking show yourself. Mel Katz, American at LSE. She's
wearing a leopardskin top and leather jeans. She's a rich
girl, but the Clash City Rocker forgives her, why? Cos
she's gorgeous, stupid. We've planned it. I am brave until
I actually get there. She pulls me into the cathedral.
Inside, she rubs my cock through my jeans. I see her
staring people out. She undoes the buttons on her
leopardskin shirt, her nipples are hard, people stare, 'Do
you wanna photograph?!' She leans back on the font. I
say, 'I can't, I can't, not here.' A tour party flood in from
the vestry, we walk past them. The vestry is ours, she
laughs, lies on the stone floor, I stand over her, look
around, I can't do it, she lifts her bum off the stone,
slides her jeans and knickers down. I have to help, I
kneel and pull them down to her ankles. A challenge to
God. If you exist show yourself now. This one's for the
nuns. She opens her shirt completely and lets her head
lie back. I get hard. I put a condom on. I check it, I
squeeze the air out of the end. I kneel over her, and enter
her. She laughs, and pulls me on, 'Fuck me, come on,
fuck me.' I come. The condom is split, ragged. I look up,

there are three windows, The Father, The Son, and the The Holy Ghost. The sun is shining, and a ray of light twinkles through Christ's eyes. We go for the abortion together, in Birmingham, a private clinic, I borrow a car from a friend, it starts to rain, and then it stops raining, the water on the M1 turns to liquid dirt, a lorry passes, sprays us, the screen wash doesn't work, the wipers paint the screen brown like a roller spreading emulsion. A challenge to God. If you exist, show yourself now. In the ambulance I'm still conscious, 'She'll be alright son, they'll cut her out, just lie back.' I don't go to New York for the funeral. I go to Heathrow. I sit and log her flight as it climbs to the top of the departures screen. When it goes off the screen, I stand up and go to the pre-flight prayer area. The Holy Trinity window there is not real. The plaque describes it as a representation of the window in the vestry of Winchester Cathedral. Someone behind me opens a door and light floods in, and Christ's eyes twinkle.

(*Silence.*

KEITH finishes his drink. He then stands and checks that LAURA has not swallowed her tongue, and just moves her head slightly so she can breathe. He gently moves a lock of hair from her face. He studies whatever exposed flesh there is, then gently picks at her T-shirt to reveal some midriff, confident of her lack of consciousness. He then picks her up and carries her into the ibi turning left into his room. We see him place her on his bed and then he closes the shutters.)

(*To black.*)

INTERVAL

September

MONDAY: Wale Adenuga, my father's father's grandfather, was not a warrior, he was a story teller, and the first man in Unoka to see an iron cow. He told this story every week of his life and he was still telling it on the day they carried him back into the forest to sleep the long sleep. He was weeding his land when he heard a strange thunder. He called the Poro and they came with their machetes. A white man came out of the forest riding on a great iron cow. The white man could not speak properly and had a Kebbe man with him to change his words. 'There is only one God,' said the white man, 'and he gave us a son, Jesus Christ, who is also a God, a God who is both man and god, and then there is the Holy Ghost. You must not worship false gods, and it is wrong to eat human flesh.' The Poro warriors wanted to kill the white man but Wale Adenuga knew that he could destroy the white man with words. 'You say there is only *one* God. And this "One God" has a son called Jesus, who is also a God. Things must be different where you come from, because here, in Unoka, one and one makes two.' The Poro had never laughed so loud. The white man turned red, and they had never seen skin change colour, so they laughed even harder, and Wale Adenuga with skill was riding the laughter like a snake on the white water. 'And this brother of the One and only God, the quiet one, the Holy Ghost, he must be a god too, so that's three gods, and the big One God if he has a son, must have a wife, who would have to be a god too, because the big One God would not want to lay down with the daughter of a yam farmer. So that is four gods already, but wait, I need a piss!' And Wale Adenuga walked over to the iron cow and pissed against the wheels, and as he pissed he carried on counting, 'four, five, six gods, seven' and all the Poro laughed, and no work at all was done that day in the fields, and the

women were brought together and Wale Adenuga was made to tell the story again and again, until he fell down drunk from palm wine and happiness.

(*Beat.*) Three market weeks later the white man returned with warriors wearing coats made of blood. They went into the bush to where the young Poro where living, and learning the ways of the forest. Twenty-three were killed. The Poro collected their bodies and ate their hearts so that their power was not wasted and today their spirits live on, and they are forever with the Kebbe.

(*KEITH and LAURA sit. KEITH is reading a letter. LAURA is holding a newsletter from the Bracknell Head Office of the NGO. IBRAHIMA is seen in the background, cleaning. A television and satellite dish, still in their boxes, are set by the gate to the road.*)

LAURA: (*Out front.*) Dear Pip, You are not a lesbian. Everybody fancies Bjork, I do, and so does my mother. You've read the Koran in two days! Yes, it's a beautiful text, and stylistically much more interesting than the Bible. And yes, of course, Britain has become an entirely alcoholic nation. Very astute of you, oh vodka queen. I agree, Muslims are so right, acts of violence are almost always caused by alcohol. Except maybe the Iran-Iraq war. One million Muslims dead and not a Babycham between them.

KEITH: Fuck! Pauline has become a Buddhist. The butcher's kicked her out. He said she was beginning to undermine his confidence. She's changed her name to Hari.

LAURA: Harry?

KEITH: No. H, A, R, I.

LAURA: Does that mean anything?

KEITH: Yeah. Gullible white girl.

LAURA: What have you got against Buddhists?

KEITH: None of them can cook, yet they all insist on running fucking cafes. Thai Buddhists are alright. They eat meat. When I was working with the prostitutes in Pat Pong –

LAURA: – Where?

KEITH: Bangkok, Thailand. Ha! That was a good gig.

LAURA: (*Out front.*) Do you remember the night of the tap celebrations? I got totally lashed. Well, I woke up in Keith's bed. He was in the chair. He said he wanted to make sure I didn't do a Jimi Hendrix so he put me on the bed face down. I don't think he did anything but, I don't know. I should have told you last month. You feel a long way away Pip.

(*To KEITH.*) Have you seen the newsletter? Belle Yella.

KEITH: (*Engrossed in his personal letter.*) Yeah. Terrible innit?

LAURA: Why would anyone agree to work there? They, like, executed them! I mean, why? They're there helping people.

KEITH: They're Brits. Brits / Americans. Iraq? Is Yahiya expecting me?

LAURA: Yeah, but ring, check.

(*KEITH dials from his mobile.*)

I saw the Dalai Lama when I was in Rio. He was supporting Sting.

KEITH: (*On the phone.*) Yahiya? It's me…here, she won't talk to me.

(*He passes over the phone.*)

LAURA: Eeeeee! Agi, agi! Mr Keith he will bring the television today…thirteen inch…we don't have any flat screen plasmas. Have you got your money through? …Good. Agi, agi! Ciao!

(*Phone off.*)

KEITH: They fucking love you don't they?

LAURA: Do you think we've gone too far?

KEITH: One television in every village is hardly a revolution is it.

LAURA: Two televisions in every village. One for the girls and one for the boys.

KEITH: Course.

LAURA: What do the boys watch?

KEITH: Al Jazeera, Turkish porn, and golf.

LAURA: The girls watch Al Jazeera and Turkish porn. They don't like golf.

(*Enter MONDAY with a swagger. He is wearing sunglasses and a fake Rolex. He gives KEITH a piece of paper.*)

KEITH: Where's my fucking drill?

(*MONDAY and KEITH face off for a moment.*)

What's this?

MONDAY: My joinery homework.

LAURA: I think this joiner thing is a cool idea. You'll raise a bride price –

MONDAY: – If you had not brought a tap to the village I would have a big fat wife already!

LAURA: Monday, can you go with Keith in the puk puk and take a television up to Yahiya in Maduka?

MONDAY: No! Tuesday is Turkish cowboy movie night!

LAURA: Pornography.

MONDAY: You can call it pornography but sometimes there is a good story and interesting characters, but not often, thank God! Ah, you know, there is something wonderful about sitting around in a darkened room with fifteen Kebbe brothers all with a big bamboo!

KEITH: How many tons of maize will this design hold?

MONDAY: It's a CD rack.

KEITH: I asked you to design a three ton maize crib.

MONDAY: I don't need a maize crib! I've got two CDs and nowhere to put them!

LAURA: What are your CDs?

MONDAY: Tupac, 'Fucking with the Wrong Nigga', and Charlotte Church. Charlotte Church is my favourite. The voice of a virgin! And the body of a virgin, let's hope! If not, we've all been done!

LAURA: The maize cribs round here –

MONDAY: – our maize cribs have been like that since Muhammad.

KEITH: The cobs on the bottom always rot!

MONDAY: That's how it works! The bottom cobs rot, so the top ones don't.

KEITH: No cobs have to rot!

MONDAY: Your head has become a coconut.

LAURA: You'll raise a bride price quicker this way.

MONDAY: Soon I will have three wives and much cooking on the go.

KEITH: What are you up to? Where's my drill?

MONDAY: I am now in the oil business.

KEITH: Stealing diesel.

MONDAY: I am Kebbe. It is Kebbe diesel.

KEITH: Your government sold the oil.

MONDAY: My government are not Kebbe.

KEITH: Fucked!

LAURA: How much do you get for a can of diesel?

MONDAY: Every day is different. Today, many hungry lions.

LAURA: It's incredibly dangerous, you know, in Nigeria –

MONDAY: – Nigerians were not behind the door when brains were given out!

KEITH: The drill?

MONDAY: I will give you money.

(*MONDAY gets a significant wad of money out.*)

KEITH: I don't want money, I want my fucking drill. Do you know what the curse of the thief is?

MONDAY: Success!

KEITH: I taught you that.

MONDAY: (*Angry and confrontational.*) You have always tried to teach me many things when all I ever needed was a bloody drill!

KEITH: I'm going. I'm gonna take the puk puk.

(*KEITH leaves taking the boxed television with him.*)

LAURA: You know this maize cribs thing. I think that's a good idea.

MONDAY: I am not a bloody farmer!

LAURA: I remember when you wanted to be a farmer, you said it was a man's job. It's this new Imam isn't it?

MONDAY: He fainted today when we killed the sheep! He is very sophisticated, very city. Shit and him have never met!

LAURA: What does he have to say about the destruction of the twin towers?

MONDAY: What? Wembley?

LAURA: The World Trade Centre.

MONDAY: He is selling the video.

LAURA: Oh no!

MONDAY: There is two hours of Ali Bakassa talking at the beginning but you can fast forward through that bit.

LAURA: And these videos are being played on our TVs?

MONDAY: The top seller! Would you like one?

LAURA: I feel a bit sick.

MONDAY: Today, he has given us all the nod to beat our wives! But I am sad, I do not have a wife.

LAURA: (*Angry.*) And, like, exactly why are the wives going to be beaten?

MONDAY: 'For the things they might have done!'

LAURA: That is pathetic!

MONDAY: It is very wise. Before the tap arrived the women spent five hours a day collecting water, but now, for them each day is a pick and mix of temptations. They might be drinking; might be fornicating; might be thinking about drinking and fornicating; they might be voting in the elections, then having one for the road, and then back for more fornication! So tonight we men are doing Allah's work and guarding the polling stations here in Unoka and up in Enuga.

LAURA: Why Enuga?

MONDAY: When the polling station closes we can go straight to the wild movie club.

LAURA: I know I've only read the Idiot's Guide but obviously there is absolutely no endorsement for this kind of violence towards women in the Koran.

MONDAY: Ali Bakassa reads the Koran several times every day. And he has found it by diligent study.

LAURA: 'It'?

(*MONDAY opens his copy of the Koran at a marked page.*)

MONDAY: (*Reading.*) 'As to those women from whom you fear defiant sinfulness' – (*Translating.*) – if you 'think' your wife *might* be sinful –
(*Reading.*) 'first admonish them, then refuse to share your bed with them'
(*Translating.*) – tick her off, if that doesn't work spend all night on the settee in a big fuck-off sulk –
(*Reading.*) 'and then, if necessary, slap them.'

LAURA: Hit her?

MONDAY: Yes! With a toothbrush!

LAURA: Hit her with a toothbrush?

MONDAY: Oh yes! A man once asked Muhammad, peace be upon him, for advice on the best way to beat his wife and Muhammad, peace be upon him, happened to be brushing his teeth at the time, and so Muhammad, peace be upon him, said, 'Hit her with a toothbrush.' But Ali Bakassa he says that the toothbrush is a metaphor!

LAURA: For what?

MONDAY: A very big stick!

LAURA: Look, don't you think it's more likely that Muhammad –

MONDAY: – Peace be upon him!

LAURA: – meant, kinda, don't beat your wife at all when he said a toothbrush because, you know, it's not easy to hurt someone with a toothbrush.

MONDAY: You have only read some crappy paperback written by an American girl. I will take your motorbike.
(*Exit MONDAY. LAURA sits. A mobile phone goes off. She thinks it's hers and picks it out of her pocket only to discover that it is not hers. Enter IBRAHIMA on the phone.*)

IBRAHIMA: (*On the phone.*) Yeeee! Chim kolle fum age fum. Eeeee! Agi, agi! Swayinka! Fem, fem, agi, agi! Chem sway! Enuga. Yee! Agi, agi. Enuga! Ciao.

LAURA: (*Happy.*) You're so big now?

IBRAHIMA: (*Not happy.*) Yes.

LAURA: What's wrong?

IBRAHIMA: If the child is another 'not a boy' my husband will kill me.

LAURA: No, no, I don't think...will he?

IBRAHIMA: He said even a poor man can have too many sticks.

LAURA: When is it due?

IBRAHIMA: The last market week in December. I go to the mountain a month before it is due.

LAURA: That's, like, Sande stuff, yeah?

IBRAHIMA: The Earth Spirit will decide whether it is to be a boy.

LAURA: But you're six months already, the sex is already...no.

IBRAHIMA: What?

LAURA: Nothing.

IBRAHIMA: (*Conspiratorial.*) I am going to vote tonight.

LAURA: But the kpelle had a meeting, they agreed that the women would not be allowed to vote.

IBRAHIMA: Fuck the kpelle! We women have the right to vote! Tambekistan is a very modern democracy. Tambekistan will be sending representatives to monitor the fairness of the next American elections. That's my little joke.

LAURA: That's a very good little joke. But I don't want you to vote. It's dangerous, there are –

IBRAHIMA: – the President of Bangladesh is a woman, and so is the Deputy Prime Minister of Iran, and then there's Imran Khan's wife.

LAURA: What's she?

IBRAHIMA: A woman. We cannot vote here in Unoka because the diesel boys are guarding the polling station, so we will walk over the hills to Enuga.

LAURA: Don't try and vote OK! I don't want you to vote. Have you got that? At no point did I ever suggest that you should exercise your democratic right to vote. OK?

IBRAHIMA: (*Genuinely angry.*) Voting is my idea!

LAURA: Oh God, you don't understand, these things are like subtle, I mean – alright! Do what you like, but it has nothing to do with me.

(*IBRAHIMA moves towards the gate.*)

Don't go to Enuga.

IBRAHIMA: What?

LAURA: There will be men there. Monday has gone up there with the Imam and a gang from the mosque.

IBRAHIMA: Today is the last chance to vote!

(*LAURA and IBRAHIMA both get on their mobile phones and make calls. LAURA's voice dominates.*)

LAURA: (*On the phone.*) Keith?…it's me… Where are you? …Can you see the polling station? …Are there any men stopping the women voting… OK cool, see you later. (*Off the phone.*) Maduka.

IBRAHIMA: Maduka, in the barn?

LAURA: Yes.

IBRAHIMA: (*On the phone.*) Yee! It's me… Agi, Maduka… Yes, there are men at Enuga. You ring Mgbafo, I will ring Kiaga. Get Mgbafo to ring Odema and pass it on. Agi! (*IBRAHIMA leaves with a wave, still on the phone.*)

LAURA: Oh fuck!

(*To black.*)

October

IBRAHIMA staggers on and is supported by LAURA. Slowly LAURA lifts the burqa over IBRAHIMA's head. Her head is completely bandaged. LAURA carefully places the burqa over her face. IBRAHIMA goes into the ibi to work.

Enter MONDAY.

LAURA: Monday, you can get anything Russian.

MONDAY: No. I will not get you a gun.

LAURA: How do you know what I want?

(*Beat.*) You are clever, like an old fish.

MONDAY: English girls do no go around the place killing people with guns.

LAURA: If she has a girl, and he kills her. I might start. I'm angry with you.

(*Out front.*) Dear Pip. I know you sent me a copy of *Heat* because there was a Toni and Guy voucher in the envelope, but, customs must have nicked the magazine! Aagh! Ibrahima voted in the elections. When her husband heard he threw kerosene on her, and set light to her. She's lost her hair, and the flesh on her ears. Keith and I went to the police. Joke! (*To MONDAY, angry.*) Did any women try and vote in Enuga?

MONDAY: I've told you!

KEITH: Oi!

MONDAY: I didn't hit anyone!

KEITH: Cool it! Let's have a drink.

MONDAY: All the hitting was at Maduka!

KEITH: (*To MONDAY.*) We're out of vodka.

LAURA: Muslim heaven's not short of booze is it.

KEITH: Let it lie!

MONDAY: Oh yes, Muslim heaven is very good! We are all just warming up for one big jam session!

LAURA: Muslim heaven is just booze and girls isn't it!?

MONDAY: There will also be many beautiful fountains.

LAURA: I bet there's a fuck of a queue for the fountains.

KEITH: I'm the boss here, right? I said –

LAURA: (*To KEITH.*) – No! I'm fucked off.

(*To MONDAY.*) These whatsaname sex slaves –

MONDAY: The houris. Built for sex!

LAURA: Lara Crofts. They don't have souls, they're not real women, not human.

KEITH: Course they're not human, it's heaven.

LAURA: But no souls!

MONDAY: Brilliant! No bloody waterworks when you dump them!?

KEITH: What do you know about dumping women?

MONDAY: I listen to the world service! Also, in Muslim heaven everyone is about thirty.

LAURA: Sounds like Crouch End.

KEITH: (*To MONDAY.*) You might go to hell. You're a thief, a wanker, a Christian, an alcoholic, you worship Poro gods.

MONDAY: – Muslim hell is much better too, it's
 temporary! Christian hell is forever! Very bad!

LAURA: What's Muslim hell like then?

MONDAY: Fountains of puss, blood, and boiling muck, and
 utter hopelessness and despair everywhere.

KEITH/LAURA: Crouch End.

LAURA: (*In his face.*) Muslim heaven seems to me like a
 pornographic fantasy. One long, immature, teenage boy's
 wank.

 (*MONDAY exits.*)

KEITH: Monday!

 (*To LAURA.*) Brilliant.

LAURA: I'm sorry. Where will he go?

KEITH: On the piss.

 (*LAURA picks up MONDAY's blue fez Christian clan hat.*)

LAURA: He's forgotten his drinking hat. Oh shit!

 (*LAURA runs into the road.*)

KEITH: Oh wupsadaisy!

LAURA: He's gone. Fuck!

KEITH: He'll be alright. Do you wanna spliff? Don't let the
 bastards grind you down.

 (*KEITH lights a spliff.*)

LAURA: What are you grinning at?

KEITH: Listening to a feminist having a go at Islam is
 about all the fun I can handle.

LAURA: I'm not a bloody feminist! How can I be? I'm
 only twenty-four.

KEITH: (*Laughs.*) Feminism eh? The dog that didn't bark.

LAURA: What?

KEITH: (*Chuckling.*) They've left Islam well alone haven't
 they. Daren't start, cos it'd make their little western
 whinges look very silly. Wages for house work. Huh.
 Glass ceilings, huh, huh!

LAURA: Listen! Ibrahima's baby is due next month. If it's
 another 'not a boy' he'll kill her.

KEITH: He might not.

LAURA: He fucking will! And what are we going to do
 about it?

KEITH: We can't get involved.

LAURA: We are involved. You've been using her for sex, we're –

KEITH: Prostitution is consenting sex. Between adults.

LAURA: Why don't you get yourself a Philippino catalogue bride, settle down in Oldham and stop inflicting yourself on the third world? You wanker.

KEITH: I wish you wouldn't use the term 'the third world'.

LAURA: If she has a girl and he kills her. I think I'll fucking kill him. I'll buy a Kalashnikov from Monday. I will!

KEITH: Has she been to the mountain yet?

LAURA: She goes quite soon.

KEITH: Wait for that then.

LAURA: It's either a boy or a girl already.

KEITH: Faith.

LAURA: Fuck faith.

KEITH: Shh!

(*Enter IBRAHIMA.*)

IBRAHIMA: Hi.

LAURA: Hi.

KEITH: Hi.

IBRAHIMA: Do you have the Internet working?

KEITH: Not yet. Almost. I've set you up an account. Ibrahima dot globeact at aol dot com. I'll write it down for you.

IBRAHIMA: My own email! Eeeeee! Agi! Are you still leaving after Christmas?

KEITH: Laura is taking over.

IBRAHIMA: And the computer will stay?

KEITH: Yes.

IBRAHIMA: I would like to help to run this place.

KEITH: Your husband will want you to look after the boy.

IBRAHIMA: Yes.

KEITH: Laura will talk to all the women and see what can be done.

LAURA: Where will you give birth?

IBRAHIMA: In my ibi. With the other wives and my sisters.

LAURA: I will pay for you to go to Kante, the hospital there –

KEITH: Laura!

LAURA: – has got good facilities and I'll stay with you and –

KEITH: You can't save these people from themselves.

LAURA: (*With sarcasm.*) It's like herding cats.

KEITH: There is only one hope.

LAURA: A Christian God? You know, for someone like me, I mean, there was a time when I would have wanted there to be a God, it woulda been kinda nice, you know, but not now cos the really really stupid thing about, you know, the world now, yeah, is that there is no God, he or she is dead, in fact never was. So the whole premise of religion is a complete fucking fantasy non-starter, and the little history thing between Christianity or the West and Islam is utterly pathetic because it's the same God of course, the same God that doesn't exist. But if you say these gobsmackinglyobvious things it makes it worse doesn't it. If you tell people like you to pack up and go home, or tell the Imam to fuck off back to Medina, they come out spitting fire, cos you've taken away the only idea they've got, and you're asking them to face up to the difficult and dispiriting job of living, here, now, on earth, with each other. And all they're left with these people, you!, is people, and people like you hate people because people are sinners.

(*Beat.*) Don't take notes, there's a handout at the end.

(*To IBRAHIMA.*) Sorry about this.

KEITH: Only –

LAURA: – I haven't finished! I'm the really brave one here, because I've made the tough decision not to, like, console myself with a fucking fairy tale, a ready made answer to the question that, like, has no answer and will never have a fucking answer. Who are we? And, like, why are we here? I mean it's like as if the whole world is made up of five year olds who believe in Father

183

Christmas. It is not a sensible way to run a fucking planet!!

KEITH: I pity you.

(*Internet connection noises.*)

Here we go!

(*Beat.*) I'm through! Come on, come on.

(*The AOL voice sounds.* YOU HAVE E-MAIL!)

Yes! Ha, ha!

LAURA: What is it?

KEITH: Yup. Chuck and Patti from Care in Kante.

(*Reading.*) They're in Kante for a 'thanksgiving' lunch but would love to come to the beautiful Unoka for a turkey lunch on Christmas day.

LAURA: Where are you getting a turkey? No-one round here farms turkeys.

KEITH: I'm getting it Fedexed. Ibrahima's got mail! Ha, ha!

LAURA: You're having a turkey posted here?

KEITH: Yeah, from Oldham. I've done it before.

LAURA: It takes two weeks, if you're lucky.

KEITH: My mother cooks it, freezes it and vacuum seals it. Puts it in a cool box and labels it Essential Medical supplies and it takes a week.

(*To IBRAHIMA.*) You've got mail.

IBRAHIMA: E-mail? Me? EEEEeeeee! Agi! Agi!!

KEITH: Yeah.

IBRAHIMA: (*To LAURA.*) 'I've got mail!'

LAURA: Yes.

KEITH: Just double click.

LAURA: Who's it from?

IBRAHIMA: (*Reading.*) Expand, lengthen and enlarge the girth of your penis.

(*To black.*)

November

MONDAY is being flogged.

MONDAY: (*Out front.*) I am a Christian!
(*Lash.*)
Agh!
(*Lash.*)
Agh! I was drinking but I have a Christian name.
(*Lash.*)
Agh! Monday! My name is Monday. An old English name!
(*Lash.*)
Agh! You cannot lash an Englishman!
(*Lash.*)
Agh! I am not in the mosque. My father is the mission.
(*Lash.*)
Agh! Your law is not my law!
(*Lash.*)
Agh! Do I have a beard!? I lost my hat on the road!
(*Lash.*)
Agh! I am Egwome Christian, Kante Egwome. My hat –
(*Lash.*)
Agh.
(*Laughing.*)
I lost my hat in the wind.
(*Lash.*)
(*Laughing.*) The wind blew my hat off!
(*Lash.*
Lash.
Lash.)
(*Quietly to himself.*) I am Poro. I am Kebbe.

(*To black.*)

(*Lights up.*
IBRAHIMA is very pregnant. LAURA is hugging her, and crying a bit.)
LAURA: I wish I could come with you. Ask the Earth Spirit for a boy, from me.
IBRAHIMA: It is not good to ask too hard. Where's Mr Keith?

LAURA: He went to see that Monday was lashed properly, you know, humanely. Is there anything I can do?

IBRAHIMA: Are you a Christian?

LAURA: I was christened.

IBRAHIMA: Pray to your God then.

(*IBRAHIMA kisses LAURA and walks off stage left.*)

LAURA: (*Out front.*) Pip twenty-seven at hotmail dot com Subject. A prayer for Ibrahima. I am so ashamed that we are on AOL. Uuugh! We're a bloody NGO for Christ's sake! NGO not VSO, OK? You want my advice? OK. Here goes. I know you're in deep shit with Uni debts and credit cards and I know you're, like, totally deconstructed over Barry, still, but I am absolutely solid that going to America to sell your eggs is wrong. Ethically and morally, and you won't make that much money anyway, not after all your costs. Now I need a favour. Remember that Internet chain letter you organised for the Mujahidin human rights at Guantanomo Bay. Well, basically I want a global chain prayer thingy for a woman called Ibrahima in Unoka, Tambia. She is due to give birth and if the child is a girl, her husband will kill her. He will. Please Pip. Kiss, kiss, kiss.

(*To black.*)

(*Lights up.*
Enter MONDAY wearing only shorts and flip flops, his back is bleeding. He is carrying a AK 47 which he gives to LAURA.)

LAURA: I don't want it.

MONDAY: It is mine. Take it from me, please, and hide it in the ibi. I want to use it.

(*LAURA takes it.*)

IBRAHIMA: (*Out front.*) Earth Spirit. I am Sande. You are God of All things. I have washed. I have eaten. I carry one of yours. It is time for you to decide. I am now nine months without bleeding and the child is ready. I have been here at the mountain for two market weeks. I have

not looked at pictures. I have not listened to the words of the big whitey.

(*She flinches slightly with guilt.*)

(*Less confidently.*) I have not listened to words. My little God is fed. I have three girls. Your decision will please me. Take this wine, it is fermented.

(*Her phone rings. She panics and turns it off. And starts to cry.*)

I have not listened to words. I have not looked at pictures. I am clean. I am mountain. I will sleep here now. I will take pleasure in your decision.

(*To black.*)

(*Lights up.*
LAURA is dressing MONDAY's wounds.)

MONDAY: – Agh!

KEITH: You're not allowed to touch him.

LAURA: Alright, I won't do it.

MONDAY: No. It is good. It is very good.

KEITH: Can someone tell me why there's an AK47 in our fridge?

LAURA: Had you been drinking that night Monday?

MONDAY: Egg nog! It has me in its grip!

LAURA: Look, the Diesel boys are the bully boys for the Sharia Committee. They nick diesel from the pipeline. They just wanted to warn you off, you know, off their diesel.

MONDAY: – Take the logs from your eyes! Of course! They were buying the bloody drinks! That's how they could be sure I was drinking!

KEITH: (*Laughing.*) Huh, you see, without the rule of law you're fucked. That's what Britain gave the world, and from that one idea, flows everything. Equal rights for all men, Shakespeare, cricket, The Clash. Look at the sports we invented: football, rugby, swimming –

LAURA: – swimming?

KEITH: The rules of swimming. Sports we didn't invent: wind-surfing, kick-boxing, and the luge.

LAURA: 'Things we invented before the Nazis.' Concentration camps.

KEITH: The Spanish were the first to use concentration camps, in Cuba, eighteen-ninety – [six].

LAURA: – Slavery?

KEITH: We ended slavery!

LAURA: Who, like, started it though?

KEITH: The Portuguese! Actually that is the fucking problem, cos no-one is taught the bloody truth anymore are they, they're taught a concocted, apology for the truth by some twenty-two year old Australian supply teacher who puts a question mark at the end of every fucking sentence and thinks the Spanish Armada is a tapas bar in Putney.

LAURA: I've been there.

KEITH: We invented human rights.

LAURA/MONDAY: (*Laugh.*)

KEITH: The lawyer who started Amnesty International was an Englishman! He wasn't a fucking Libyan that's for sure. Libya are chair of the UN Commission for Human Rights, you know. How the fuck did that happen?

LAURA: You're gonna tell us aren't you?

KEITH: It's the African nations' turn to chair that committee – as if it's a game of pass the fucking parcel. So they lock them in a room and tell them not to come out until they've chosen someone suitable. Ten minutes later out comes Colonel Gadaffi with the bin on his head. You know, sometimes I'm ashamed to be a liberal!

LAURA: It's like herding cats!

(*MONDAY and LAURA laugh.*)

KEITH: I'm a pacifist, naturally, but you've got to admit, the British army is the best in the world.

LAURA/MONDAY: (*Giggle.*)

KEITH: If it had been us at Srebrenica instead of a bunch of Dutch transvestites there would be six thousand Muslim men still alive today.

(*Double mouse click.*) Fuck! Chuck and Patti have pulled out of Christmas dinner. Worried about the diesel boys. Bloody Americans. Wimps.

MONDAY: Agh!

KEITH: (*Clicks and brings up another e-mail.*) Peter fucking Nicholson's global wank, sorry, update. Hi! Devastated by the atrocity at Belle Yella, bla, bla, tragic, bla, bla, wives and families, bla, bla…the work will continue.

LAURA: Why don't they just close it down? We pulled out of Pakistan.

KEITH: Belle Yella is where we started, and Peter fucking Nicholson has had his 'resolve strengthened'.

LAURA: They're not restaffing it are they?

KEITH: Yup. Leapfrog Technology Co-ordinators. I told you he'd nick your ideas. In fact you're the best person for the job.

LAURA: Insane.

(*Enter IBRAHIMA. She stands and stares at LAURA.*)

IBRAHIMA: I have been sent the dream. Eeeee!

(*IBRAHIMA hugs LAURA. MONDAY takes an interest.*)

KEITH: Good.

LAURA: Calm down, calm down. Just tell me.

IBRAHIMA: It is going to be a boy!

LAURA: It was a boy in the dream?

KEITH: Oh good.

IBRAHIMA: A beautiful, big, strong boy. I am so happy!

(*IBRAHIMA hugs LAURA again. MONDAY stands.*)

MONDAY: Ig bafoo kom illi fem chu aka? [You really got a proper message dream.]

IBRAHIMA: Cha! Phuttum Yazid! [Piss off. Yazid wanker.]

MONDAY: Num, num, ig challa wole ka um fem chillo? [No, no, really, I want to know, tell me.]

KEITH: Oi! Come on we've got a rule here. English!

IBRAHIMA: Agi. Swem fila chum fem chillo. Agi, swem fallah fallah chum fem chillo. [Yes, I went to the mountain and my little god was taken from me and given a message dream.]

MONDAY: Agi? [Yes?]

IBRAHIMA: Chew fem chilla. Agi fem chillo. [A message dream. Yes, he is still alive.]

MONDAY: Swayinka!? [Really?!]

IBRAHIMA: Chem sway! Agi. [Of course. Yes.]

MONDAY: Fem, fem. Agi, agi. [Good, good. Yes, yes.]

KEITH: Excuse me! My room needs a bit of a hoover!

LAURA: There's no need. You should rest. We'll pay you just the same, can't we?

KEITH: No! Do some bloody work.

(IBRAHIMA goes into the ibi and gets on with work.)

(To MONDAY.) What was all that about? You two are normally like cat and dog.

MONDAY: We are both Poro.

KEITH: Come on!

MONDAY: The Earth Spirit gave her a message dream. We thought he was dead.

LAURA: But he gave you a dream this year about selling more water, to get a wife.

MONDAY: I made that up.

LAURA: Everybody dreams. How do you know it's, like, a message dream.

MONDAY: Your little God is taken out of your body and you can look down and see yourself.

KEITH: That's really good news. I'm very happy for you.

LAURA: Where are you going?

MONDAY: The forest. The human mind is like a parachute, it works best when it is open! After that flagrant flogging I am sticking two fingers up to Ali Bakassa. The Poro is a very natural way of life. Eating is good, drinking is very good, and fornication is absolutely essential!

KEITH: And cannibalism?

MONDAY: You can call it cannibalism. We call it 'eating people'.

LAURA: Do the Poro really, like, eat, you know, actual people?

MONDAY: Only the best! You are what you eat!

KEITH: It's barbaric.

MONDAY: (*In KEITH's face.*) When the Kebbe first cultivated this land we made an agreement with the Earth Spirit. But the big whitey 'One God' put a stop to the sacrifices and all the important eating and what happens?! Before you can say 'Ben Jonson!' Bang! No rains! No yams! No maize! And then brother is killing brother.

KEITH: (*With contempt.*) You flunked out of bush school. Couldn't eat the flesh eh?

MONDAY: It was me they were going to eat! Eating is good. Being eaten is not so good. But I am going back to the forest now. He is alive.

KEITH: No you're bloody not. You work here. I'm paying your wages.

MONDAY: (*To KEITH.*) You believe in nothing.

KEITH: I believe in the Lord God our Father who –

MONDAY: – Your father's arse is on fire!

(*To black.*)

December

MONDAY: Earth Spirit. I am Poro. I am Kebbe. I bring myself to you. I have not washed. I have not looked at pictures, not heard the words of the big whitey, not heard the words of the beards. My head is empty. There is space now. I am the forest. My little God is in me. He said go to the forest. I am here. I know you live. It is my little God you hear speaking. Take him from my body. Give him dreams. Accept me now – take my gifts. My little God will listen. I am empty now. You can fill me. I am the forest. Give me dreams.

(*A little Christmas tree with lights running off a battery with a cross on top. Christmas crackers on the table. An advent calendar, with all the windows open. On the table a Fedex box marked* MEDICAL SUPPLIES / EXPRESS.)

LAURA: (*Out front.*) Pip twenty-seven at hotmail dot com. Subject. Happy Christmas. Not. My dad has left my

mum. He's met someone younger, better looking, with a more attractive personality. Also, two days ago, in Pakistan, a bus carrying Muslim girls was hijacked by Christian boys and seven of the girls were raped at gunpoint. Al Jazeera got hold of some amateur film of it and have been playing the footage over and over again. Here in Tambia, the diesel boys and other Muslim vigilante groups went bananas and attacked all the 'Death is Certain' buses and burned all the 'God is in Control' toilet paper they could find. Public Christian worship, and Christmas celebrations have been banned.

(*Enter KEITH from the road.*)

Wow! Twenty-seven thousand people prayed for Ibrahima. You're incredible. Brill, thanks, Pip. She's gone into labour.

(*Enter KEITH from the road. LAURA stands. They face each other.*)

KEITH: She's had the baby. Half an hour ago.

(*Pause.*)

LAURA: Tell me then. Just fucking tell me!

KEITH: Calm down.

LAURA: No! No! I will not fucking calm down! Tell me!

KEITH: It's a boy! A boy!

(*LAURA does a mixture of laughter and tears and drops to her knees.*)

LAURA: (*Through laughter and tears.*) I don't believe it. I can't believe it. A boy. A boy! Oh God!

KEITH: She's alright. They're both alright.

LAURA: (*Through tears.*) I don't believe it. I just knew, I absolutely solidly knew that it was going to be a girl. I was beginning to feel as if someone kinda had it in for me, and every terrible thing that has ever happened in the world was being put before me, to kinda, you know, I dunno, test me. A boy! But this is good. This is very, very good.

(*She starts to cry. KEITH puts his arms around her. She freezes. She tries to push him off.*)

No!

KEITH: I'm sorry?

LAURA: Just don't fucking touch me.

KEITH: Woah!

LAURA: Yeah.

KEITH: What's going on?

LAURA: That night, you know, when we got drunk, the tap celebration night.

KEITH: Yeah.

LAURA: You looked after me. You put me in your bed, and you slept in the chair.

KEITH: Yeah.

LAURA: Did you do anything? To me.

KEITH: I put you in bed, I made sure you were face down –

LAURA: – so I didn't choke on my vomit. Did you do anything else?

KEITH: I see. No. After I *looked after you*, I went to sleep.

LAURA: Why did Victoria go home?

KEITH: She's was a nutter. She had a severe reaction to the malaria tablets, she was hallucinating for a whole week. I took her to the hospital. They had to strap her to the fucking bed. She thought she was a monkey. She was going to scale the outside of the building.

LAURA: I don't believe you.

KEITH: Why should I lie?

LAURA: You've lied before. She never got drunk at the army barracks. She never gave anyone a blow job in public.

KEITH: Yeah, I made that up. I was trying to make a point for your benefit. I didn't touch you.

LAURA: Did you spike my drink? OK. How about this? I think you spiked my drink, and then, I dunno, played with me, fingered me, fucked me.

KEITH: (*Angry.*) I stopped you choking on your own puke, put you in my bed, and went to sleep in the chair!

LAURA: Why didn't you put me in my bed?

KEITH: You don't have a chair in your room.

LAURA: Did you look at me? Did you wank?

(*Silence.*)

(*As a statement.*) You had a wank.

(*Pause.*)

KEITH: I didn't touch you. I didn't harm you at all.

LAURA: See you later.

(*LAURA makes to leave.*)

KEITH: You're beautiful. And clever. You're not going to be interested in me. Look at me. But I didn't touch you.

LAURA: You thought about it, considered it.

KEITH: I'm leaving tomorrow. I just want to say, it's been great. You're great.

LAURA: I saw your tickets. You're not going home.

KEITH: No.

LAURA: Freetown. We haven't got a project in Sierra Leone.

KEITH: I go overland from Freetown. Across the Liberian border.

LAURA: Belle Yella?

KEITH: Yup.

LAURA: Fuck. Don't go.

KEITH: Peter fucking Nicholson wants a leapfrog technology project on the Tambian model, your model.

LAURA: You can't go home can you?

KEITH: I didn't touch you. I didn't do anything.

(*Beat.*) Do you like Yorkshire puddings?

LAURA: Yeah.

KEITH: (*Indicating the Fedex box.*) I guess this is the turkey.

(*KEITH starts to open the box.*)

LAURA: I'm going to see Ibrahima.

KEITH: Wear a burqa. A veil's not gonna be enough. Not today.

(*LAURA goes into the ibi. KEITH starts to open the box. He takes out the turkey. Enter LAURA dressed in a light coloured burqa.*)

No guns?

LAURA: No guns.

(*She exits stage right. KEITH picks out the turkey. It is crawling with maggots. Enter MONDAY dressed in traditional African Poro bush school dress. He is holding a machete in*)

one hand, a beard in the other. He is wearing a mask and is painted with white clay like a warrior.)

KEITH: It's Christmas dinner, not fancy dress. I'm not paying you for the last two weeks. You're taking the piss. Where the fuck have you been?

(*The sound of motorbikes in the background. The noise level increases during the next.*)

Well? Cat got your tongue?

MONDAY: I have been given a dream.

KEITH: Let me guess. You were naked in the park baking bread, your mother, dressed like a schoolgirl comes in on a horse –

MONDAY: – In the dream I eat the beard of Ali Bakassa!

KEITH: Got a sense of humour then has he, the Earth Spirit. Why do you have to eat his beard?

MONDAY: The power of an imam is always in the beard.

KEITH: Course. And this is Ali Bakassa's beard?

MONDAY: I cut the hair from his chin myself!

KEITH: What with a machete?

MONDAY: (*Producing scissors.*) No I took some scissors along.

KEITH: Did anyone see you?

MONDAY: I am wearing the devil mask.

KEITH: Well that's alright then. How are you gonna eat it?

(*MONDAY bites off a bit of beard and starts to chew.*)

You'll get a hair ball.

MONDAY: I will make a sauce.

KEITH: She's had the baby. It's a boy.

MONDAY: Of course! She was given a boy in the dream.

(*The noise of motorbikes is heard outside.*)

KEITH: No-one saw you eh?

(*KEITH peeks through holes in the fence.*)

The diesel boys.

(*MONDAY turns the Christmas tree lights off, and snatches the cross off the top and lobs it into the ibi. He goes to the gate and secures it shut. He goes into the ibi and comes out with the drill and undoes a panel in the fence. He has left the machete on the table. MONDAY rushes into the ibi and comes*

*out with the drill. KEITH goes into the ibi and comes out
with the AK47. He crouches with the gun and aims at the
gate.)*

MONDAY: Come on! Are you crazy?!

(*Beat.*) Chum kolla kwafe ma. [God help you.]

(*MONDAY exits through the fence. KEITH puts the cross
back on the top of the tree and turns the Christmas lights
back on. He stands and stares at the door. The noise of the
Diesel Boys increases.)*

KEITH: Fucking come on!!

(*To black.*)

May

*A bright sunny day. Spring. LAURA is typing away at the lap top.
She has a beer open and is smoking.*

LAURA: (*Out front.*) Pip twenty-seven at hotmail dot com.
We've applied for a position in Bhutan. That's the eastern
Himalayas. Bhutan is probably the world's most
beautiful, unspoilt country. They're mainly Buddhists.
The project is to try and stop nicotine and alcohol abuse
spreading from the capital Thimbu into the regions. I
must be mad. I love it.

(*Enter HARSHA. She is a young 23-ish British woman,
second or third generation Indian. She is dressed in jeans, a
T shirt with a* NO LOGO *logo (or whatever the current vogue is
amongst globalisation protesters) and an improvised hijab.
She carries hand luggage and a big holdall. Hanging out of
the holdall is a copy of* Heat *magazine. She puts her bags
down.)*

HARSHA: Hi. Harsha. You must be Laura.

LAURA: Hi. You're late.

HARSHA: Yeah, a couple of UN blue helmets, like, stopped
the bus and took a gang off at gun point? Hey, there's a
war on. Scary.

LAURA: You weren't scared at the time, but you are now?

HARSHA: Yeah! That's it.

LAURA: Do you wanna beer?

HARSHA: We've got beer? I thought this –

LAURA: – would you prefer vodka?

HARSHA: Beer's cool. I got totally wankered last night. I promised myself I'd, like, detox today.

(*LAURA goes into the ibi and returns immediately with a beer.*)

LAURA: (*Off.*) Lakpat?

HARSHA: Some new Icelandic NGO start-up. Icelandics. They are seriously weird. One guy fell asleep, totally, like, out of it, so everyone else pissed on him. The girls as well.

LAURA: Where were you bored out of your fucking mind?

HARSHA: St Helens.

LAURA: Pilkington glass. Rugby league.

(*HARSHA gulps on her beer.*)

HARSHA: Yeah. Wow! What fantastic beer!

LAURA: It's a German recipe. No hops. Brewed under licence in Morocco. You'll get sick of it. It's too sweet. Why Tambia?

HARSHA: I guess, I kinda just needed to do something adventurous, you know, even a bit scary. And of course, you know, I really really do want to try and make some kinda contribution, you know, on a global level. Fuck, how tossy does that sound?

LAURA: You've got an MBA.

HARSHA: So's everybody nowadays.

LAURA: On the form it said Hindu.

HARSHA: My parents are Hindu.

LAURA: Wear a veil, and tell everyone you're C of E. Sorry, would that be a problem.

HARSHA: I'm agnostic really but, like, you know, I kinda believe that God is in everything, yeah, like a kinda big organic, Gaia type thing.

LAURA: An animist?

HARSHA: Is that what I am? I do believe in a spiritual dimension. It would be weird, you know, to think that

this is all there is, and you know, well, there's just so much weird stuff that can't be explained, you know er like –

LAURA: – Infinity.

HARSHA: Infinity, yeah. And poltergeists.

LAURA: Ghosts?

HARSHA: No, poltergeists. No-one disputes the existence of poltergeists, even scientists, and you know, if you accept that then you have accepted that there is another dimension.

(*Beat.*) Wow! Fuck, I went off on one, sorry.

(*Enter MONDAY. Dressed in western clothes, a white shirt and chinos, and leather shoes.*)

LAURA: This is Monday Adenuga, my husband.

(*They shake hands.*)

MONDAY: Welcome to Tambia.

HARSHA: Tambekistan.

MONDAY: Very good!

HARSHA: You're the field officer, yeah?

MONDAY: That's me!

HARSHA: OK. In Bracknell they said that men and women don't touch.

MONDAY: (*Laughing.*) Peter Nicholson.

LAURA: Have you eaten?

HARSHA: No! I'm really, like, blood sugar, zzzuuut, you know.

LAURA: We'll eat out here.

(*MONDAY goes off into the kitchen.*)

Sit down. What are we having Monday?

MONDAY: Yam foo foo.

HARSHA: Great!

LAURA: Any stew?

MONDAY: (*Off.*) I was at Enuga, in the market. I picked up some bush meat.

LAURA: Good. What is it?

MONDAY: (*Sticking his head out the window.*) Giraffe.

HARSHA: (*Hand over mouth.*) Oh no!

LAURA: It's not neck again is it?

MONDAY: You like neck.

LAURA: Be nice to have a change.

(*To HARSHA.*) Can you ride a motorbike?

HARSHA: (*Lying.*) Yes.

LAURA: What does Peter fucking Nicholson say about me?

HARSHA: He says you get things done. You make things happen.

(*To black.*)

(*The End.*)